IMAGES
of America
GLASSBORO

*To Dorothy and to all the Sisters
Enjoy being in my town!
Love, Joy
Maureen*

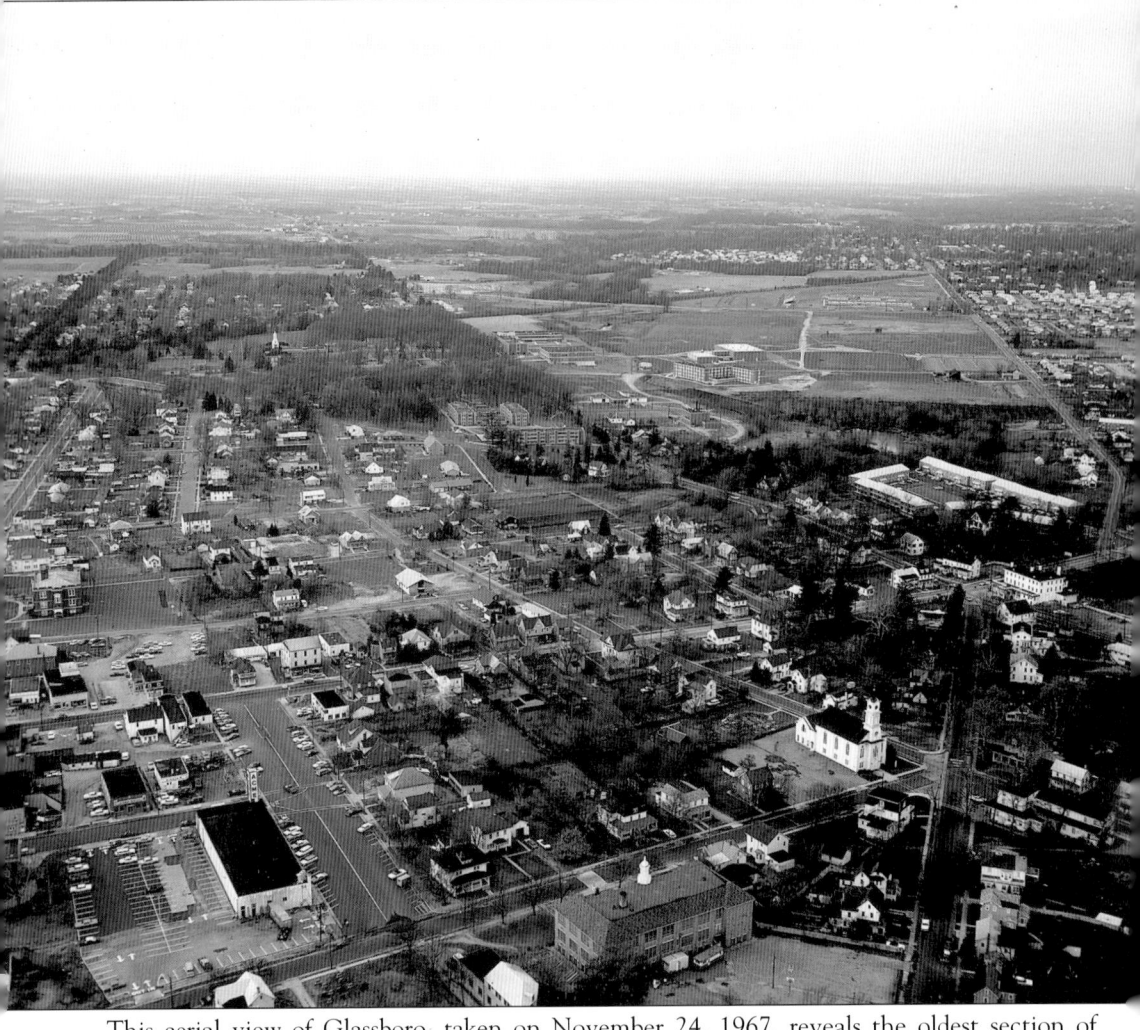

This aerial view of Glassboro, taken on November 24, 1967, reveals the oldest section of town. By 1861, Glassboro had become a well-established community, with many of the main thoroughfares connecting neighboring towns. In the early 1780s, three established roads intersected Glassboro in the proximity of the Stanger Glass Works: Mullica Hill Road, Malaga Turnpike, and Carpenter's Landing Road. Soon, the early settlers created Wood Street (now Main Street). In the 1830s, streets such as Academy, New, and High were constructed to support the Harmony Glass Works, later owned by Thomas Whitney. In south Glassboro, Grove, Oak, and Williams Streets were developed to allow access to the Temperanceville Glass Works. As evidenced by these streets, development was carefully planned to accommodate the growth of the glass industry. Noticeable are, from left to right, the Acme Store (now the Glassboro Public Library), the Academy Street School, the First Methodist Church, and the Franklin House.

IMAGES of America
GLASSBORO

Robert W. Sands Jr.

Copyright © 2004 by Robert W. Sands Jr.
ISBN 978-0-7385-3706-1

Published by Arcadia Publishing
Charleston, South Carolina

Printed in the United States of America

Library of Congress Catalog Card Number: 2004111162

For all general information contact Arcadia Publishing at:
Telephone 843-853-2070
Fax 843-853-0044
E-mail sales@arcadiapublishing.com
For customer service and orders:
Toll-Free 1-888-313-2665

Visit us on the Internet at www.arcadiapublishing.com

This vintage Glassboro postcard dates from August 3, 1914.

Contents

Acknowledgments 7

Introduction 8

1. The Glass Works: Building a Community from Glass 9

2. Hollybush: The Most Famous House in Glassboro 19

3. Business: Strength in Commerce 27

4. Glassboro Schools: Developing Minds 51

5. Churches: The Many Houses of Worship 65

6. Civic Duty: Glassboro Citizens Heed the Call 75

7. Transportation: Venturing along the Roadways 85

8. Neighborhoods: Home Sweet Home 97

9. Recreation: Community Entertainment 117

This book was created in honor of my mother, Elaine L. Jones, and my sister Elizabeth A. Sands, and in memory of my grandparents Llewellyn R. Jones Jr. and Lillian M. (McCleary) Jones.

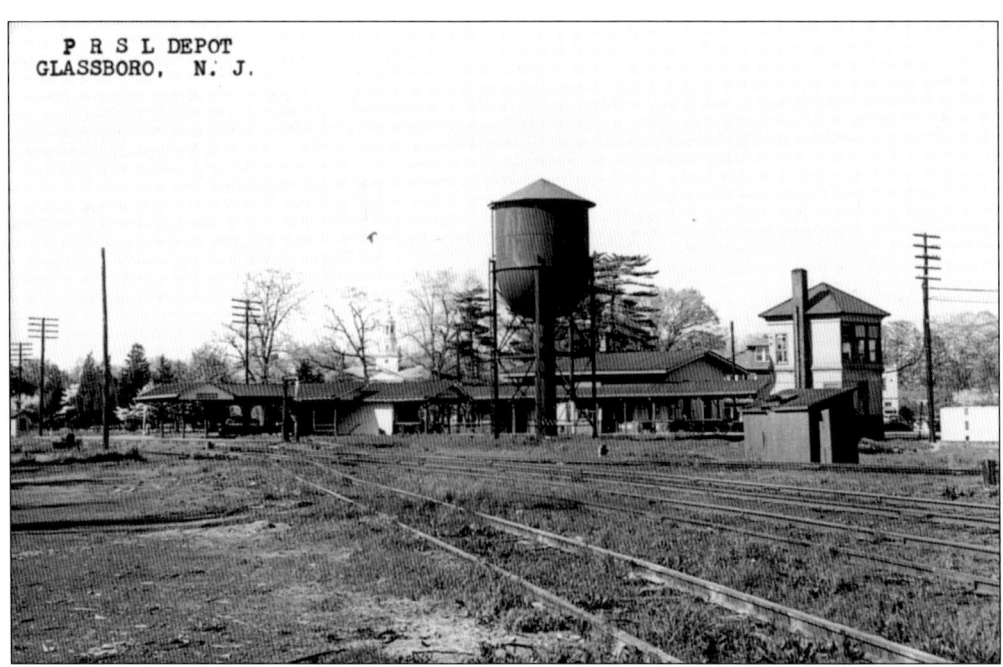

The Pennsylvania & Reading Seashore Line depot at Glassboro is pictured in May 1952. For many years, my grandfather Llewellyn R. Jones Jr. worked as a carpenter at the Glassboro yard. He retired from the railroad in 1973.

Acknowledgments

Scholars say that the wheel is man's greatest invention. This is very true. I believe there is another invention that should be placed in that category—photography. The ability to capture a moment in time with a little box and lens that would allow us to preserve an image for generations to come is simply a wonder. It is through this great medium that we are able to peer into the lives of those who have gone before us.

Glassboro is a compilation of photographs courtesy of several great sources. I would like to thank my friends and colleagues at the Gloucester County Historical Society for their help and support and for allowing the use of their resources, and two gentlemen whom I consider the greatest Glassboro historians: the late Edward H. Walton Jr. and the late Thomas C. Stewart. Walton's book *The Glassboro Story* set the stage for this publication. His information and collection of Glassboro photographs make up a great portion of this book. Stewart, at the age of 100, still volunteered at the historical society and helped identify the people and places in the images shown to him.

Several photographs come from private albums and scrapbooks that have been hidden away in closets and attics and are now being printed for the first time. I would like to thank the following: Channon Atkinson-Armstrong, George Armstrong, George Baldwin, Jack Bower, Beverly Clement, Enio DeFrancesco, Alex Fanfarillo III, Kathryn Jones, Thomas Kane, Charles and June Johnson, Muriel Johnson, John Keller, the Library of Congress, the LBJ Library, Grace (Costanzo) Mastroeni, Olivet Weslyan Church, Albert Ricci, Rowan University, Gloria Russell, Rev. Ronald Tucker, Lynn P. Ware, Don Wentzel, and Edward Van Istendal.

I would like to thank the following for helping provide information and support: the Greater Glassboro Group, Rosa Latney, George Benas, Joseph A. Brigandi Sr., Mary (D'Amico) Green, Eileen F. Shanahan, and especially my friend William C. Mitchell.

INTRODUCTION

Glassboro is a community that has been on the move since its humble beginnings in 1779. The resources in the area contained the perfect elements to produce glass: plenty of sandy soil, dense forestland for lumber and fuel, and waterways accessible to the Delaware River for transporting glassware to markets in Philadelphia. Thus, Glassboro grew around the development of the glass industry. When the Stanger brothers began their glassworks here in 1779, the site was in the heart of rural Gloucester County. The only hints of inhabitants were a few private dwellings and some lightly traveled crossroads. Woodbury and Swedesboro were the closest established communities at this time.

When Cols. Thomas Heston and Thomas Carpenter acquired the failed Stranger Glass Works, a community began to thrive. Laborers' homes sprang up, a school was built, houses of worship were constructed, shops appeared along Main Street, and in 1781, a tavern was established. Soon, this new glass settlement became known by many different names: Glass House, Glass Works, Stanger's Glass Works, Heston's Glass Works, and Hestonville. Just prior to 1800, Colonel Heston invited his comrades from the Gloucester County Fox Hunting Club to join him for an evening of socializing at his tavern. At this meeting the men debated a proper name for the village. The name Glassborough was suggested, to much acclaim.

Over two centuries Glassboro continued to flourish, attracting people of many different nationalities, cultures, and beliefs. In addition to glass production, agriculture became a great contributor to the growth of Glassboro. By 1923, with the advent of the State Normal School, the village had become a place sought out for higher education.

Glassboro has attracted the appearance of five U.S. presidents: Woodrow Wilson, William Taft, Theodore Roosevelt, Lyndon Johnson, and Ronald Reagan. It is a community that has produced an admiral from the Spanish-American War, a state senator, and a U.S. congressman. It has seen the likes of men and women who have given themselves to civic services and to the call to serve God.

Glassboro will take you on a photographic journey chronicling the transformation of this small community of humble glassmaking beginnings into a university community of nearly 20,000 residents. This book displays images that date from as early as possible up to the 1960s. Unfortunately, many photographs had to be eliminated to fit the space. I hope that my choices will best tell the story of how Glassboro, a town created from glass, was able to reach a summit.

One
THE GLASS WORKS
BUILDING A COMMUNITY FROM GLASS

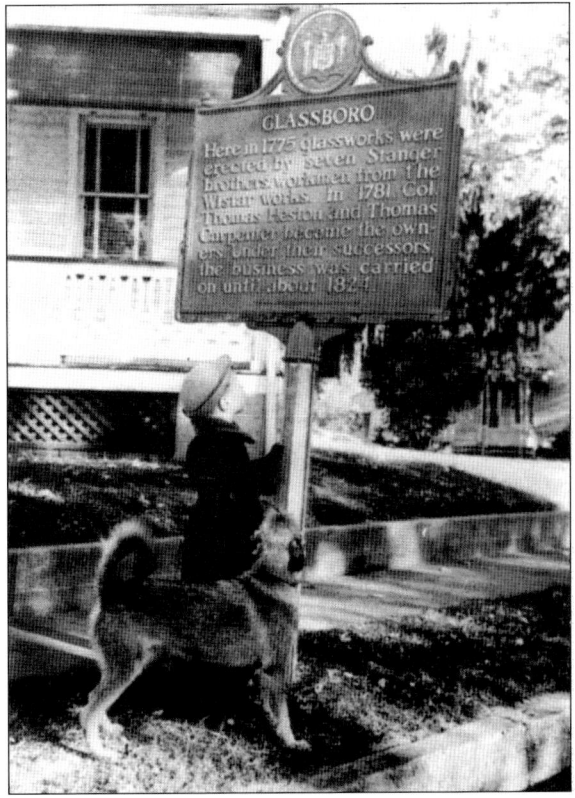

Young John Batten and his dog, Jet, gaze up at a marker placed in front of the Batten home, on North State Street, in 1953. The sign marked the site of the early Stanger glasshouse. This photograph appeared in several updated editions of John Cunningham's book *This Is New Jersey*. The plaque read, "GLASSBORO Here in 1775 glassworks were erected by seven Stanger brothers, workmen from the Wistar works. In 1781, Col. Thomas Heston and Thomas Carpenter became the owners. Under their successors, the business was carried on until about 1824." The New Jersey Commission on Historic Sites erected the sign in the 1940s. For reasons unknown, the marker was mysteriously taken down in the early 1960s and has since disappeared.

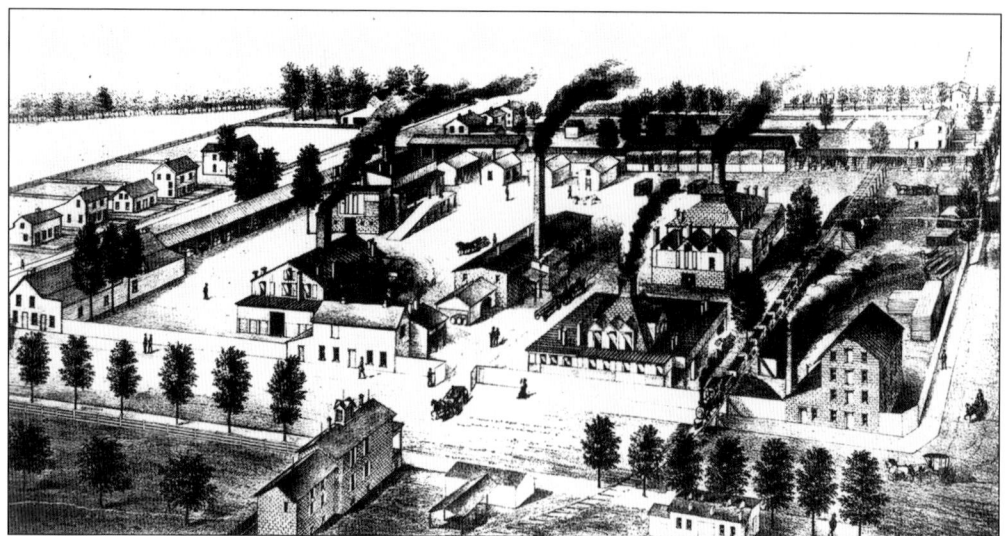

The Whitney Glass Works was established in 1813. Originally known as the Harmony Glass Works, it was purchased in 1838 by Thomas H. Whitney, who transformed the plant into a glassmaking enterprise. The glassworks covered 12 acres in the center of town and bordered the streets of Main, Academy, and both sides of High. This 1875 sketch of the Whitney plant historically preserves the structural layout of the facilities.

The Harmony Glass Works Company Store was built in 1813 on the corner of Main and High Streets. It can be seen in the sketch at the top of the page on the far left, next to three trees. It served as the Whitney Company Store until 1848, when it became the box shop. In 1891, a new box shop and packinghouse was constructed. The old structure was used for storage purposes until being demolished in 1914.

Carpenters at the Whitney Glass Works stand outside the box shop. Wooden crates and boxes were needed for storing and shipping glassware. Lewis S. Stanger, wearing a suit and appearing in the doorway, was the boss of these men when this early 1880s photograph was taken.

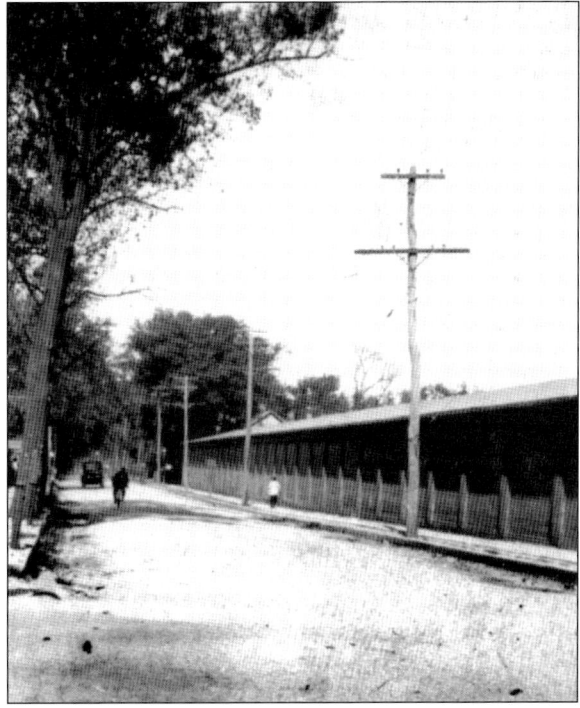

The Whitney Glass Works ware-sheds ran north along Main Street to where College Avenue is located today. In 1914, the company replaced the old wooden sheds and the company store. A 10-foot-high red brick wall was constructed. Some of these old sheds dated from the 1813 Harmony Glass Works. Looking north on Main Street, this 1915 view shows the wall from the corner of High Street.

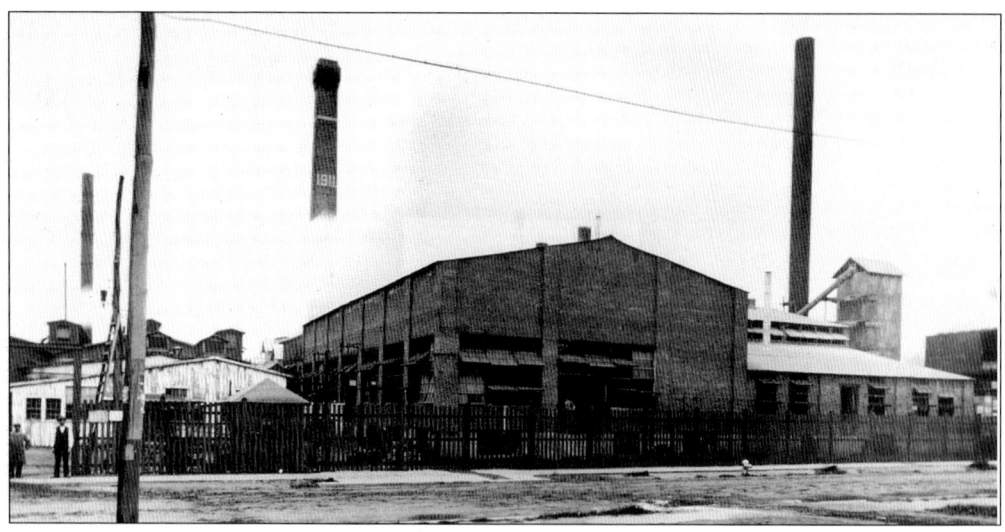

This view of the Little House of the Whitney Glass Works was taken from High Street c. 1915. The plant operated with five furnaces, generating 525 tons of glass per month. Whitney had the second- and third-largest glass furnaces in the country, producing the most extensive variety of styles and colors of any comparable glasshouse.

Becoming a skilled glassblower took years of training. Young boys ranging in age from 10 to 18 became apprentices and learned how to blow glass from their senior counterparts while doing odd jobs within the plant. In 1883, an apprentice earned $15 per month. Working conditions were long, hot, and hard. Normally, production in the glasshouses ceased in July and August and resumed during the cooler months.

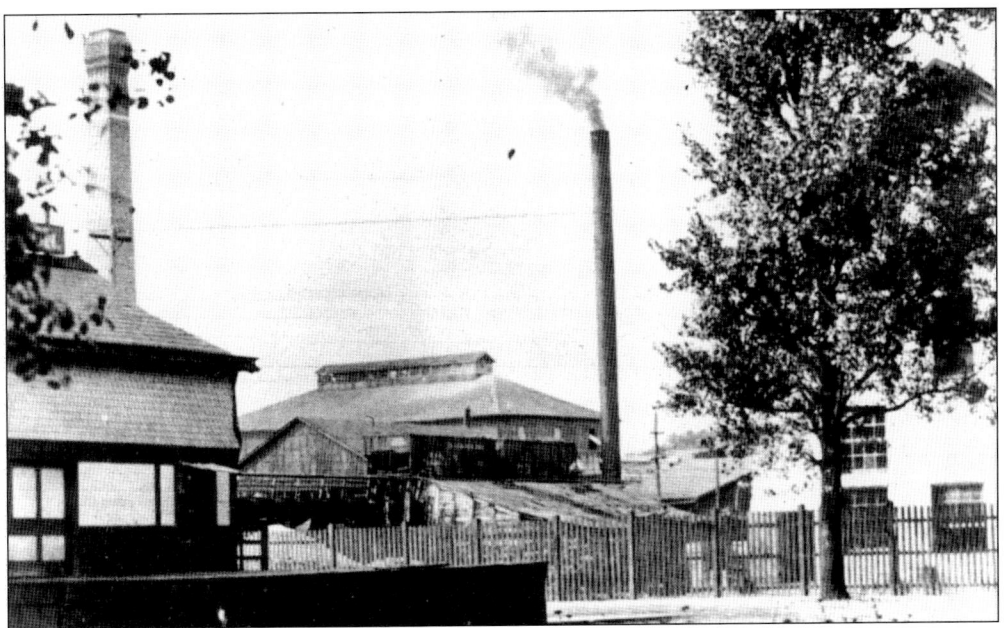

Rail service transported materials in and out of the glassworks by a trestle crossing High Street. In 1883, the Reading Railroad extended spurs leading to both the Whitney and Warrick Glass Works from its main line. This *c.* 1915 photograph, taken at Academy and High Streets, shows, from left to right, the Reading freight station, the Big House, and a portion of the trestle.

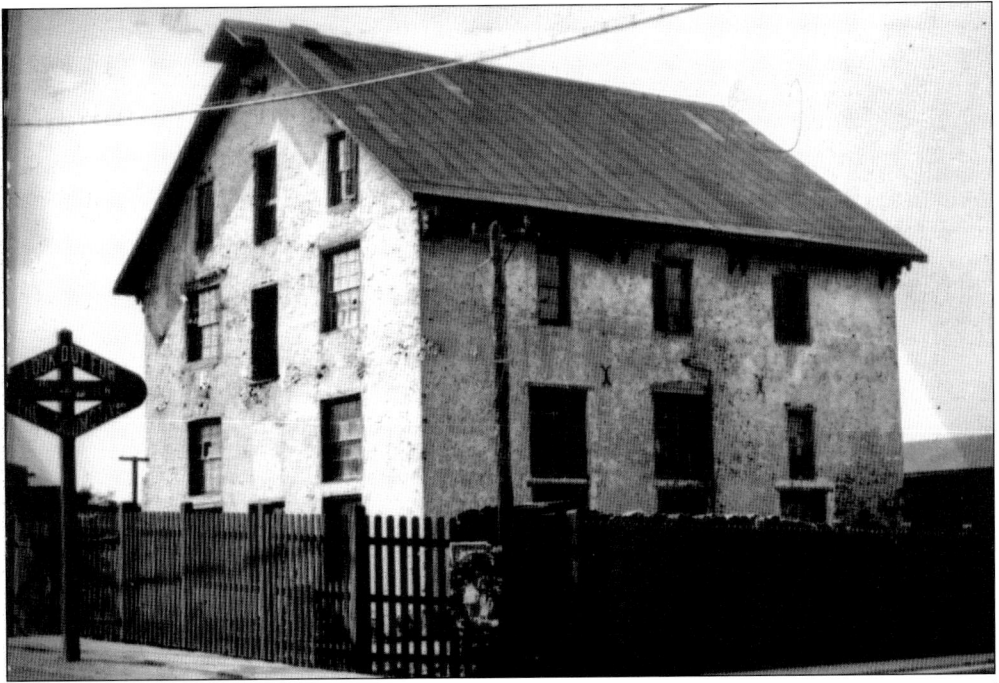

The Whitney Gristmill and Sawmill, located at Academy and High Streets, was constructed in 1856, replacing a previous mill built in 1840. Grain from the Whitney farm was milled here and sold to the public. The sawmill produced lumber for repairs to the plant and wood for the boxes used to ship glassware. The present Glassboro firehouse is located on this site.

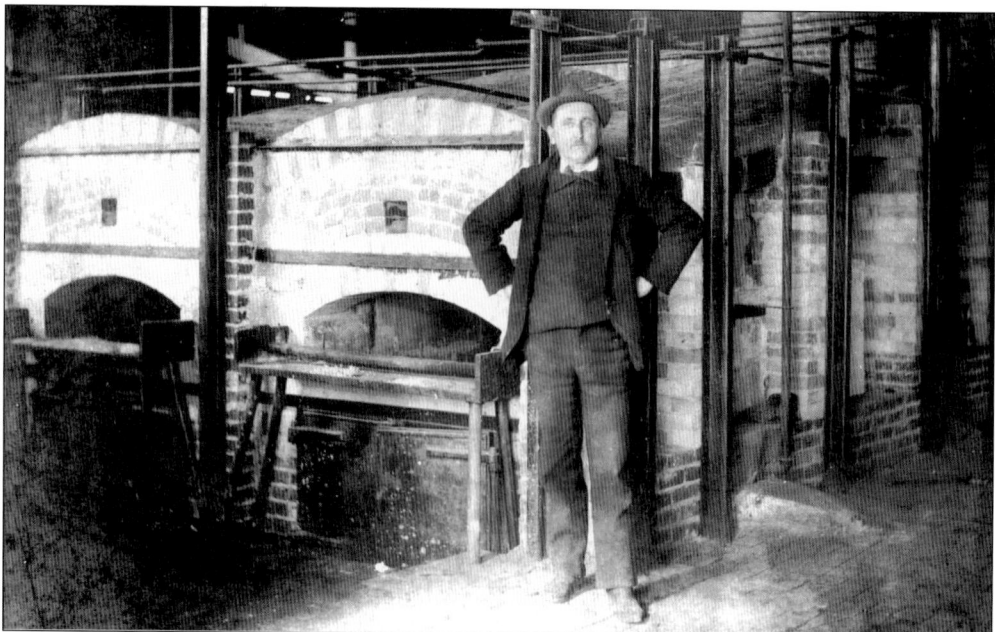

These Whitney Blacksmith Shop employees take a "tempo" (the glassblowers' term for a coffee break) to pose for a photograph c. 1895. The two men in the back row wearing derby hats are Walter Stanger (left) and William Stanger.

George M. Keebler stands next to an oven called a lehr or an annealing oven at the Whitney Glass Works c. 1890. This oven reheated the glass objects to high temperature to relieve internal stresses and then slowly cooled the glass to avoid introducing new stresses.

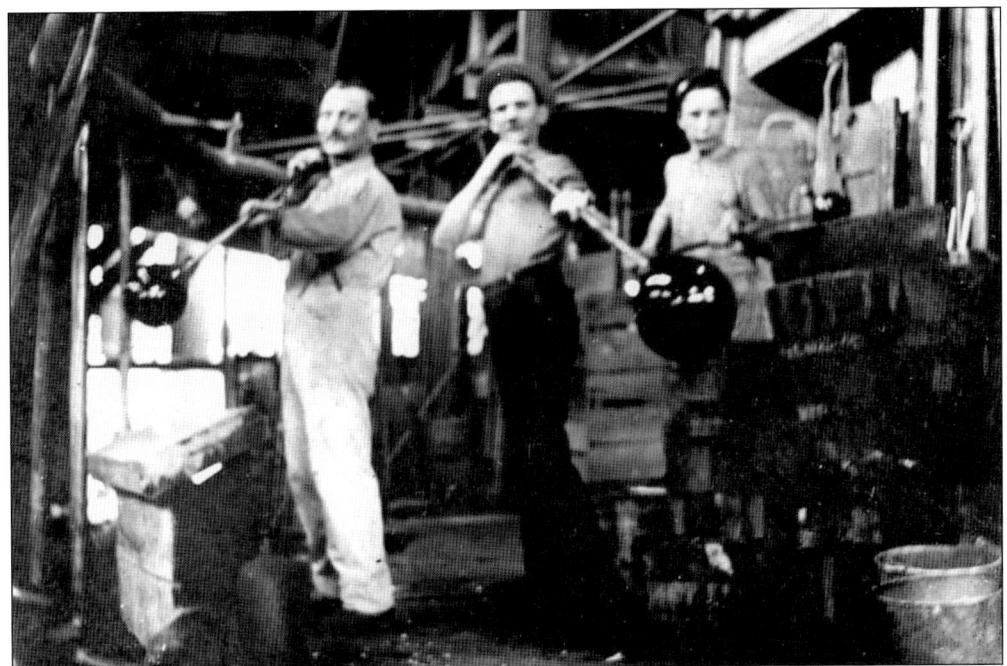

In the 1870s, Whitney produced bottles and flasks that are highly sought by collectors today. Pieces like the Booze bottle, Jenny Lind calabash, the Indian Queen, and Doctor Fisch's Bitters sell for exorbitant amounts. From left to right are Chris Warner, Chris Siebert, and Claude Cossabone, who blew glass for Whitney in the early 1900s.

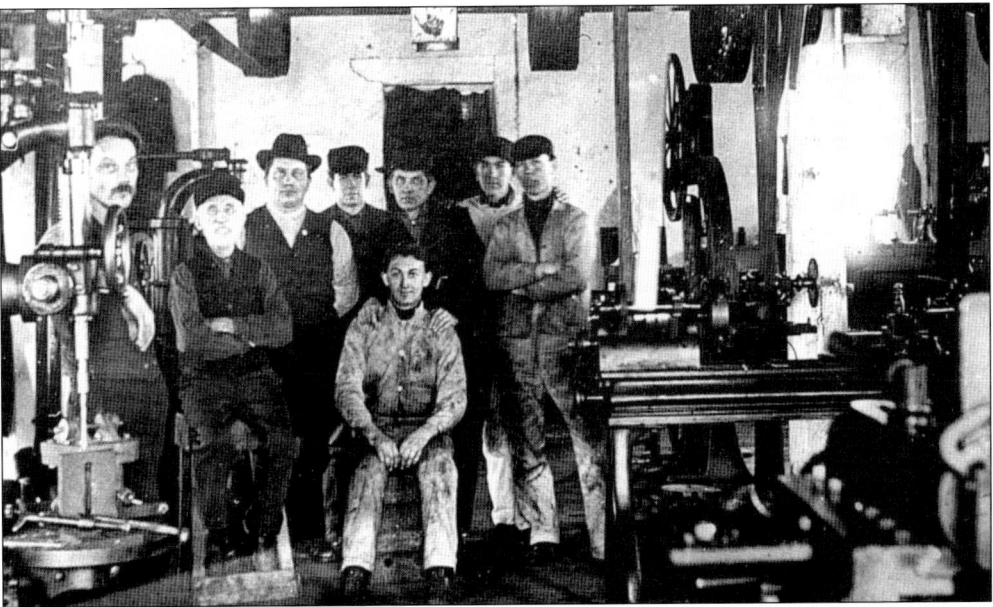

General maintenance was performed on the furnaces and equipment essential to the glassworks operation. By the turn of the 20th century, day and night shifts had been established to meet the flood of orders. Members of the Whitney machine shop crew c. 1910 are, from left to right, are T. Fry, foreman J. Albertson, W. Warner, W. Stanger, W. D. Stanger, R. Doughty, S. Thomas, and H. Ferrell.

Glassblowers used molds to letter and figure the glassware, giving the glass body form. Made of clay or metal, the molds were mainly designed in a cylindrical, square, or polygonal shape. Members of the Whitney mold shop crew c. 1900 include Walter F. Stanger (far left), James Stillwell (eighth from the left), and William Warner (ninth from the left).

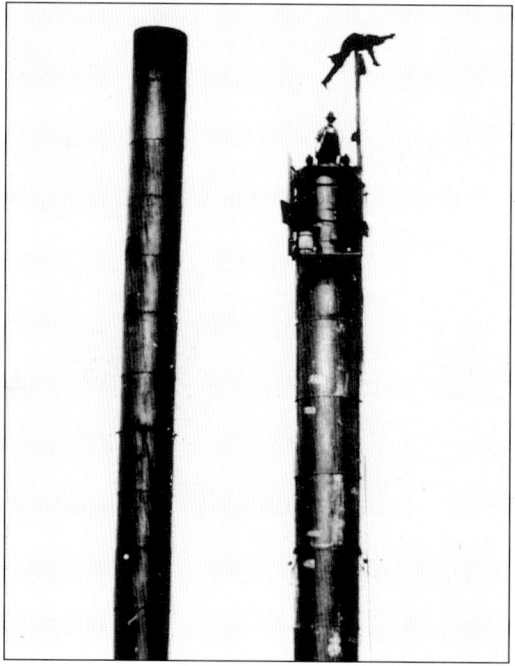

In May 1920, the fires in the old furnaces of the Whitney Glass Works went out forever. Within two years, the site was cleared of any evidence that a plant had existed there for more than 100 years. As the smokestacks of the old plant were coming down, one worker—either on a bet or a dare—balanced on a pole in daredevil fashion.

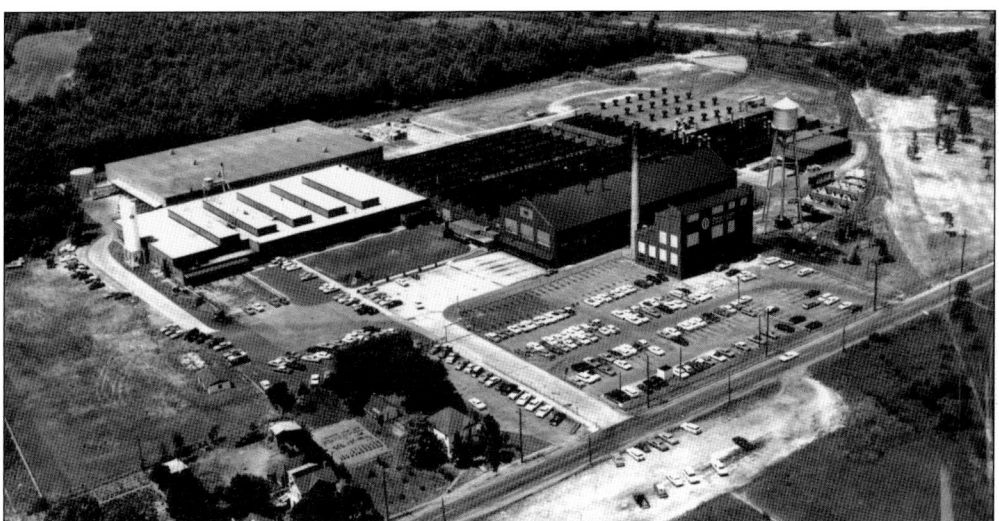

The Whitney Works outgrew its High Street facilities. A newly constructed $1 million glassworks, known as the Owens Bottle Company Whitney Plant No. 2, opened in 1918 on Sewell Street. By 1929, the automated bottle-making machines had exceeded customer demand, causing warehouses to be overstocked. The Owens Bottle plant then merged with the Illinois Glass Company, forming the Owens-Illinois Glass Corporation. At that time, the Glassboro facilities only produced plastic and metal closures.

Like other area glass companies, the Whitney and the Warrick-Stanger Glass Works paid their employees with script, or company money. Employees and their families could only redeem this type of currency for goods at the company store. Most often, items cost double or triple the amount they would have if paid for with U.S. currency. This act of labor control was finally abolished through union pressure and legislation.

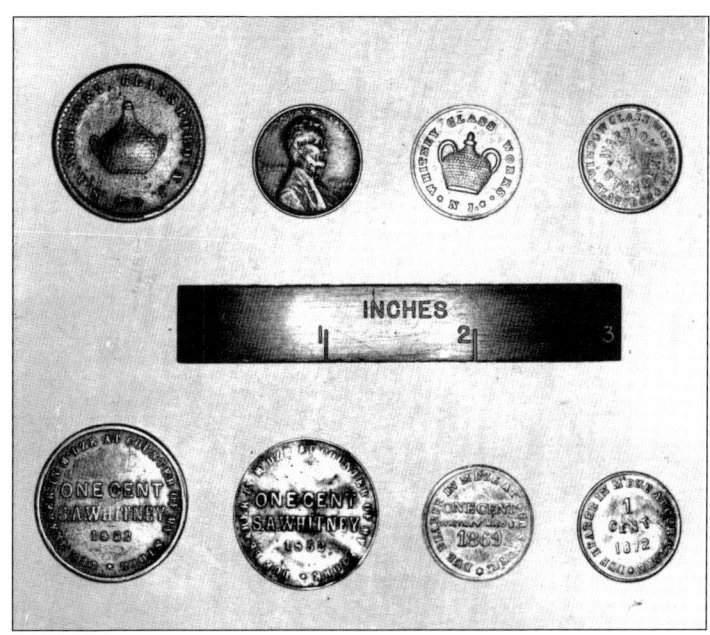

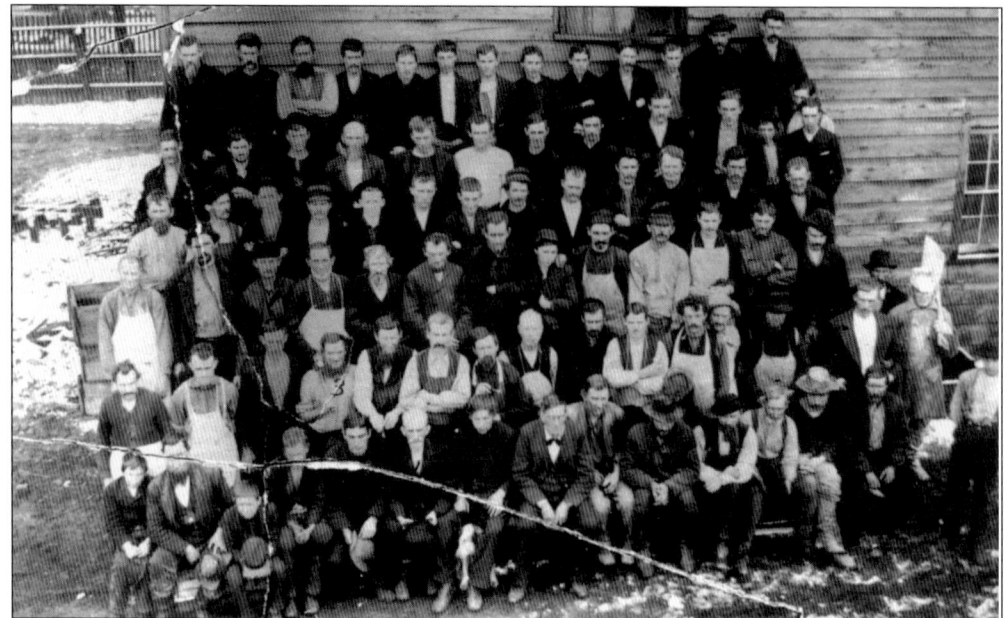

Workers at the Warrick-Stanger Glass Works are pictured c. 1880. This plant was located in south Glassboro at Grove and Academy Streets. Known as the Temperanceville Glass Works, it began operations in 1834 under the ownership of Lewis and George Stanger. The Stanger brothers took a strong stance against the use of intoxicating liquor and only employed nondrinking workers. The name Temperanceville was quickly given to this pre-Prohibition glassworks.

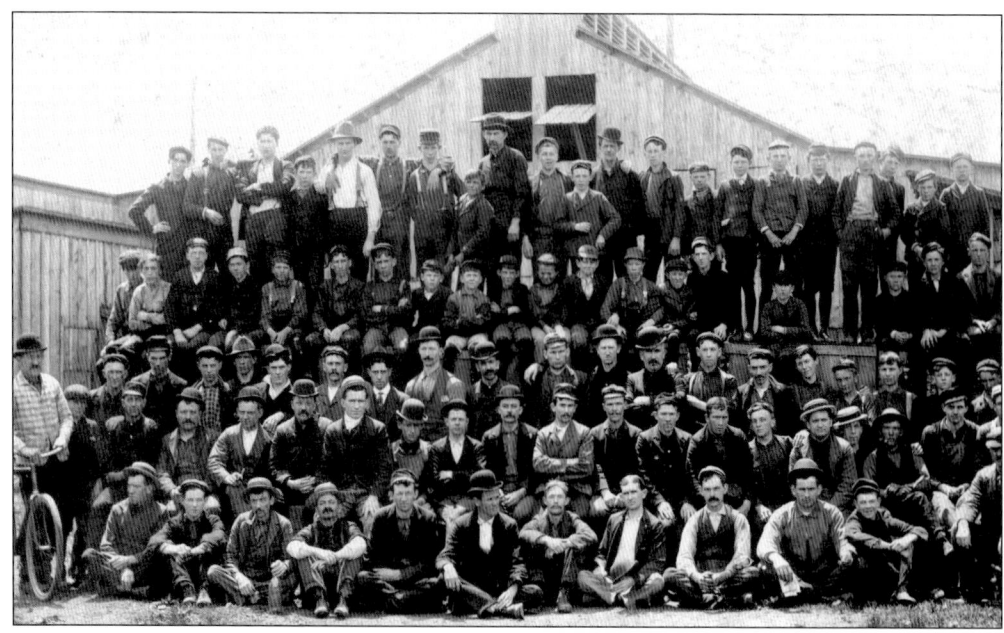

The Temperanceville Glass Works produced mainly window glass and a very small amount of hollowware. The company employed 100 workers and leased 55 tenement houses to its workers. Economic disaster had begun to take its toll by the late 1880s. Employee wage disputes and competition from western glass companies led to the plant's closing on April 8, 1891.

Two

HOLLYBUSH
THE MOST FAMOUS HOUSE IN GLASSBORO

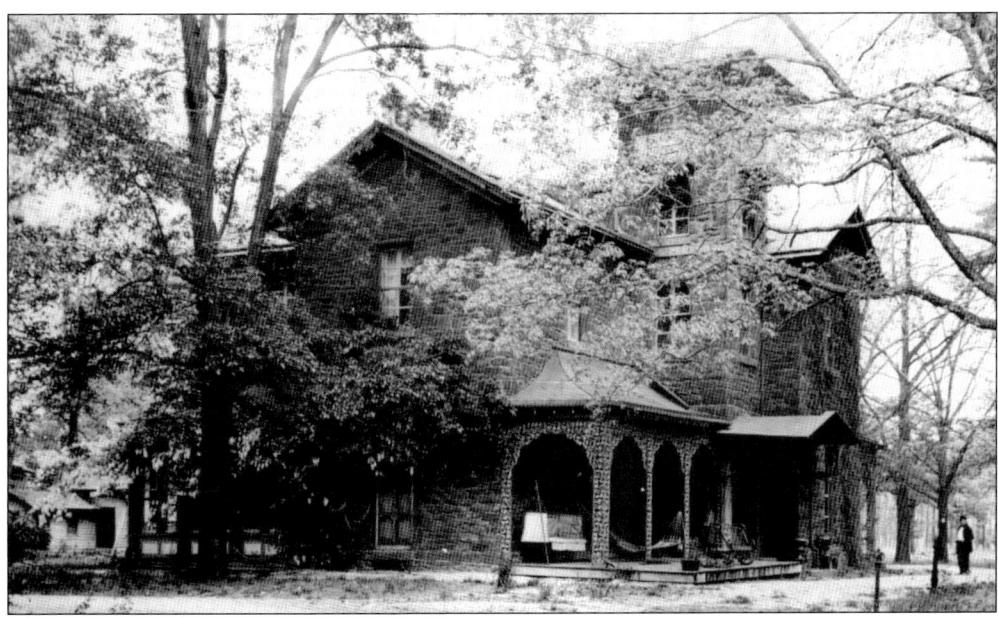

Historic Hollybush Mansion is the most famous house in Glassboro. The was constructed by Thomas Whitney constructed it in 1849 of native ironstone from the nearby Chestnut Branch quarry. The Italian villa design was inspired by Whitney's trip to Europe in 1847. With its imposing tower and intricate ironwork, Hollybush became the social gathering place. The mansion, pictured here c. 1910, was placed on the National Register of Historic Places in 1972.

Portraits of Bathsheba Heston Whitney and her son Thomas H. Whitney grace the walls of Hollybush. Bathsheba Heston was the daughter of Revolutionary War hero Col. Thomas Heston. In 1786, Colonel Heston purchased the failing Stanger Glass Works and began an enterprising venture of glassmaking in Glassboro. Several years later, his grandson Thomas H. Whitney continued the family venture, making it one of the leading glass-manufacturing companies in the country.

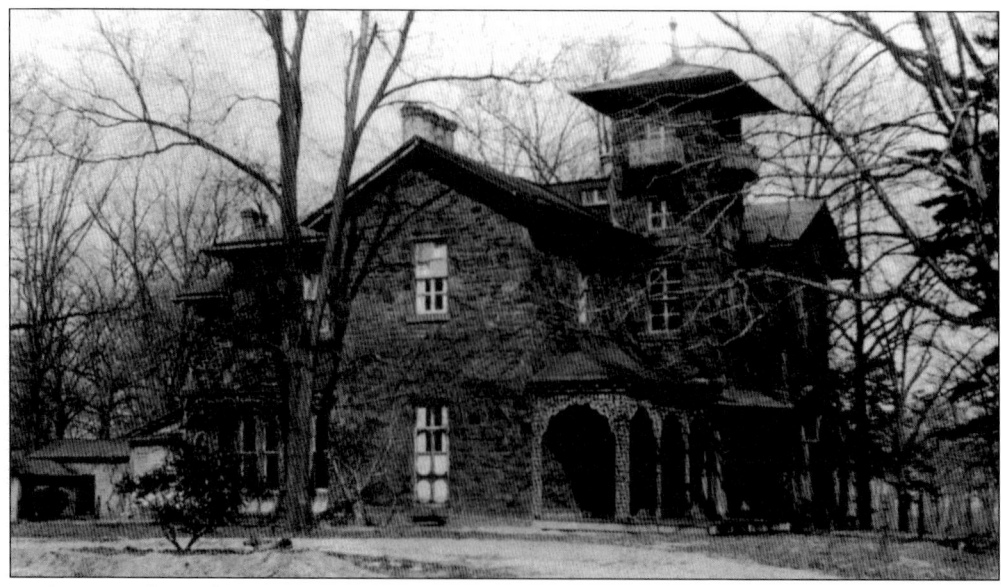

Architecturally, Hollybush was a modern marvel. Credited as being Glassboro's first home with running water, it used a hydraulic ram to pump fresh water from the Chestnut Branch stream into a large storage tank within the tower. Another unique feature of Hollybush is its interior layout. The first floor has seven rooms, and the upper floors have three large bedrooms on one level, with seven more on two other levels.

"HOLLY BUSH" TRACT AS SEEN FROM W. J. & S. R. R. DEPOT

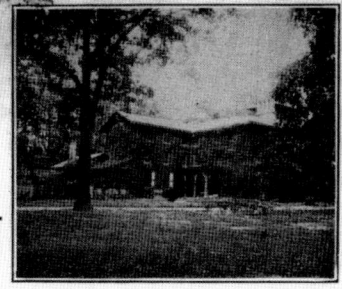
"WHITNEY HOMESTEAD" ON THE "HOLLY BUSH" TRACT—GLASSBORO, N. J.

GLASSBORO'S IMPORTANT REAL ESTATE DEVELOPMENT

"EVERY LOT TO BE SOLD AT AUCTION WITHOUT RESERVE"

"HOLLY BUSH"
THE HEART OF GLASSBORO, N. J.

"WATCH FOR ANNOUNCEMENT OF OUR SALE OF THESE LOTS"

THIS Tract of land is a veritable Park with a wonderful growth of noble Oaks, Hickories, Spruce, Walnuts, Elms, Maples and Lindens. It has been carefully preserved for over a century and now offered to you as choice Home and Building Locations.

"ANDREW JACKSON" A FINE OLD HICKORY ON "HOLLY BUSH"

THIS Tract is unusually situated, lying between the Depot and the present center of Glassboro. It is bound to be the very heart of this growing community. An inspection of this property will show you why. You will have an opportunity to locate on this tract at your own price.

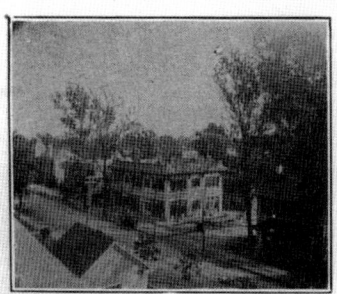
A PART OF GLASSBORO AS SEEN FROM THE NEW HIGH SCHOOL BUILDING

"GLASSBORO HAS NEARLY 100 TRAINS EACH DAY
Only 39 minutes from Philadelphia, large and growing Glass Industries, excellent Business and Banking Facilities, high elevation, clean surroundings, Approved High School, Ideal Home Community.

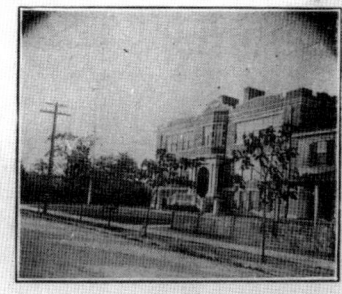
NEW HIGH SCHOOL BUILDING SHOWING THE HOLLY BUSH TRACT IN THE DISTANCE

For Particulars Address **THE JOHN A. ACKLEY AUCTION CO.**

By 1915, the Whitney dynasty was coming to an end. In 1916, the Whitney heirs sold the Hollybush tract, along with the mansion, to John A. Ackley of Vineland. Ackley soon subdivided 45 acres of the southeastern section into streets and lots. This advertisement displays Ackley's attempt to promote Glassboro as conveniently located to Philadelphia and offering all the essentials of an up-and-coming community. Soon, the areas of West High, Ellis, and Lake Streets, along with Whitney and Railroad Avenues, expanded Glassboro's neighborhoods. The remaining 25 acres of the Hollybush tract and the mansion were purchased by 107 residents in 1917 for more than $6,500. They were offered to the state in an attempt to attract a new State Normal School to southern New Jersey. The deal was accepted, and the first group of students began classes at Glassboro State Normal School in 1923.

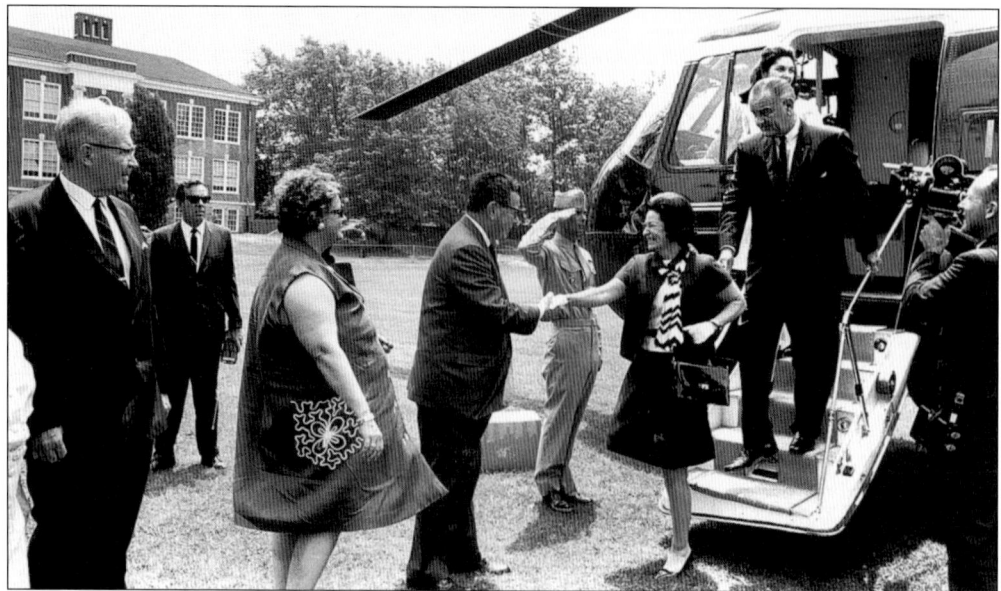

The Glassboro Summit Conference, on June 23, 1967, was a momentous event that changed the course of history for this small community. At 10:40 a.m., Pres. Lyndon B. Johnson's helicopter landed on the Glassboro State College baseball field, beside Bunce Hall. Gov. Richard Hughes is shown greeting Lady Bird Johnson, the president, and daughter Lynda Bird, as his wife and college president Dr. Thomas Robinson (far left) look on.

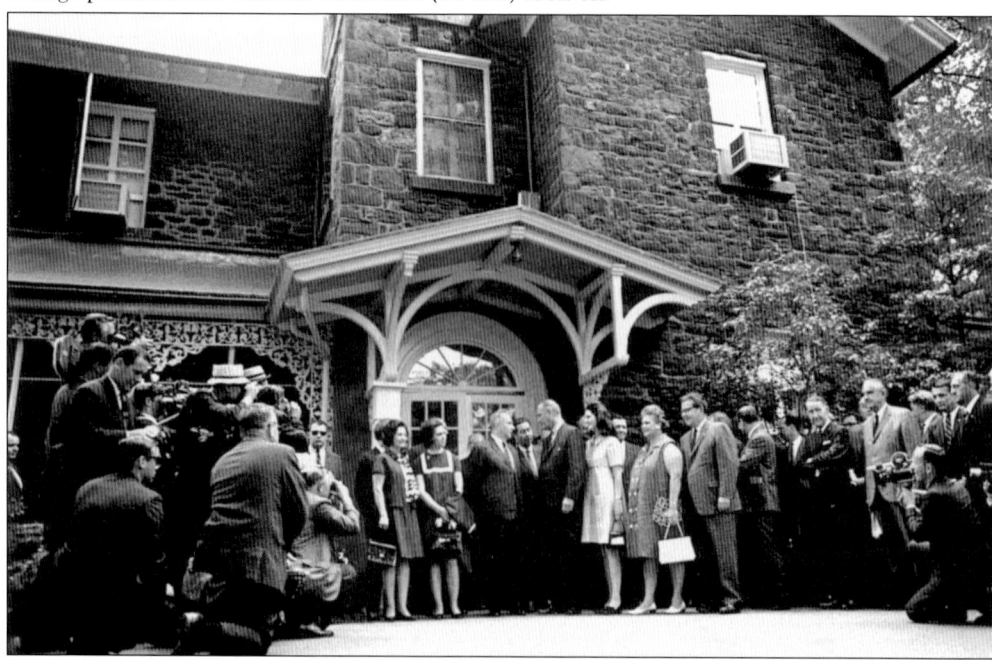

The Glassboro Summit marked a crucial point in Cold War negotiations between the United States and the Soviet Union. Issues on nuclear disarmament, the Vietnam War, and the recent conflicts between the Arab nations and Israel were major concerns that caused the two super powers to unite for a conference. Soviet Premier Aleksei Kosygin (center) arrived in Glassboro by car at 11:20 a.m. Formal greetings took place in front of Hollybush.

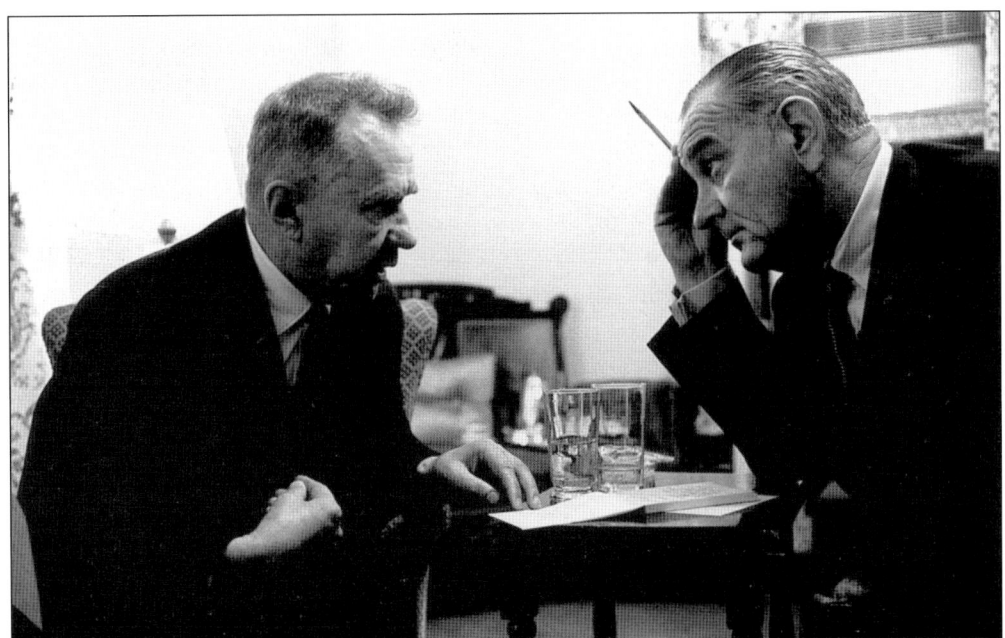

The two leaders sat together in the library of Hollybush with only a small table between them. After two hours of polite conversation on personal matters, the tone of the meeting quickly changed when Premier Kosygin (left), with a skeptical smile, abruptly said to President Johnson, "You are for war, and we are for peace."

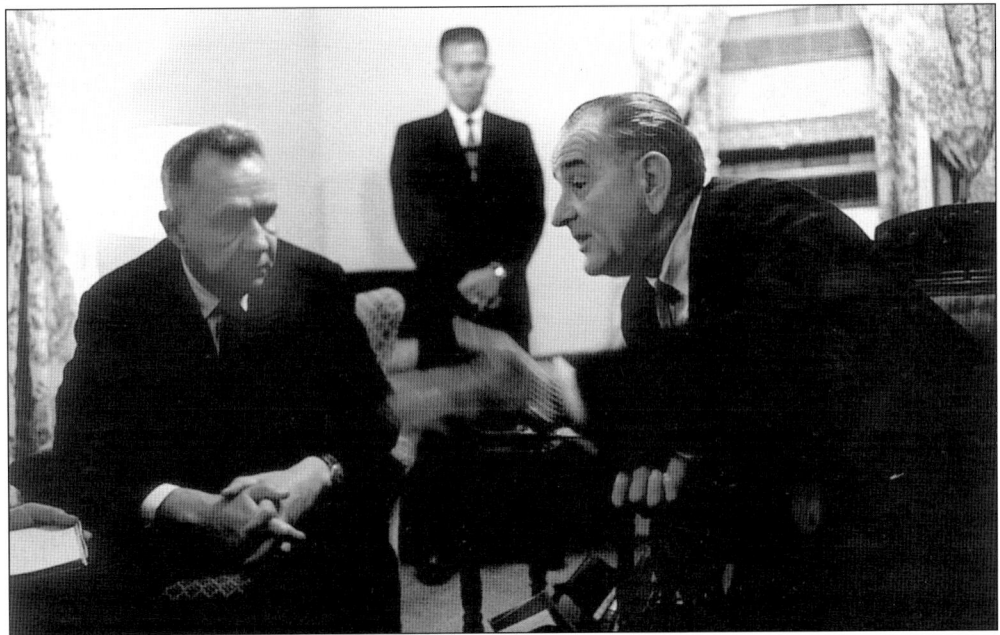

Secretly counting to 10, President Johnson (right) responded calmly. He assured the Soviet premier that the American people sincerely desired peace as much as the people of the Soviet Union did. He continued by listing his efforts to reach understandings with the Russians by signing several treaties. He reminded Kosygin that, "Despite the Vietnam War, Russia and the United States have signed more agreements during my term as president than ever before."

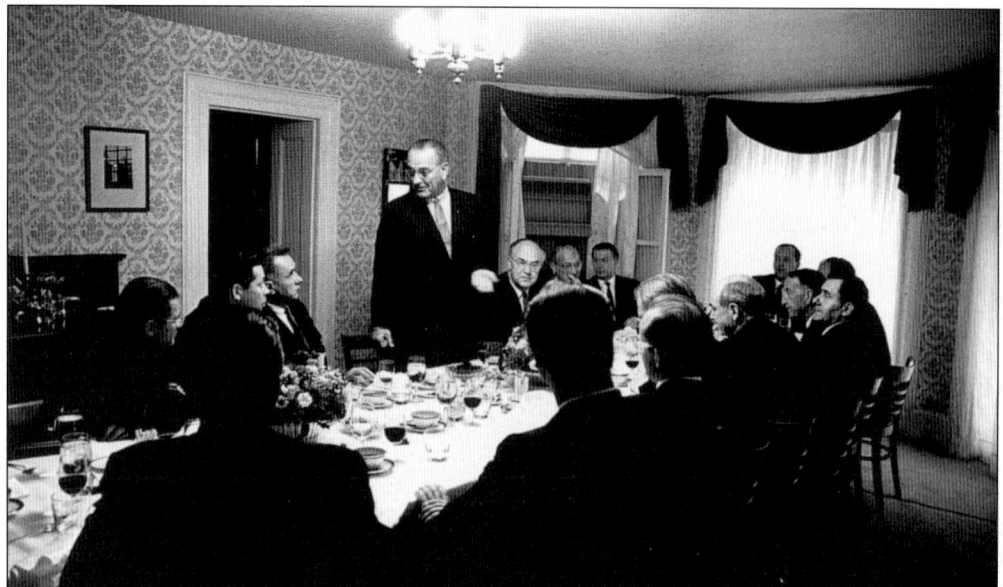

During lunch, the president offered a moving toast: "We both have special responsibilities for the security of our families, and the security of the entire human family inhabiting this earth. There is a . . . special responsibility placed upon our two countries because of our strength and our resources. This demands that the relations between our two countries be as reasonable and as constructive as we know how to make them."

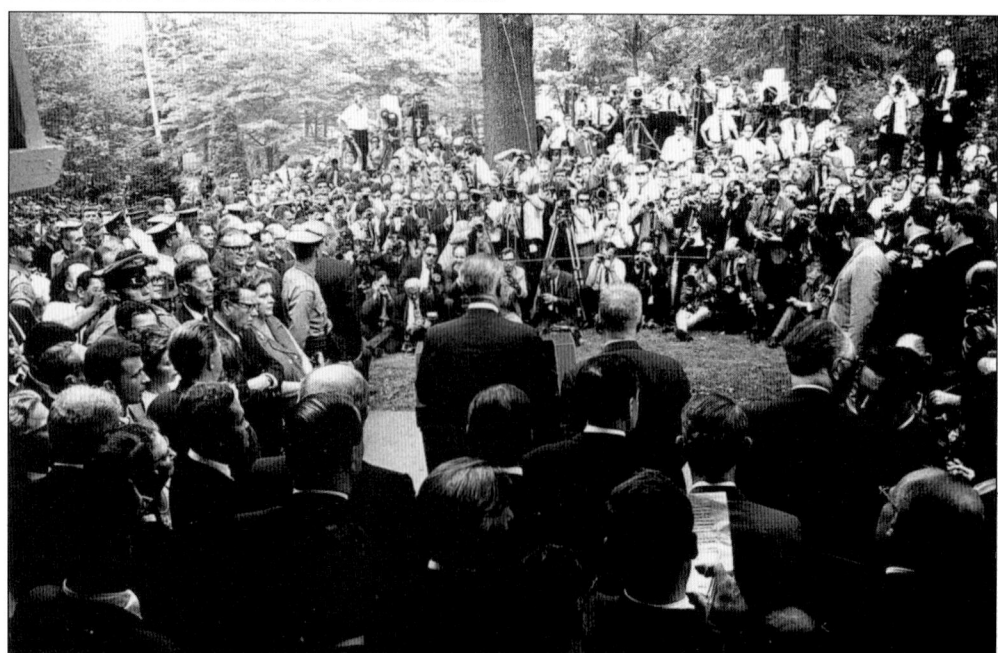

The Glassboro Summit made worldwide headlines. Later that afternoon, the two leaders met with reporters who had descended upon Glassboro State College campus from all over the world. The Esbjornson Gymnasium was converted into media headquarters. Throughout the night, Bell Telephone workers laid more than 200 miles of telephone circuits, along with 300 special circuits for the press and vital presidential communications.

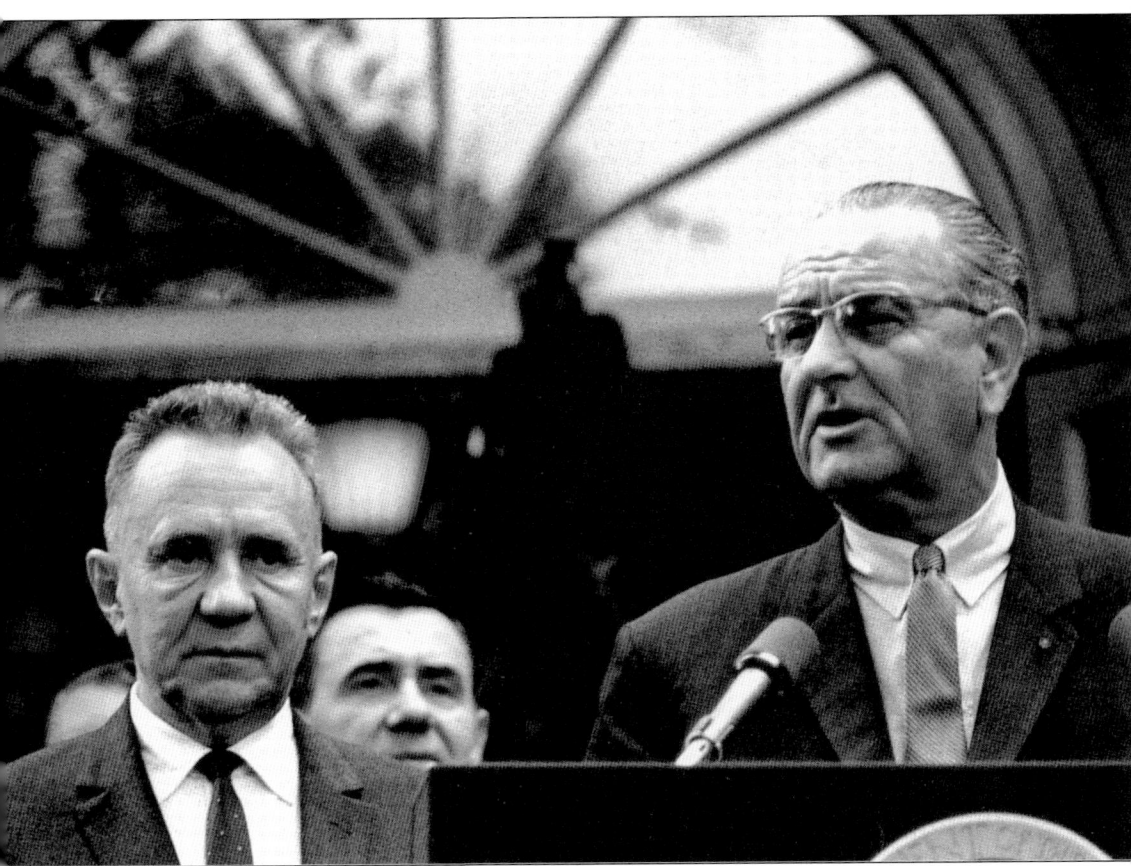

During the press conference that followed the five-and-a-half-hour meeting, President Johnson (right) described the talk as "a very good and very useful meeting." He conveyed that the two men had exchanged views on the Middle East, Vietnam, the deployment of nuclear weapons, and U.S.-Soviet relations. He also stressed that Secretary of State Dean Rusk and Soviet Foreign Minister Andrei Gromyko (center) would further explore the conference's questions the following week. When Premier Kosygin (left) addressed the press, he stated that President Johnson and he had "amassed such a great number of questions that we weren't able to go through them all today, which is why we have decided to meet again this Sunday." The two leaders met for a second round of talks at Hollybush on June 25. The Glassboro Summit Conference did not resolve any substantial issues, but it gave the leaders of the two powerful nations an opportunity to talk and to improve relations between their countries.

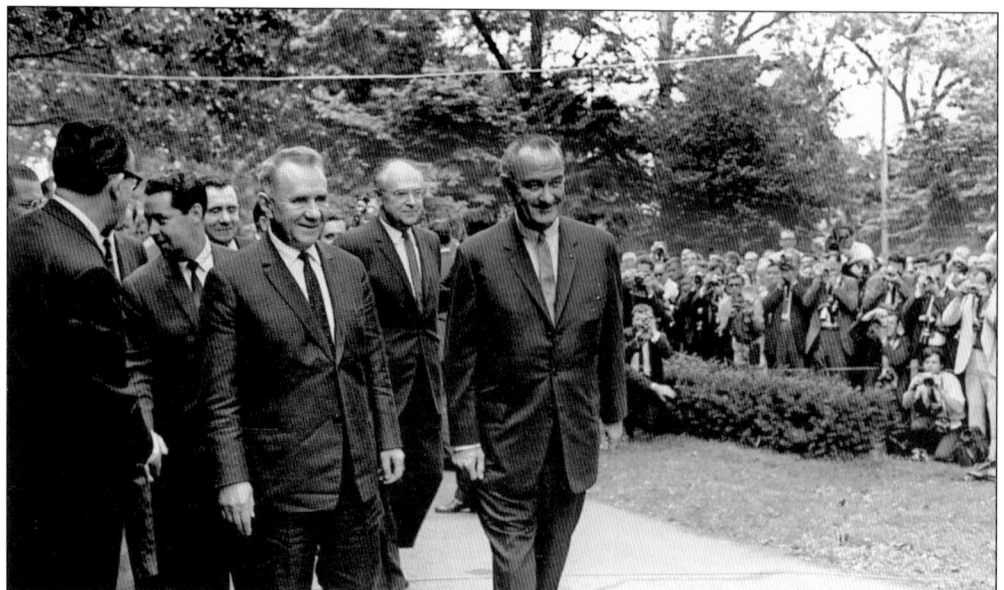

After meeting with the press, the two leaders greeted the crowds that had gathered along Whitney Avenue, just off the campus. In front are Premier Aleksei Kosygin (left) and Pres. Lyndon Johnson, followed by, from left to right, Mr. Sukhodrev (Kosygin's interpreter), Soviet Foreign Minister Andrei Gromyko, and Soviet Ambassador Anatoly Dobrynin.

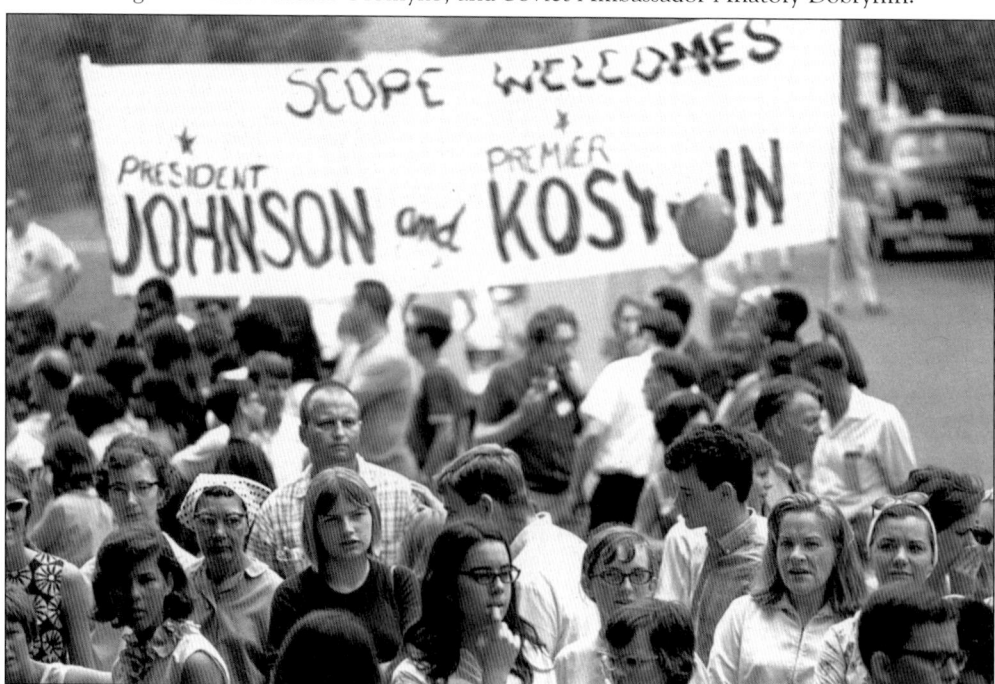

More than 3,000 people gathered for nearly nine hours along Whitney Avenue, waiting to catch a glimpse of the world leaders. As Premier Kosygin's motorcade began to leave, the Soviet leader ordered his driver to halt the car. He emerged from his limousine in response to the cheers of the crowd and spoke briefly: "I can assure you we want nothing but peace with the American people." With that, he drove off.

Three
BUSINESS
STRENGTH IN COMMERCE

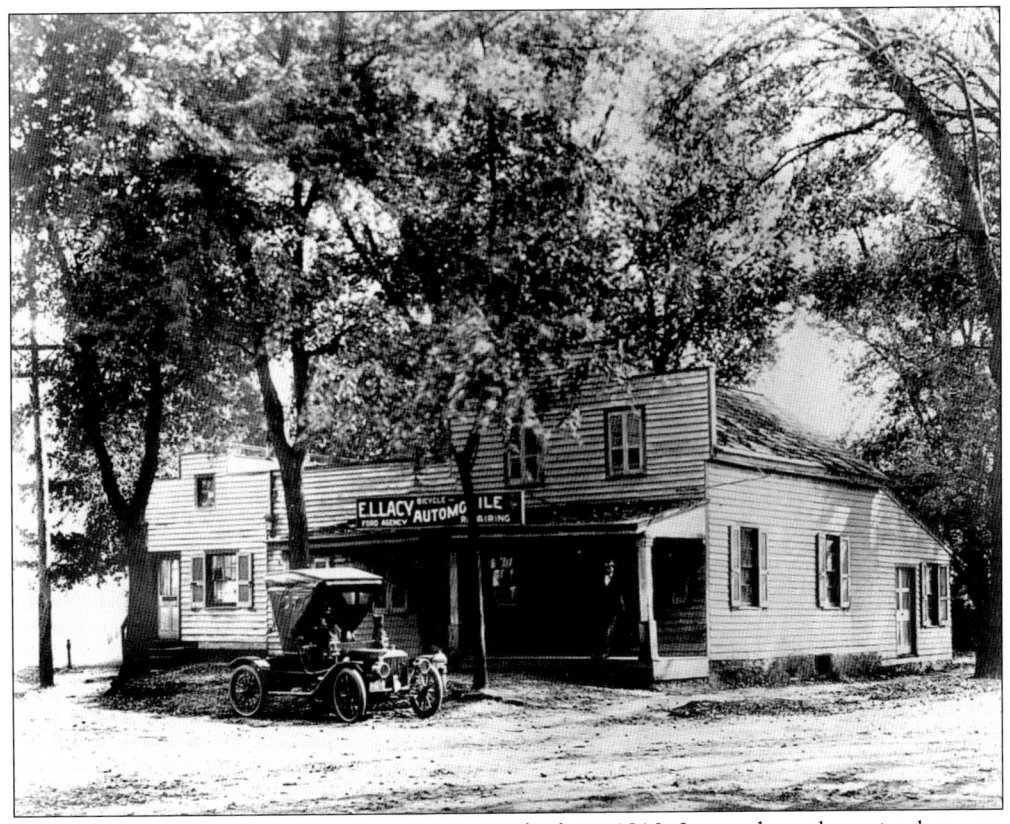

The old Olive Glassworks Company Store was built in 1810. Located on the point between Main and State Streets, opposite the former Franklin House, this structure housed Glassboro's first post office in 1822 and the town's first Ford agency in 1908. E. Linwood Lacy, seen standing on the porch with one of his cars, sold Model N for $600 and Model R for $750.

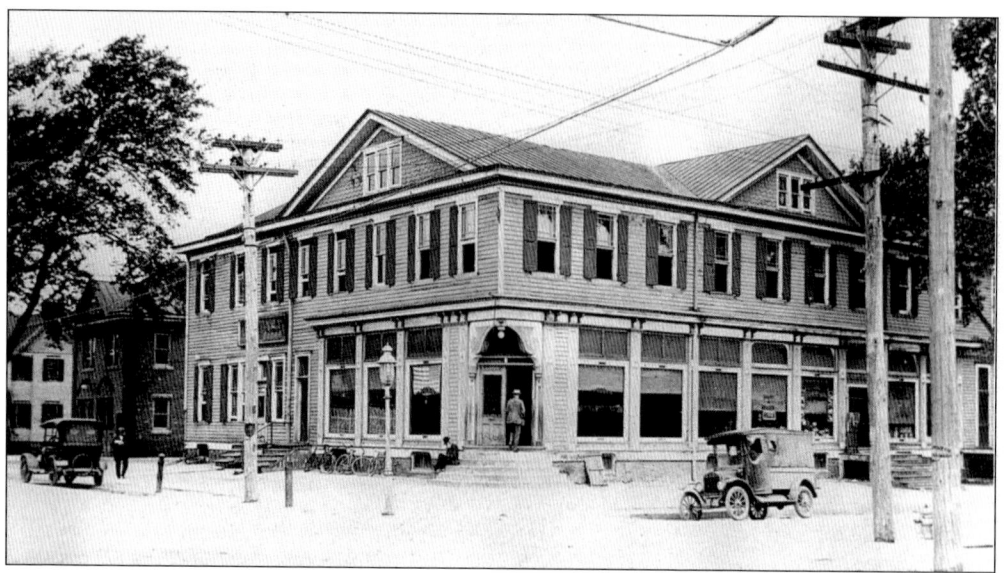

The Whitney Glass Works Department Store stood at Main and High Streets for 48 years. This became the third company store. Construction began in April 1896, with more than 100 workers on the job. At the time, it was considered to be one of the largest structures erected in Glassboro. Pictured here c. 1915, the old store became the Glassboro Post Office in 1913.

The Whitney Department Store interior is shown shortly after its October 10, 1896, opening. It offered Glassboro residents a complete stock of essentials. The first floor contained an up-to-date grocery department, dry goods and housewares, ladies' and gentlemen's furnishings, shoes, and hardware. The second floor housed the carpet and furniture, china and glassware, and millinery departments. In September 1912, the Whitney Store ceased operations.

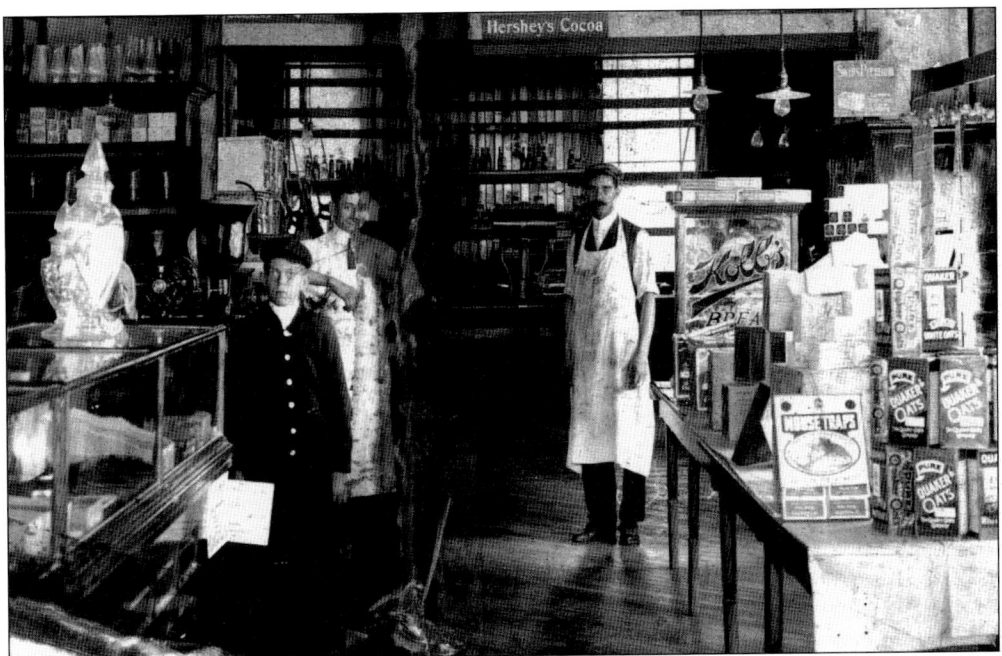

Stewart's Meat Market was owned and operated by Andrew G. Stewart. Originally the Whitney Market, it was located on Main Street in the old Whitney Store. Andrew Stewart was the manager of the Whitney Market unit it closed in 1912. He then purchased the market and continued the operation. Pictured c. 1915 are, from left to right, Thomas C. Stewart, Andrew Uhl, and Henry Rynhart.

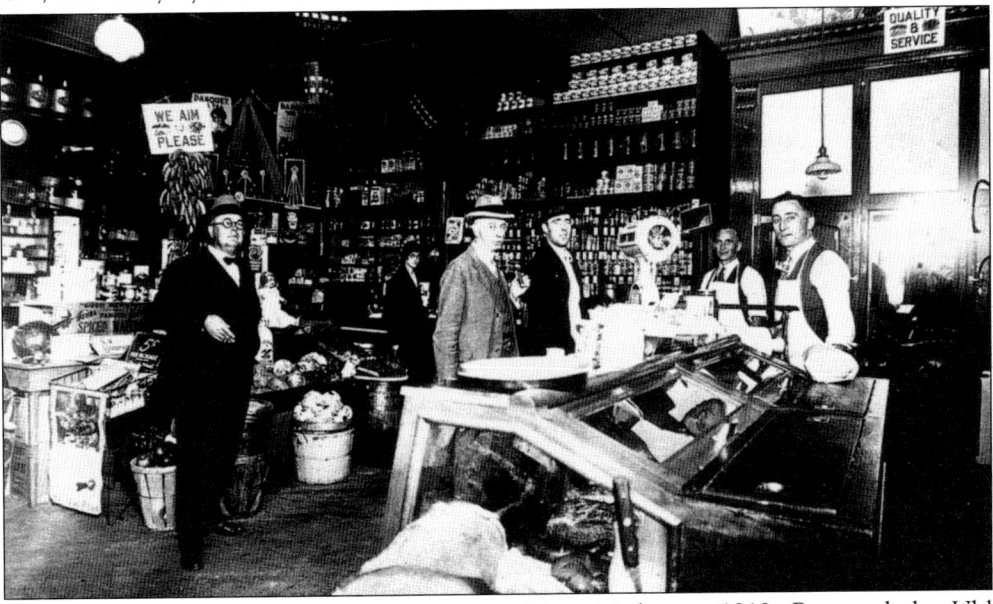

Andrew and George Uhl purchased Stewart's Meat Market in 1919. Renamed the Uhl Brothers' Market, the store was popular, as this 1923 interior view shows. From left to right are William Heritage, Elizabeth Hillyard, William Abdell, Charles Fowler, and George and Andrew Uhl. By 1935, the store had relocated to the Middleton Building, on High Street. This became Glassboro's first self-service market and sold the first frozen foods in town.

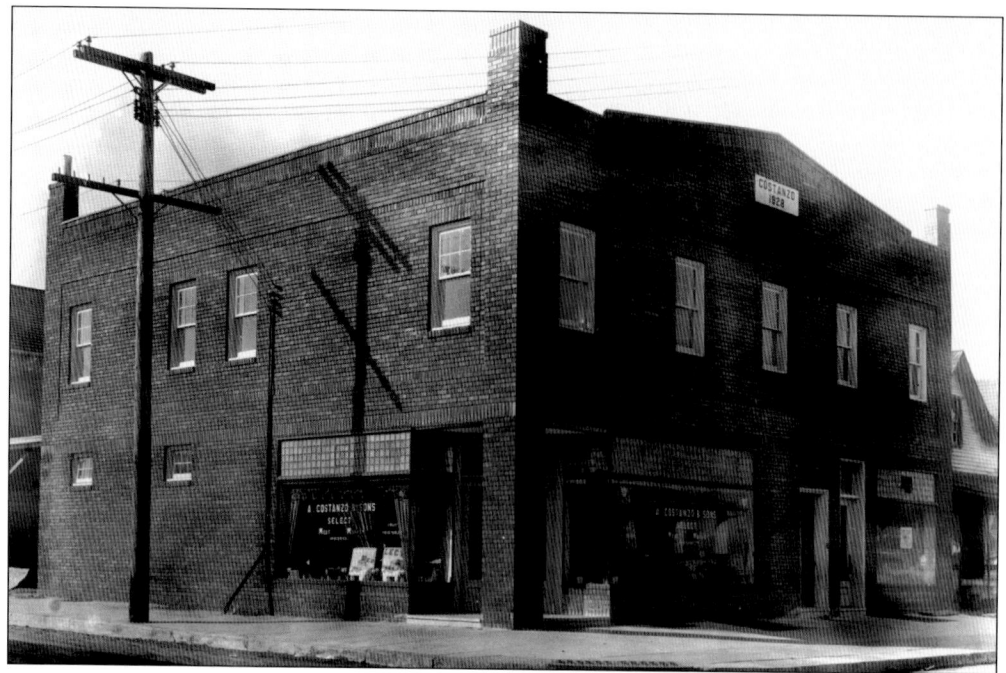

In 1928, Anthony Costanzo constructed this building at High and Lake Streets. The Great Depression crushed the dreams and livelihoods of many Americans, and Glassboro was not immune to this tragedy. Costanzo found he had too many unpaid customers on his books. The store soon closed. Over the years the building was occupied by various businesses, and in August 2001, it was demolished.

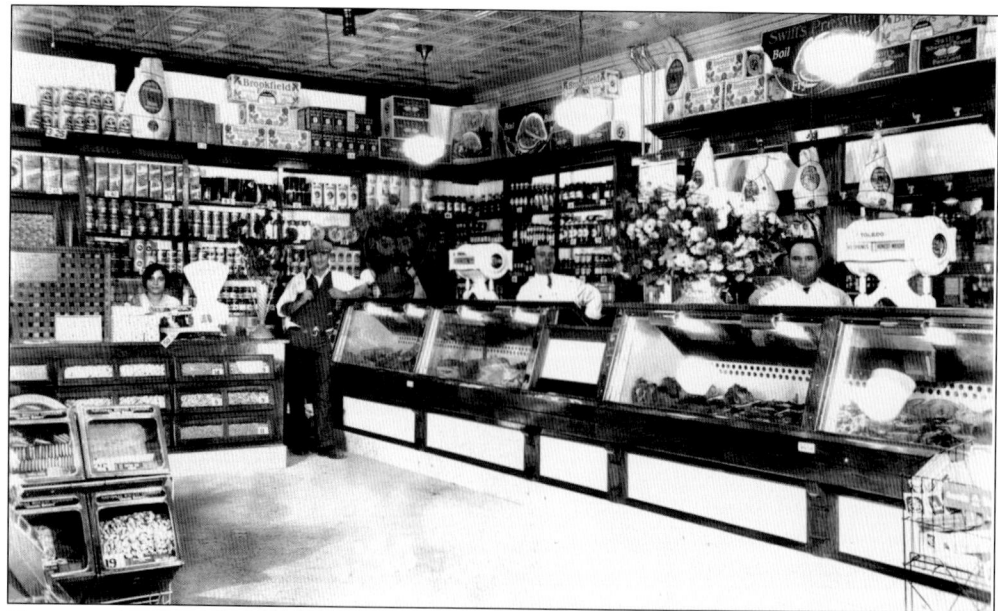

Shown is the interior of Costanzo & Sons Meat Market in 1928. When Costanzo's opened, it was one of the finest markets in town. It was stocked with some of the best cuts of meat in the area and carried a large selection of fruits, vegetables, and groceries. From left to right are Lucy Saia, Samuel Costanzo, Henry Costanzo, and Michael Costanzo.

Oscar Carr's general store stood on South Main Street for 64 years. Oscar Carr purchased the property in 1907 from Joseph Shute, who sold coal, lumber, millwork, building materials, paint, lawn mowers, and refrigerators. Carr continued the business but added a full line of groceries and other hard-to-find items. Pictured c. 1914 are, from left to right, daughter Ada Carr, wife, Clara Carr, and deliveryman Harry Mick.

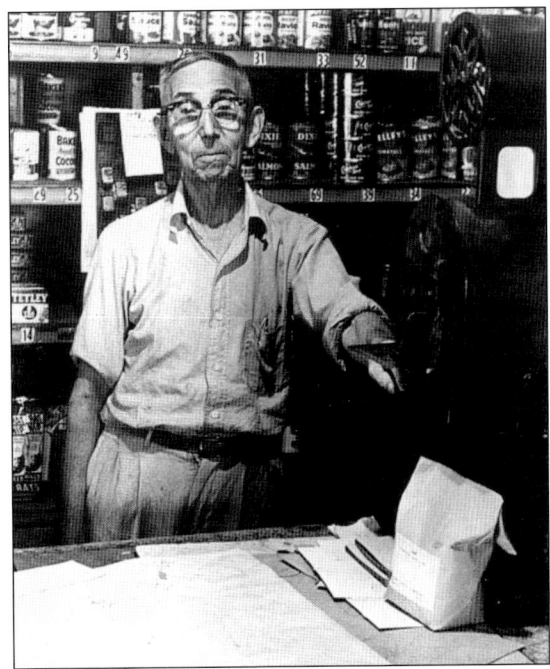

Oscar Carr, at age 85, stands behind the counter in 1967. He was active in many local organizations and was a former member of the Glassboro Borough Council. After closing in October 1971, Carr's general store was boarded up and stood empty until being torn down in the mid-1980s.

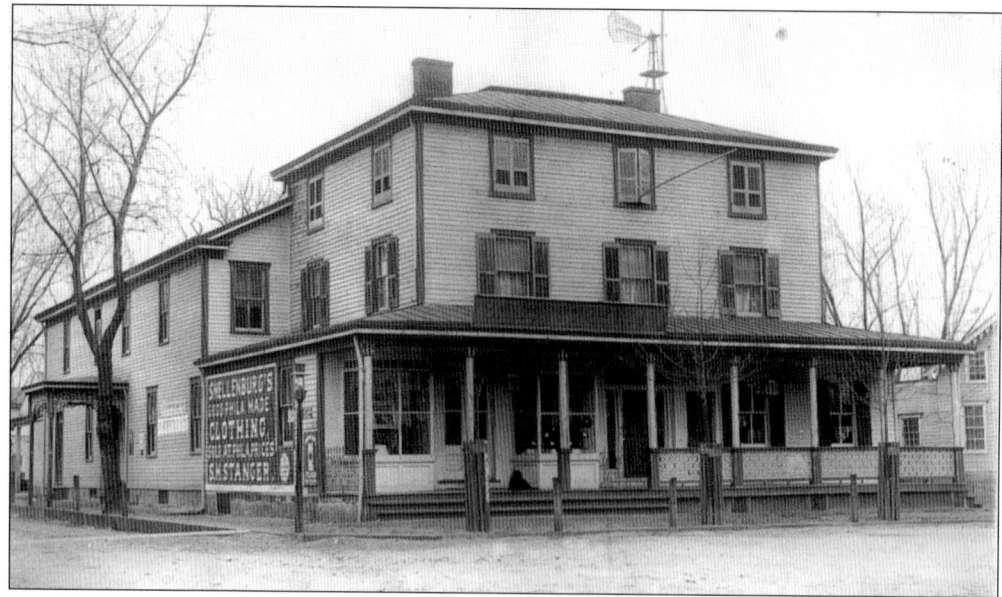

The S. H. Stanger Store, located at State and New Streets, was built in 1852 as a boardinghouse. Stanger purchased the building in 1882 and converted it into his home and business. In this c. 1893 photograph, wooden hitching posts stand in front of the store. They were replaced with cast-iron posts in 1896 and remain today. The Methodist church purchased the building in 1958.

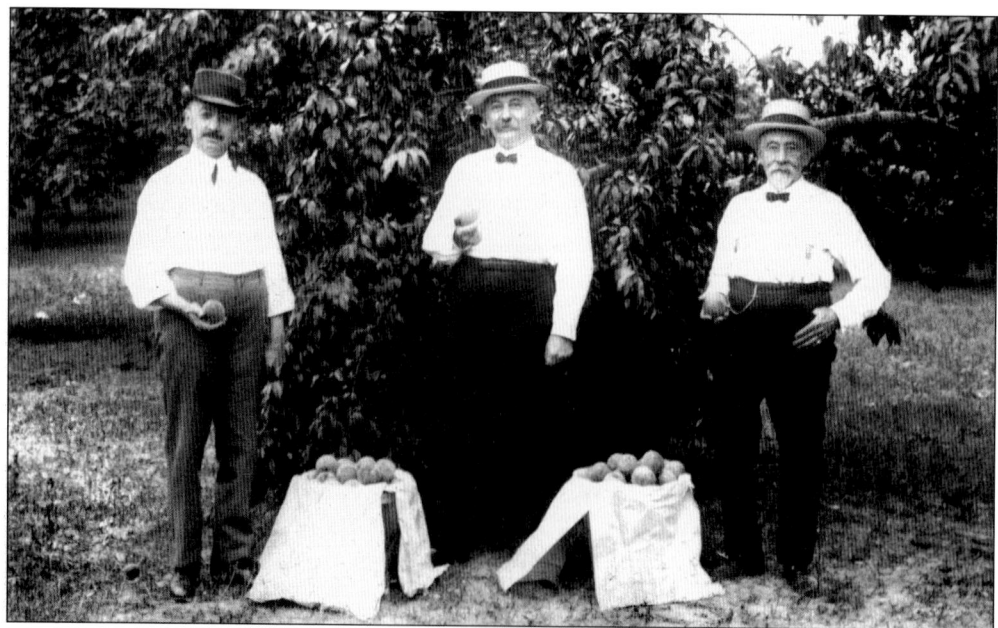

This father-son team was given the nickname "the Stanger Trio." In their Pomona Orchards, on Delsea Drive, c. 1910 are, from left to right, sons Frank R. Stanger and C. Fleming Stanger and their father, Solomon H. Stanger Jr. These men not only were successful in their business ventures but also were devoted to community affairs. Frank Stanger was Glassboro's third mayor, serving from 1923 to 1930. Solomon Stanger was elected to both the the state assembly and the state senate.

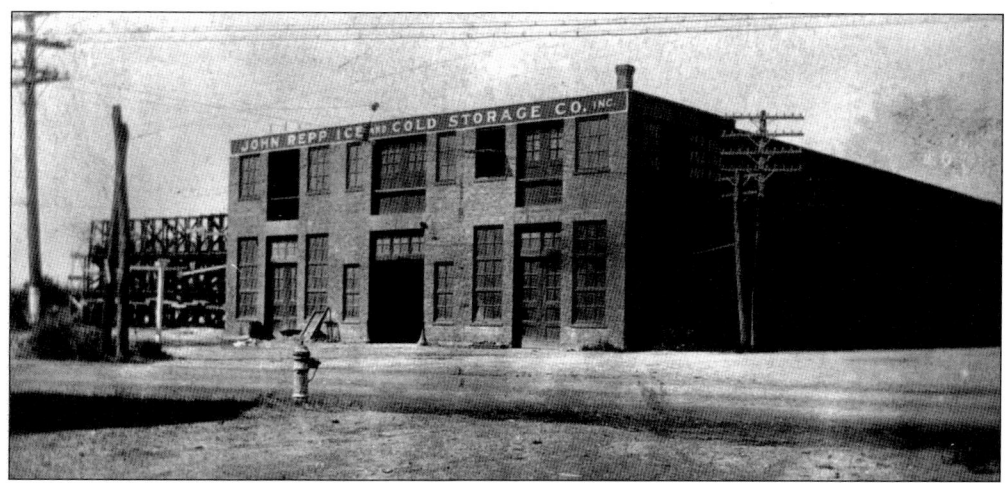

The John Repp Ice and Cold Storage Company began in 1886 on South Delsea Drive. John Repp, a farmer himself, saw the need for a cold storage facility for the ever-increasing quantities of produce grown in the area. He constructed his facility with a 400-barrel capacity, which had become obsolete by 1896. In 1903, he built a larger cold storage facility with the capacity of 10,000 barrels, along with an ice-manufacturing plant.

Pictured c. 1925, the Repp-U-Tation Cider & Vinegar plant, on South Delsea Drive, produced apple cider and vinegar products for many years. Robert Zimmerman managed the plant when it became known as National Fruit Products. Wine vinegar was produced here under the White House brand name.

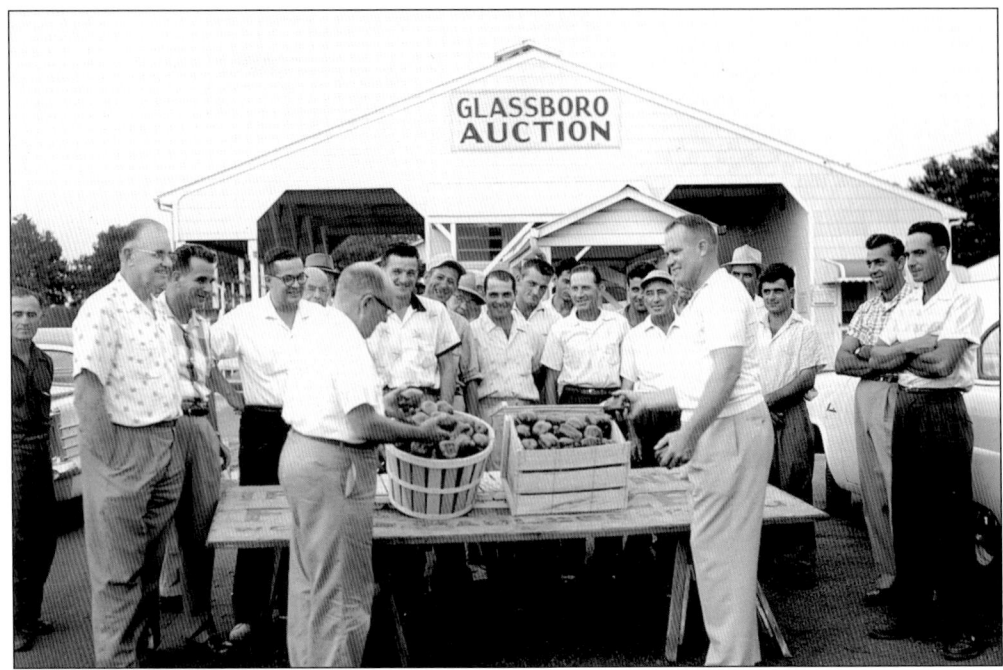

The Glassboro Cooperative Farmers Auction Market, pictured on July 31, 1959, was located between Market Place and Delsea Drive. At the height of the growing season, the auction was at its busiest. Local farmers would bring their fresh produce here to be sold. Most of it was shipped to New York City and also sold to local supermarkets such as Acme, Food Fair, and A & P.

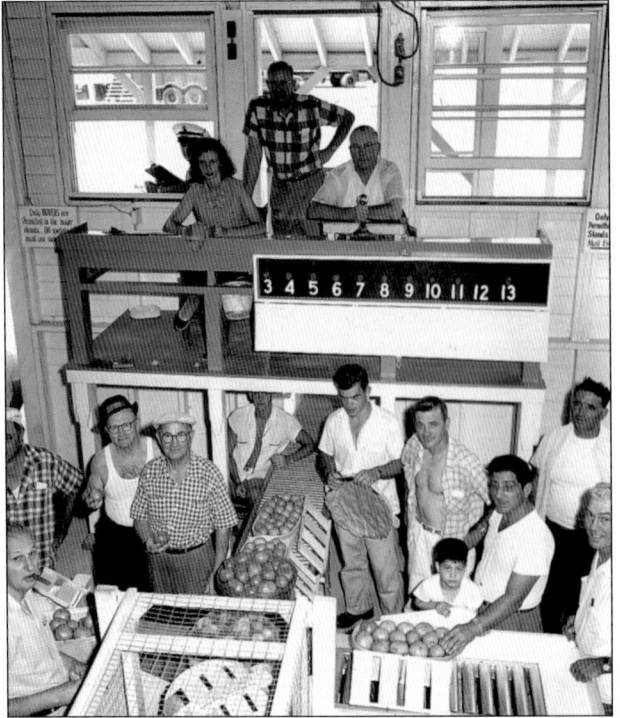

Seen on July 16, 1958, the busy Glassboro Auction generated much competition among area farmers' auctions such as Swedesboro and Vineland. It was operational into the 1970s. Today, the auction site has been cleared and is now Dr. Robert H. Renland Park.

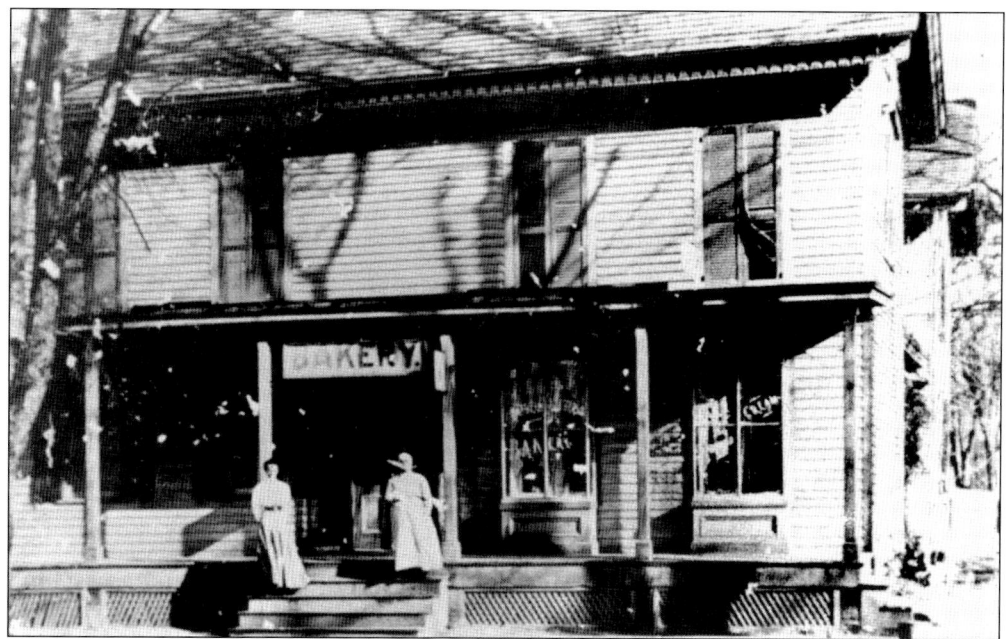

The Gibbons Gray Lloyd Bakery was situated at Main and New Streets. Gibbons Lloyd bought the property from Thomas Whitney in 1870. In 1885, Lloyd installed an eight-horsepower engine in the bakery and began manufacturing ice cream. The bakery was sold in 1902 to Marshall Campbell and Frank Paterson. Pictured are Mrs. Frank Paterson and Isabel Gray Paterson.

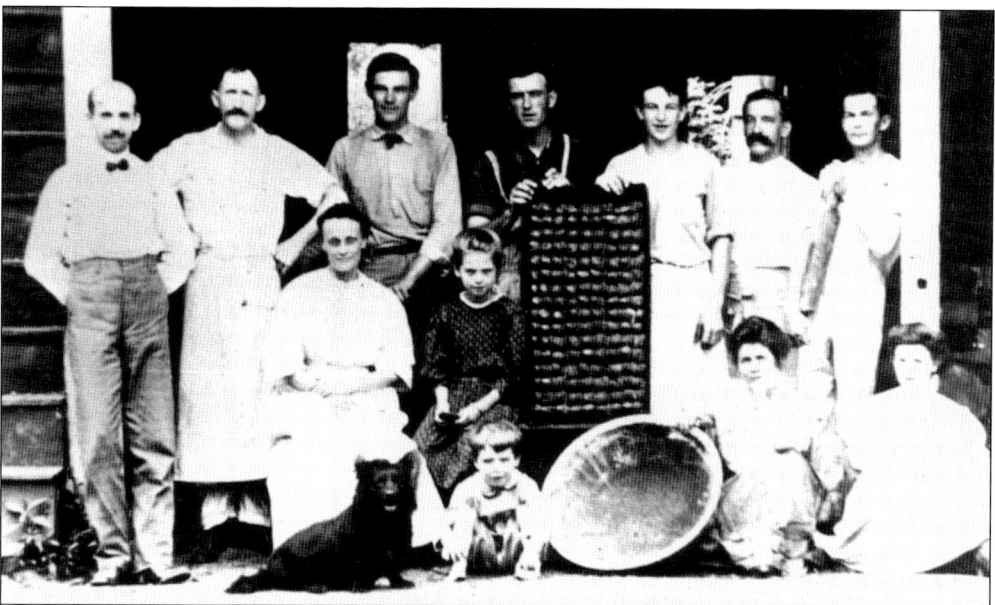

The Campbell & Paterson Bakery operated until 1913. This photograph, taken *c.* 1905, shows the bakery's owners and employees. From left to right are the following: (first row) Abbie Paterson, Trixie the dog, Isabel Campbell, Marshall Campbell Jr., Jessie Campbell, and Della Nickerson; (second row) Marshall M. Campbell and Frank Paterson (owners), Bert Johnson, William Chew, unidentified, George McCraken, and Joseph Kincade (bakers).

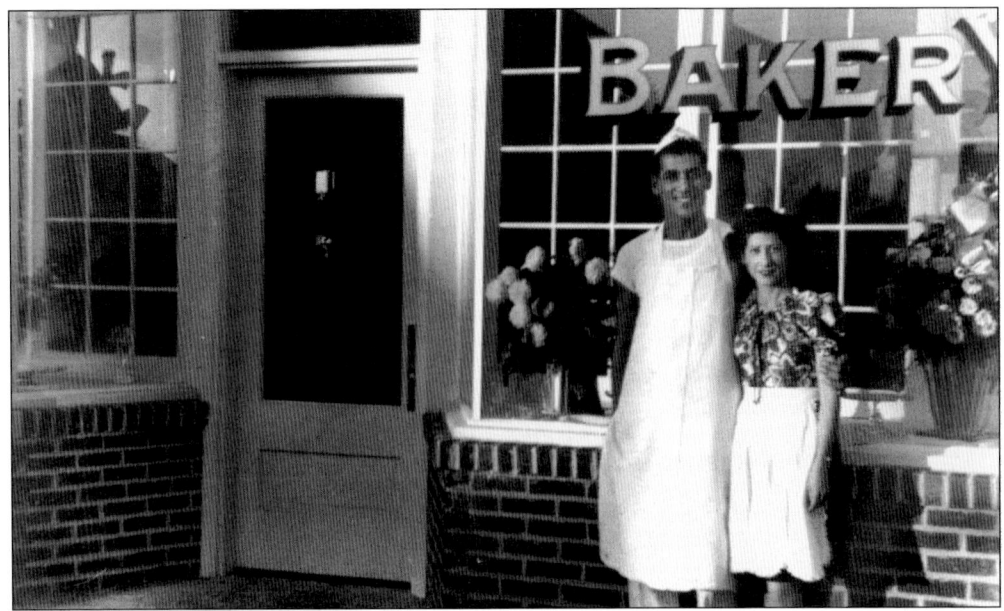

In 1946, Russell and Mary D'Amico opened the Elite Bakery on the north side of High Street. The name derived from a barbershop owned by Russell D'Amico's brother. The business was a success from the very beginning. Mary D'Amico recalls, "We had only been open a month when on a Sunday afternoon the store filled up with customers. When my husband and I took care of them, we were completely sold out."

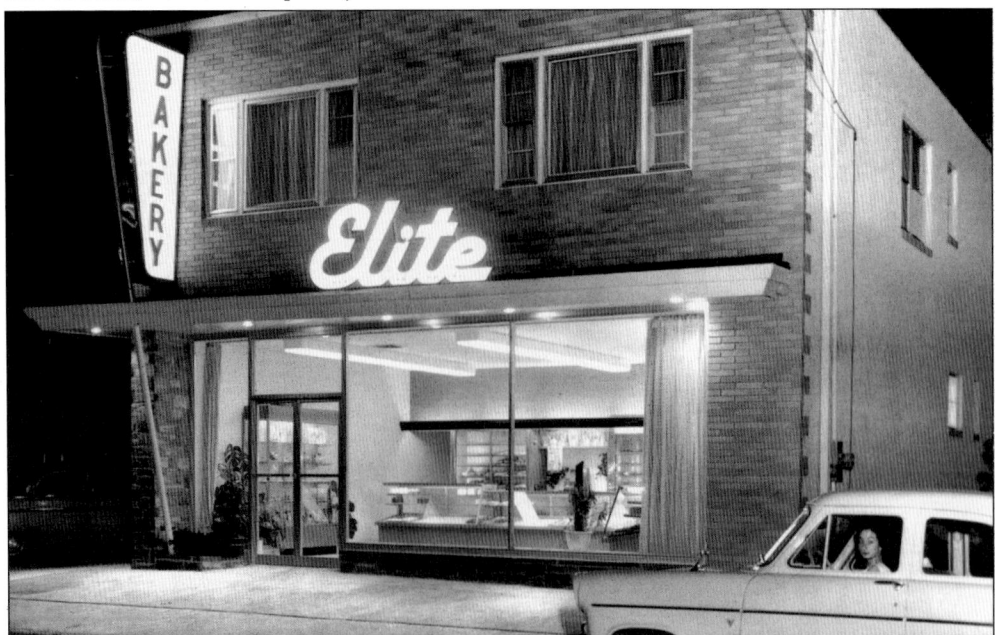

By 1957, Russell D'Amico had begun plans for a larger bakery across the street. Two homes that occupied the site were moved to other locations. Construction was completed in January 1958, and the D'Amicos continued baking their customers' favorites: Italian bread, rolls, and cream donuts. From 1971 to 1996, Charlie and June Johnson owned the bakery and continued the D'Amicos' pastry skill. This photograph was taken in 1960.

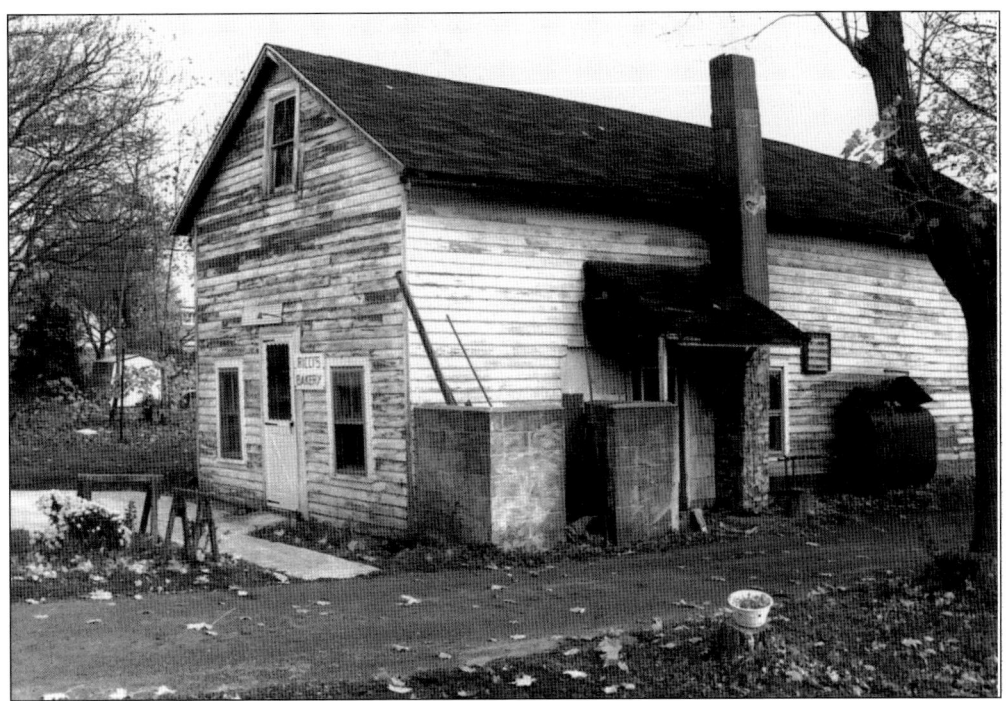

Since 1910, Glassboro residents have been treated to possibly the best-tasting Italian bread this side of the Atlantic. Dominic Ricci opened a bakery behind his Ellis Street home in January 1911. The old wooden structure, shown here in the early 1980s, made way for a new cinder block building that still houses the original oven.

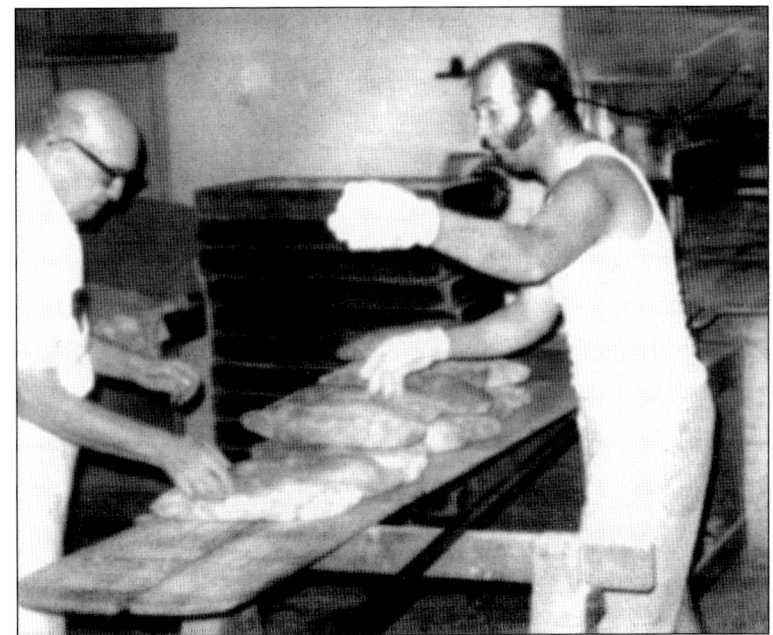

For nearly a century, three generations of the Ricci family have baked bread in the same old stone and brick oven, which is still the focal point for customers who stop by. Here, Alfred Ricci (left) and his son Albert have just taken several loaves of fresh-baked bread out of the oven c. 1975.

For centuries, the northeast corner of Main and West Streets has been the site of the town's tavern. Founding father Solomon Stanger applied to the Gloucester County courts for a license to operate a tavern on the site in 1781. The Bismark House, pictured in 1872 under the ownership of John H. Coles, later became the Franklin House. Over the years, the proprietor, name, and appearance of the tavern has changed.

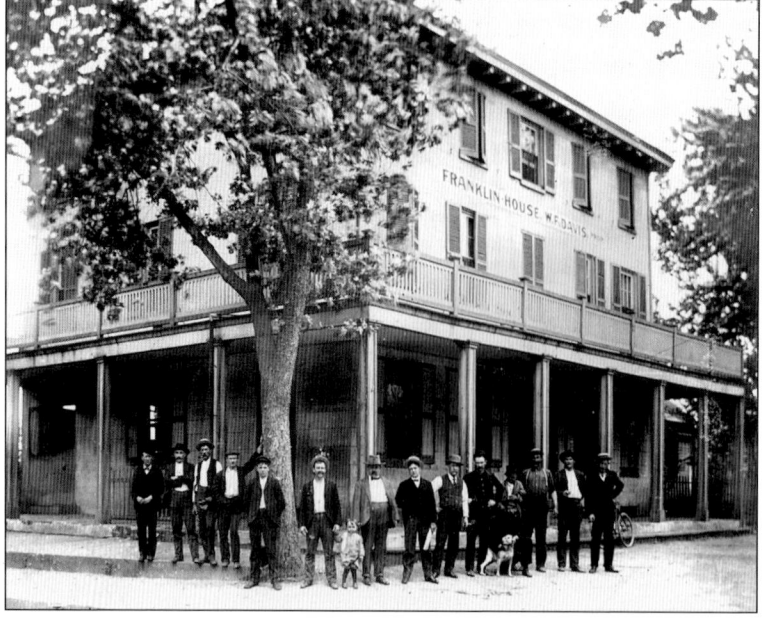

The tavern was built of Jersey sandstone in the early 1850s. Under the ownership of William F. Davis, (to the right of the child) the tavern was renamed the Franklin House, after his son in 1907, the year this picture was taken. Between 1908 and 1909, Davis constructed a three-window addition to the eastern end of the structure, increasing its size.

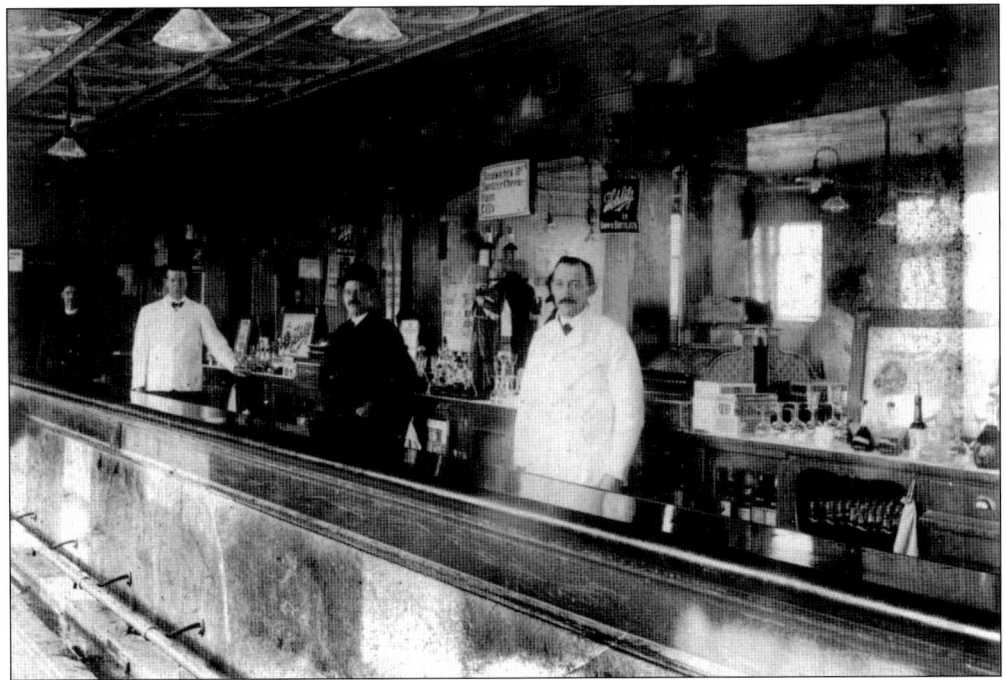

This rare photograph of the bar in the Franklin House was taken c. 1916. William Davis stands in the middle. After Davis's death, son Franklin Davis assumed responsibility for the hotel. In the 1960s, the son retired. The management of the hotel was placed in the hands of his daughter Celia (Davis) Risner and her husband, Ernest Risner, who ran the hotel until selling it in 1972.

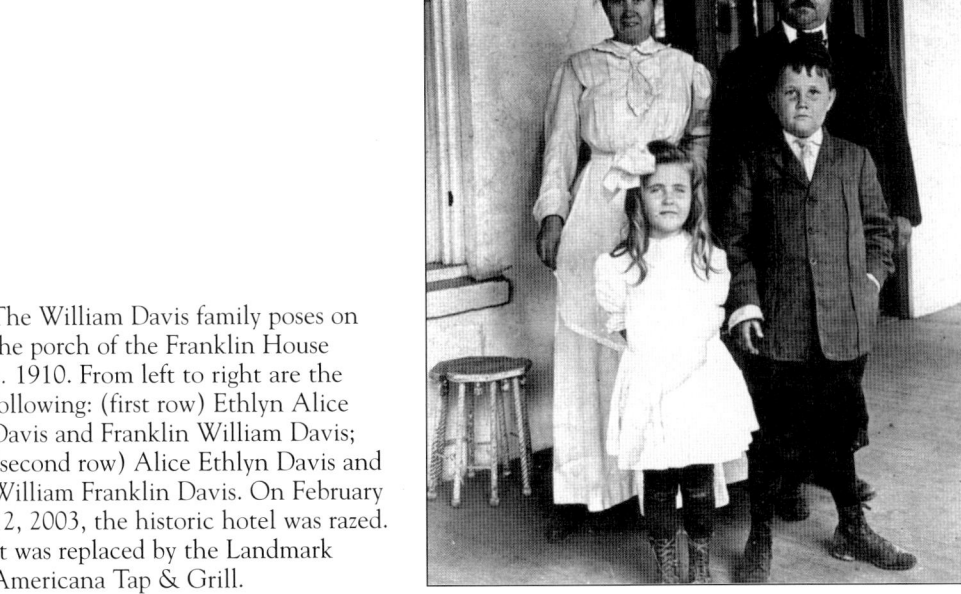

The William Davis family poses on the porch of the Franklin House c. 1910. From left to right are the following: (first row) Ethlyn Alice Davis and Franklin William Davis; (second row) Alice Ethlyn Davis and William Franklin Davis. On February 12, 2003, the historic hotel was razed. It was replaced by the Landmark Americana Tap & Grill.

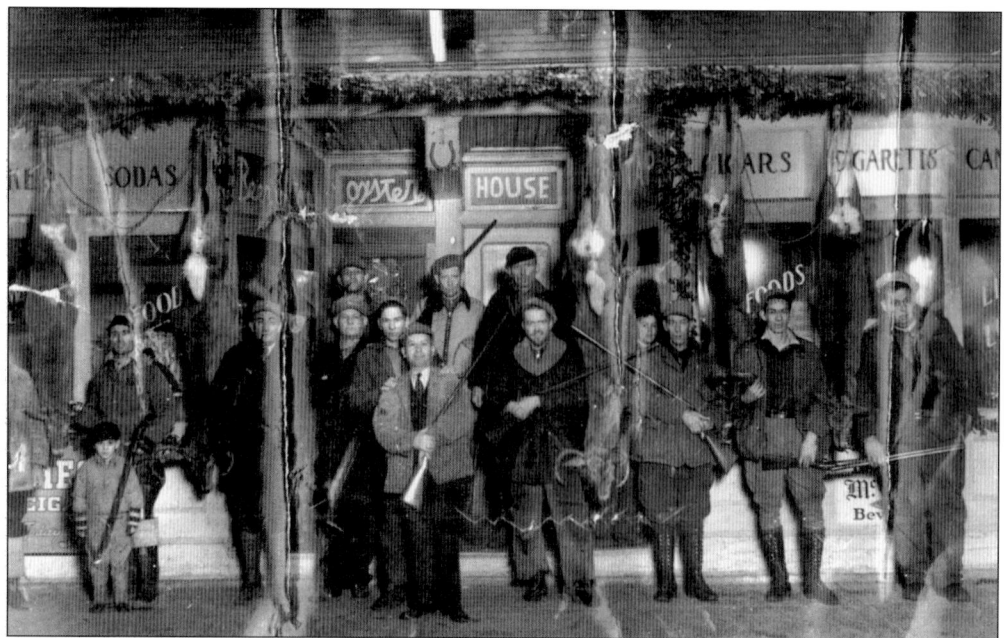

In the 1930s, Mazzeo's Café was located on South Main Street, next to the municipal building. Pictured out front are Frank Mazzeo (front, wearing the tie) and his deer-hunting club buddies. Old-timers recall Mazzeo serving wine out of paper cups during Prohibition. In the 1940s, Mazzeo moved his establishment to East High Street. Under new management in the 1980s, the café became known as the Study Hall.

In the days of poodle skirts and malt shops, Ware's Dairy Bar, on Delsea Drive, was a social gathering spot for students of the old Glassboro High School. Bill and Minerva Ware opened the dairy bar in 1947, and for eight years, soda fountains flowed and bananas were split. George and June Armstrong were Ware's last customers before the June 1955 closing.

For more than half a century, this diner has been a popular Glassboro eatery. Angelo Tubertini opened the establishment as the Glassboro Diner in 1946. Shown in 1947, the diner was originally located closer to the corner of Main and High Streets. Later known as Angelo's Diner, the structure was moved just a few yards up Main Street to its present site in 1951.

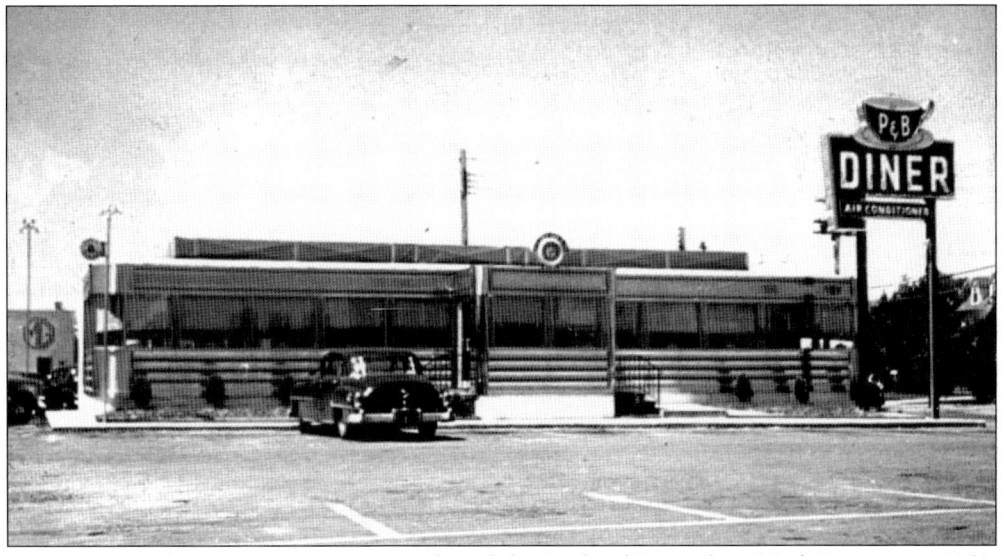

Greg Petsas and Constaninos Benas purchased the Orchard Diner from Nick Prieston in 1953. The structure, located between Delsea Drive and Main Street, then became known as P & B Diner. Renovated with a 1950s chrome-style appearance, as shown here in 1955, the diner took on a Colonial design in 1963. In 1984, it was moved to Mullica Hill and renamed the Harrison House. The new PB's Diner was erected across the street on Delsea Drive.

Joe's Sub Shop was a landmark Glassboro eatery for more than 50 years. Located on the corner of High and Lake Streets, the shop was opened in 1949 by Joe Lisa (left). Sadly, Joe Lisa died in 1960 at age 44. A year later, Joseph A. Brigandi Sr. purchased the establishment for $15,000; he still jokes that he never even had to change the name. Brigandi successfully operated the shop until April 2002.

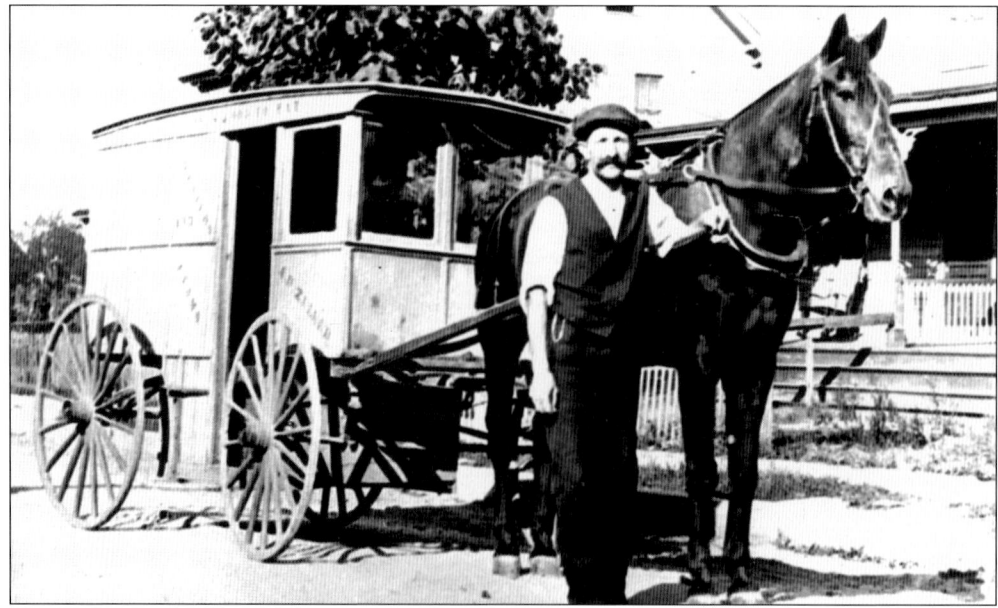

Before the convenience of strip malls and online Internet shopping, local merchants delivered products like milk, eggs, and other essentials directly to the home. Many Glassboro residents can still remember having a milk box placed outside their door. In 1908, Albert Zulker delivered fresh fish, clams, and oysters from his fish wagon to homes in Glassboro.

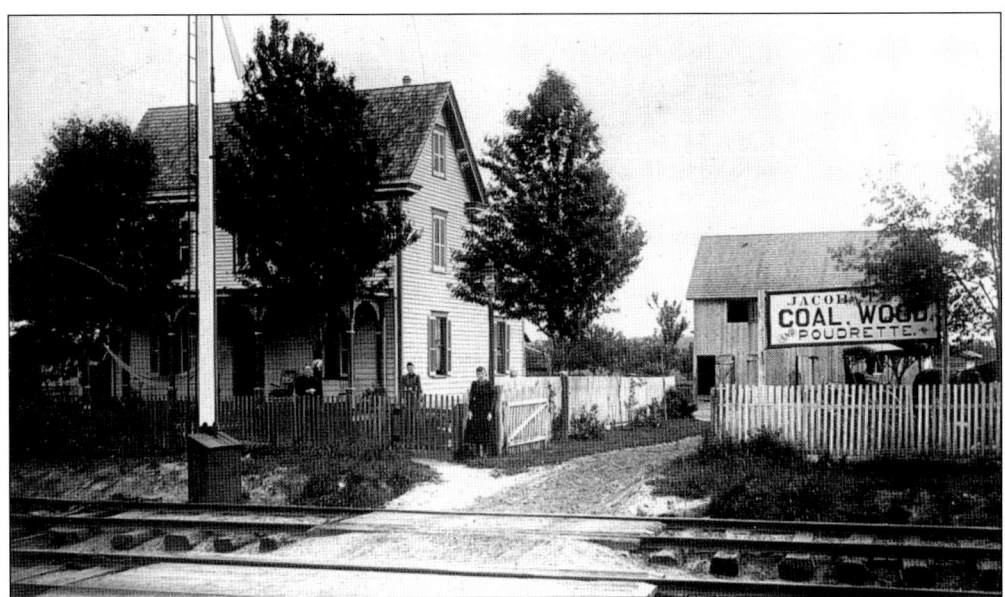

The Jacob Long home and business was built in 1878 and located on the west side of Zane Street, opposite the West Jersey Railroad tracks. Jacob Long sold coal, wood, hay, straw, and poultry feed. His business was successful, and it continued until his death in 1896. In the 1930s, the Owens Company purchased the Long property, and the house was demolished. Today, Glassboro Municipal Water System Well No. 5 occupies the site.

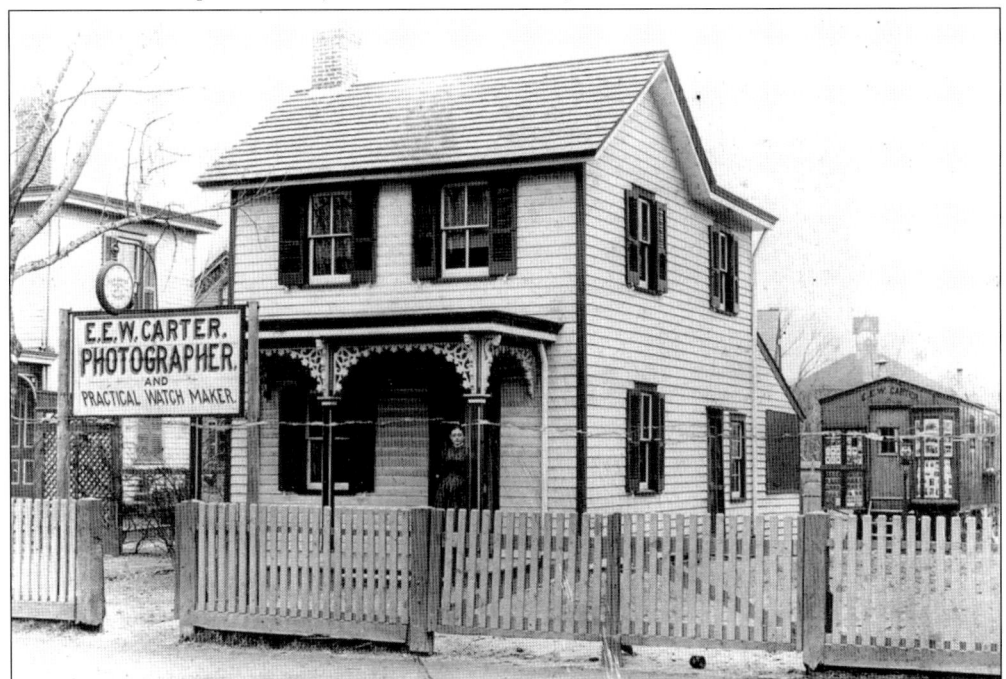

E. E. W. Carter had his first photography studio and watchmaking shop (far right) behind his home, which was located on High Street, across from the present Glassboro Post Office. This photograph was taken c. 1910. Carter later established his home and business at Main and Focer Streets.

Albert P. Wilcox built the Wilcox Harness Shop in 1884 at State and New Streets. He then moved the structure to the back of his lot facing New Street and constructed Wilcox Hall. The old harness shop later became a clubhouse, bicycle shop, photography studio, and classroom space—after the Academy Street School fire in 1917. Still standing, the building has been converted into a residence.

Wilcox Hall, seen here c. 1891, was located at New and State Streets. Albert P. Wilcox built the three-story structure in 1889. In 1893, the building was purchased by a group of Glassboro businessmen and renamed Association Hall. From left to right are Jennie Stiles, L. Holland, Max Steinfelt, Howard Moore, Roscoe Luffbary, Stultz Pierce, Bessie Wilcox, Mrs. Albert P. Wilcox, and Albert P. Wilcox.

Built in 1891, the First National Bank was the first banking institution in Glassboro. For 80 years, this stone structure stood at High and Main Streets. On the steps are, from left to right, P. K. DuBois, A. S. Emmel, and Oscar Casperson. Seated in the car are, from left to right, William Downer (driver), James DuBoise (passenger), Lawrence Sickler (behind driver), and Louis Shreve.

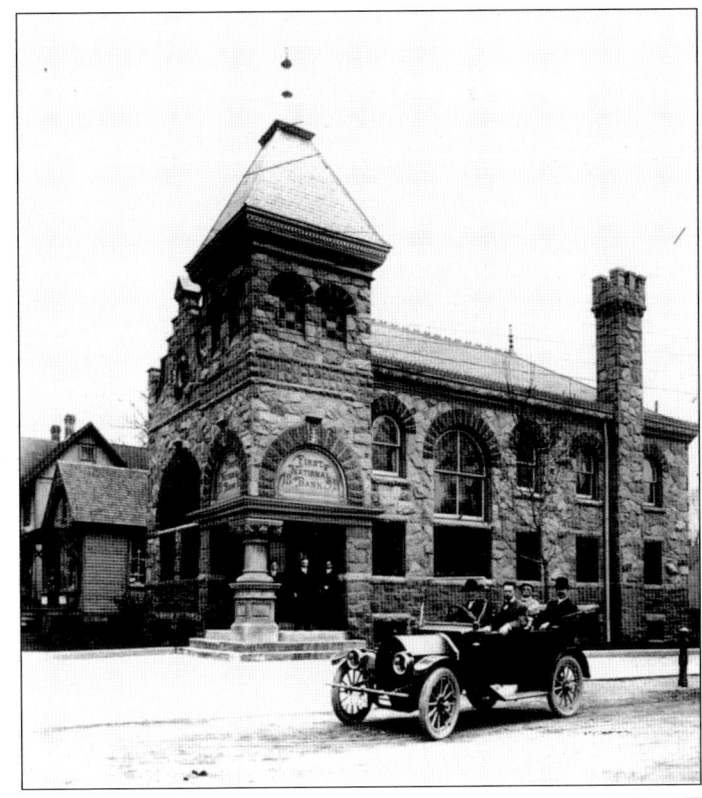

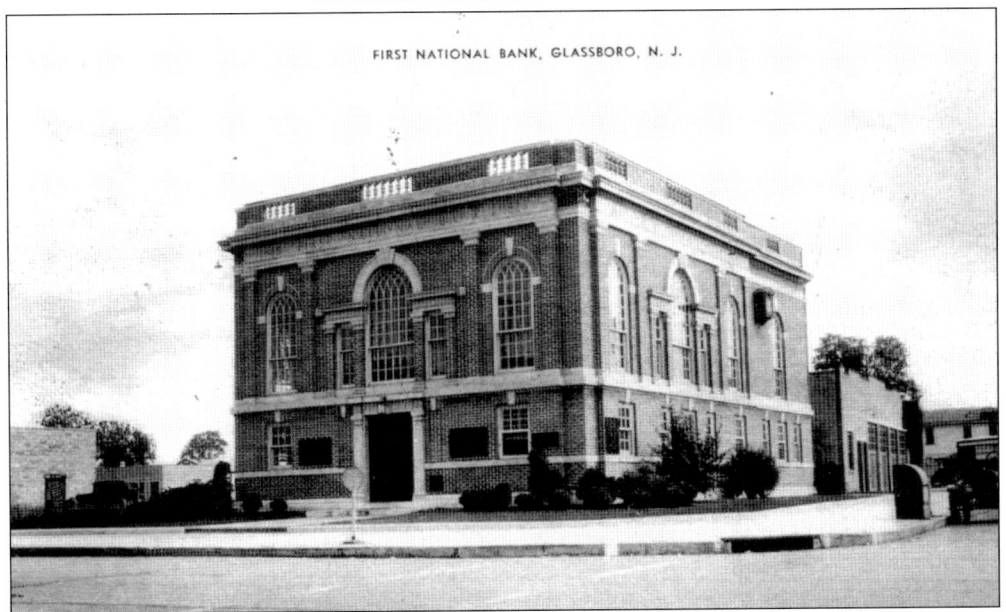

In 1926, the First National Bank constructed a new and larger facility on the southeast corner of High and Main Streets, where it remained a banking institution until 1995. The borough of Glassboro purchased the old 1891 stone structure in 1927 and converted it into the town's municipal building. In 1970, the old building was demolished and a new municipal building was constructed.

Postal service began in Glassboro in 1822. In 1889, Thomas Whitney had constructed for the postal department this building on the south side of High Street, across from his glassworks. Saved from flying embers during the 1895 glassworks fire, the structure was later moved to South Main Street, where it became a residence. It is currently the office for the Glassboro Child Development Center.

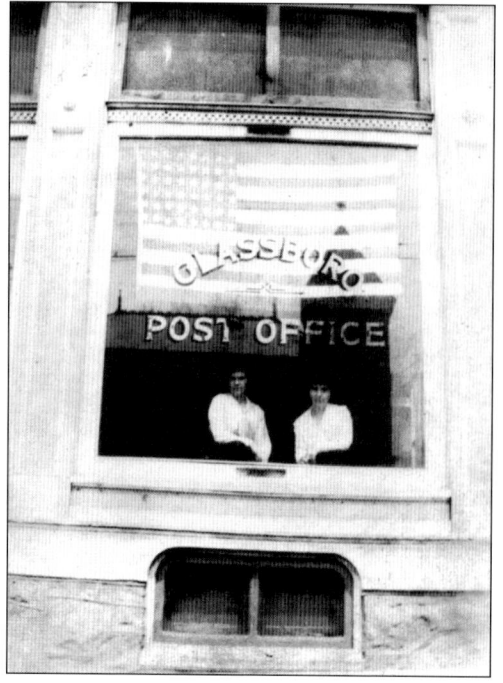

In 1913, the Glassboro Post Office moved into the former Whitney Department Store. On December 8, 1913, the new facility opened under the management of Postmaster L. M. Sickler. It contained new office furniture and the best equipment in the state. Here, two young ladies peer out a large window of the post office c. 1915.

In July 1920, Postmaster George Keebler promised town residents that home delivery would come in the near future. In 1924, the borough council advised residents to start numbering their homes in preparation for visits by mail carriers. It was not until 1926, however, that mailmen began depositing letters in residents' mailboxes. The post office, seen here c. 1948, was located in the Middleton Building, on High Street.

Due to Glassboro's growth, the post office needed to enlarge its facilities. A new building was constructed on Center Street (across from the present library) in 1950, under the leadership of Postmaster Laura Ware. After 10 years, this building also became obsolete. A new facility was built at High Street and Warrick Avenue, under Postmaster George H. McCullough, and was dedicated on July 22, 1961.

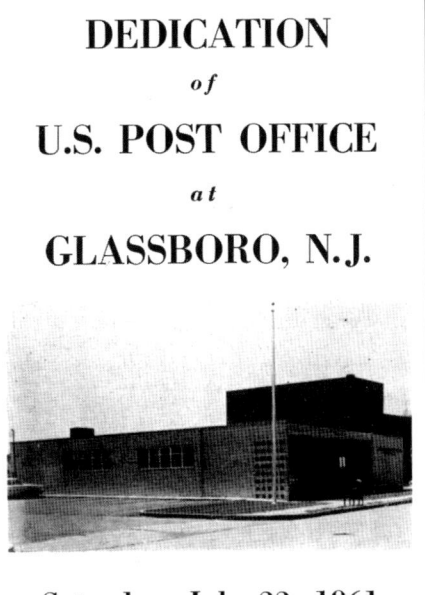

DEDICATION
of
U.S. POST OFFICE
at
GLASSBORO, N.J.

Saturday, July 22, 1961
2:00 P.M.

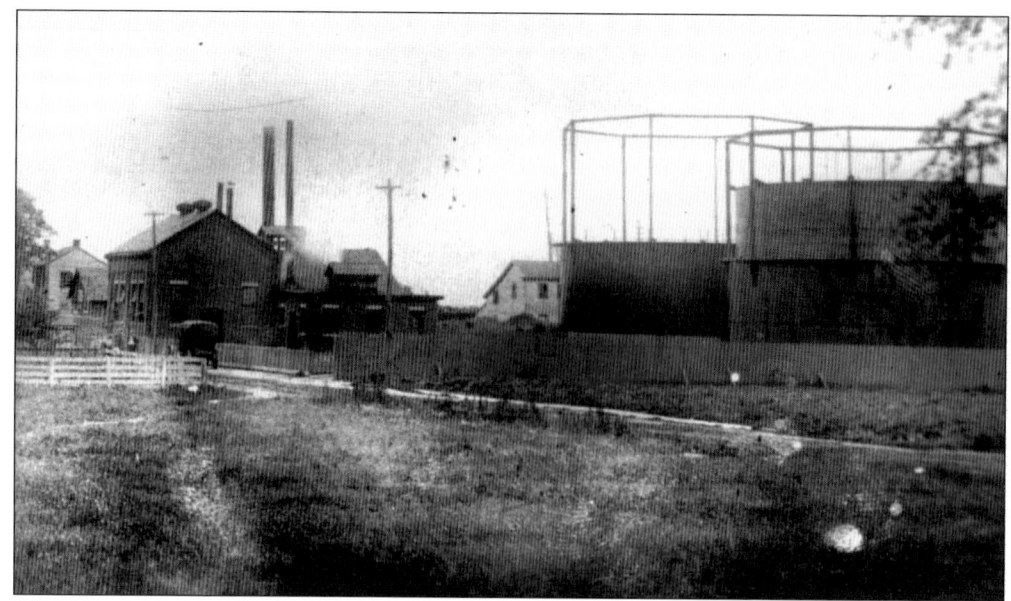

The Glassboro-Pitman-Clayton Gas Company began operations in 1906 on Union and Grove Streets. This plant merged with a number of smaller gas providers to form the New Jersey Gas Company. In 1922, it became the Peoples Gas Company. The plant manufactured carburetor blue gas, which was distributed to 54 communities in South Jersey. By 1980, the old tanks had been removed, along with the other plant structures.

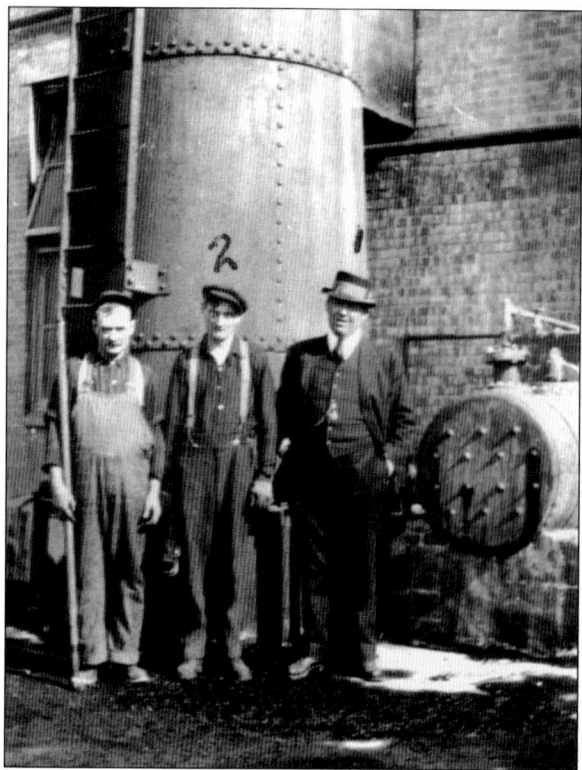

The Peoples Gas Company developed into a substantial industrial unit, valued at $2 million. In 1925, it employed nearly 156 people, most of whom lived in Glassboro. Workmen pictured here in 1915 are, from left to right, Thomas Dare, Alfred Wagner, and George Ryan.

The Glassboro Lumber Company Office stands at High and Center Streets. Built in 1925 as the Glassboro Title and Trust Company, the institution closed in 1931 after questionable drops in bank funds caused the State Department of Banking to investigate possible fraud. Two of the bank's highest officials had made unauthorized loans to themselves. In later years, the building became a public library and a museum.

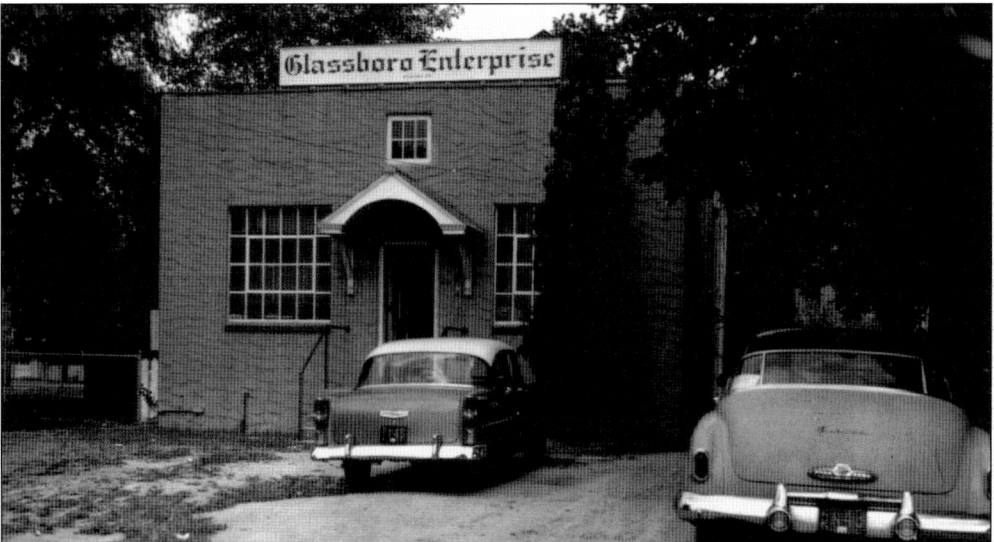

The Glassboro Enterprise Printing Company was located on Academy Street in 1946. For nearly 100 years, the weekly newspaper, delivered on Thursday, carried the news of Glassboro and surrounding communities. It was the first regularly published newspaper in Glassboro. By the 1980s, the *Enterprise* had been absorbed by Cam-Glo Newspapers.

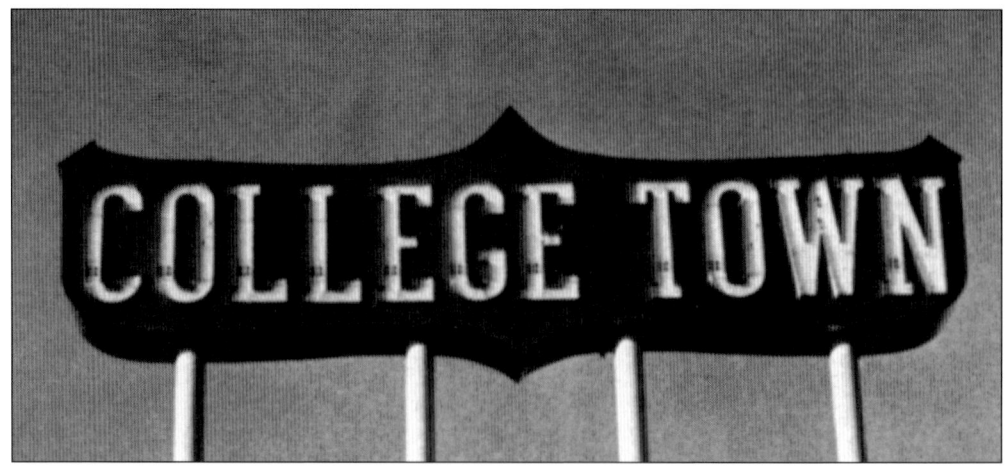

The College Town Shopping Center sign, seen here c. 1966, was a landmark on Delsea Drive for many years. In the mid-1960s, Americans were looking for new and convenient ways to purchase goods. Soon, enclosed shopping malls like the Cherry Hill Mall, the first of its kind in the country, were erected along with shopping centers. This contributed to the decline of many of the nation's downtown areas.

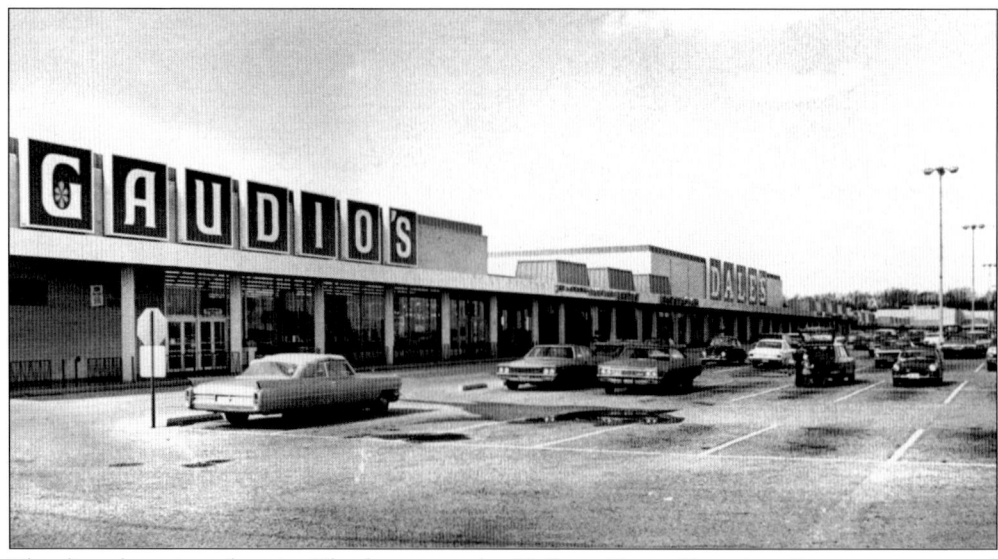

The first shopping plaza in Glassboro was the College Town Shopping Center, constructed c. 1965 at Delsea Drive and Barger Boulevard. Shown here c. 1970, the plaza had as its main anchor stores W. T. Grants, Gaudio's Garden Center, Penn Fruit & Dales, a Sears catalog store, Jack Lang's Men's Wear, and a movie theater. Today, this intersection could truly be considered the center of commerce in Glassboro.

Four
GLASSBORO SCHOOLS
DEVELOPING MINDS

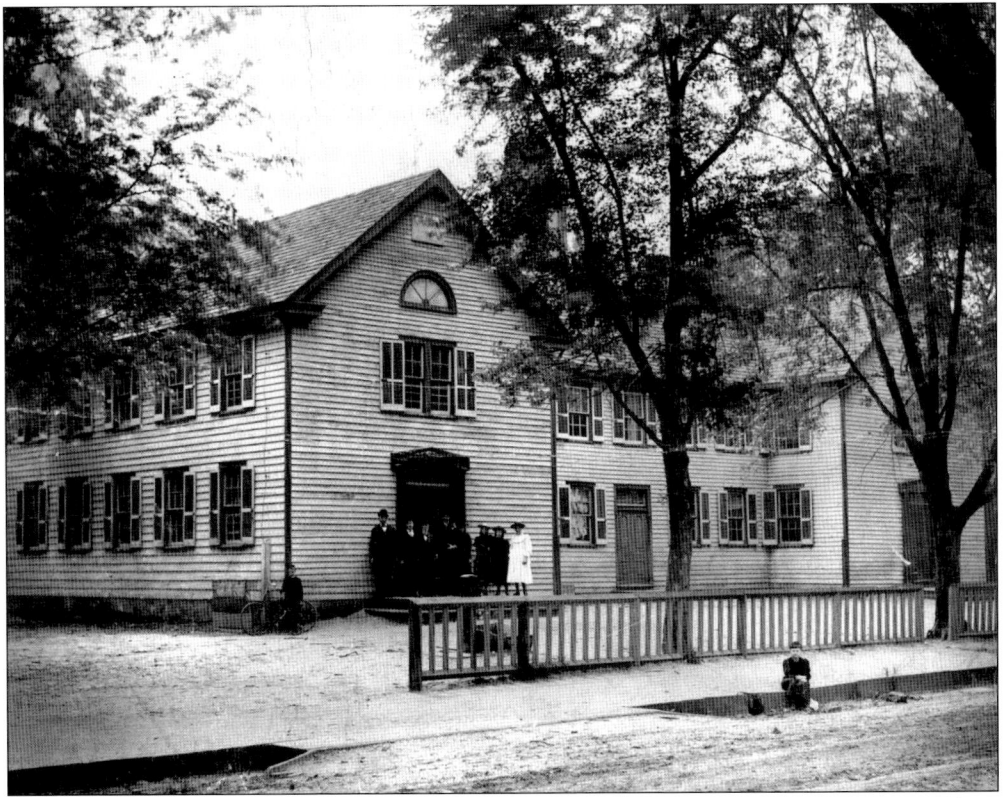

Built in 1841 entirely of wood, Glassboro Academy was the first grammar school erected on Academy Street. Shown c. 1880 are, from left to right, Frank Haight (with the bicycle), Mizeal Parker, Albert Stanger, John Z. Stanger, Prof. Frank Bowen, Effie Parker, Lelia Stanger, Augusta Buck, and Edna Moore (seated on the curb).

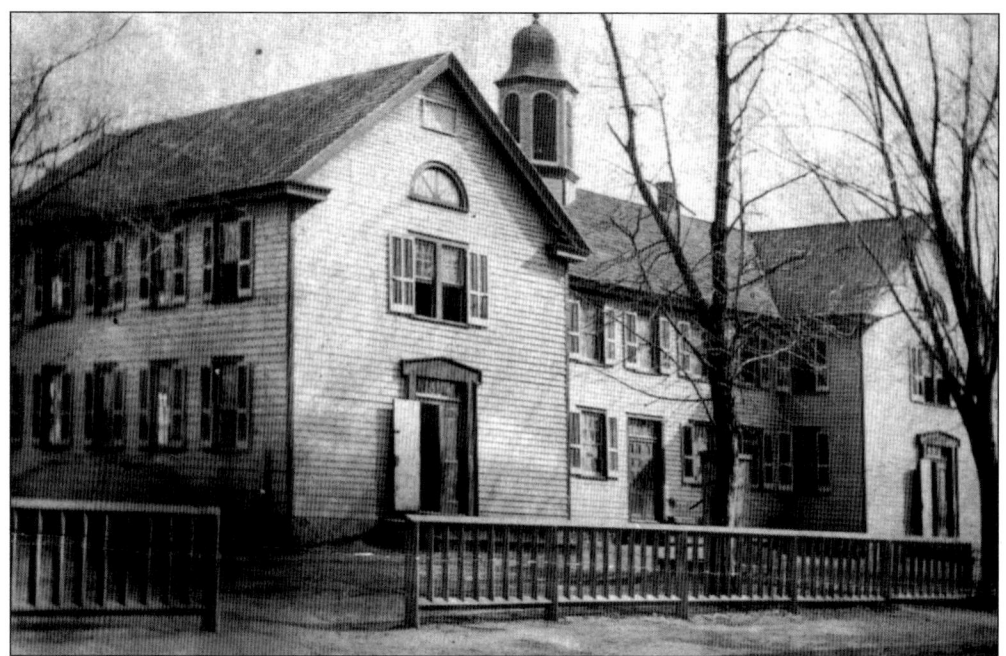

The north wing of Glassboro Academy was added in the summer of 1857 at a cost of $2,060, and the south wing was completed in 1872 at a cost of $2,250. In 1893, the school was sold in three separate parts and relocated to various sections of town. Only one portion remains today, as a home located at 30–32 North Delsea Drive.

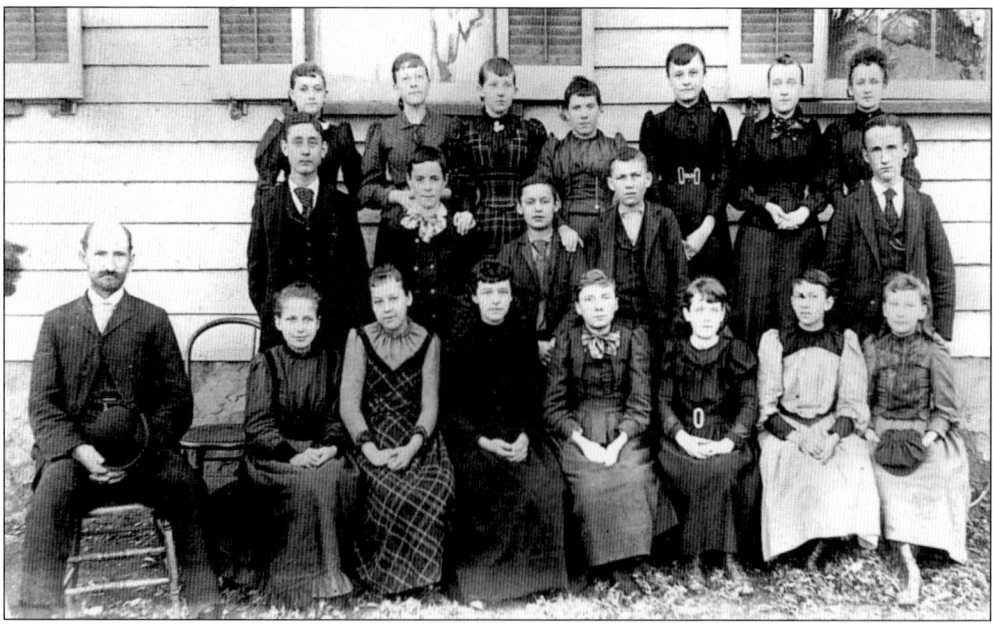

Students in Glassboro Academy's eighth-grade class pose in 1889. From left to right are the following: (first row) Prof. Frank Bowen, Ella Skinner, Alma Simmermon, Alice Emmel, Leona Long, Martha Stanger, Sarah Heritage, and Effie Parker; (second row) George Keebler, Sherwin Moffet, Howard Moore, Jesse Reeves Jr., and Clinton Shute; (third row) Ella Lutz, Emma Long, Nellie Proud, Jennie Duffield, Anna Montgomery, Sibil Lull, and Laura Albertson.

Construction of the second Academy Street School began with elaborate cornerstone-laying ceremonies on July 4, 1893. Under the auspices of the Pocahontas Council No. 48, Junior Order of United American Mechanics (OUAM) of Glassboro, Dr. John Z. Stanger (front left) gave the presentation of the stone and S. S. Iszard (center) set the cornerstone in place.

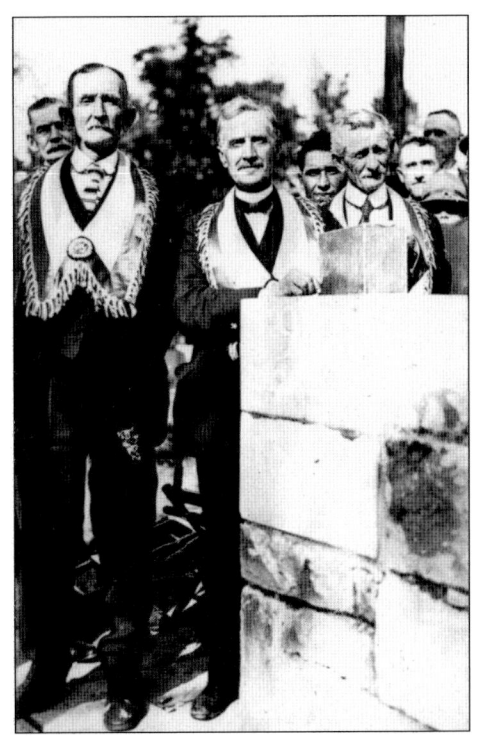

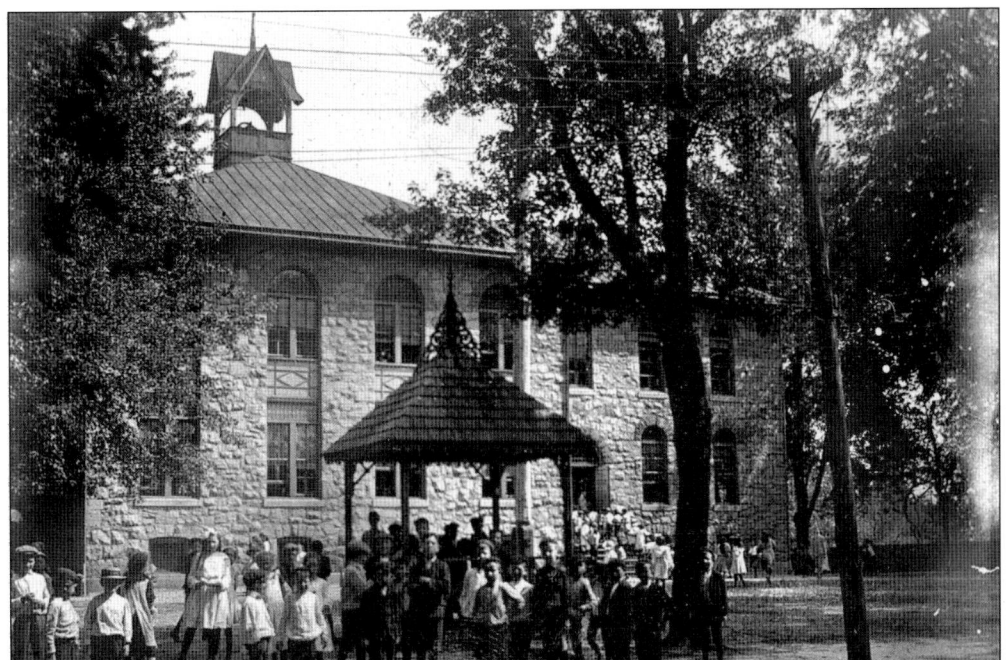

When the second Academy Street School was completed in 1894, it was considered one of the finest schools in South Jersey. Constructed at a cost of $15,000, the two-story stone structure had 12 classrooms heated by steam. Running water was not yet available in Glassboro; all plumbing facilities were still located outside. In this 1910 photograph, the children are seen playing around the pump shelter.

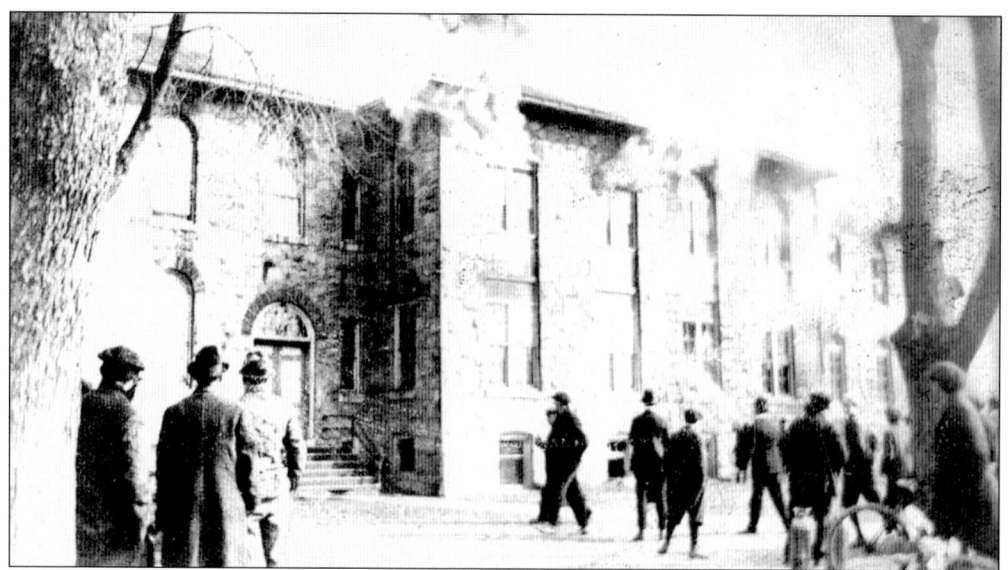

On the afternoon of February 21, 1917, a fire broke out at the Academy Street School, completely destroying the entire structure. The fire was reported by student Bertha Turner, who noticed flames coming from a wastepaper pile in an area of the basement known as the locker room. When the Glassboro Fire Department arrived to the engulfed school, all students and teachers had safely evacuated the building.

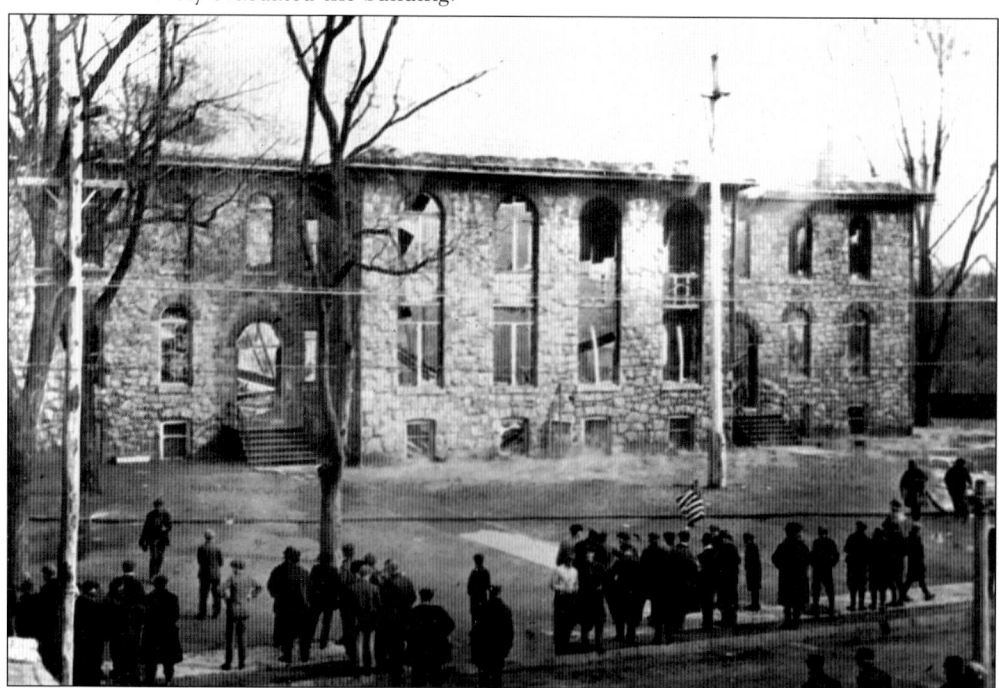

This was the second large fire in less than a month for the Glassboro Fire Department. Just weeks before, the Glassboro Auditorium, directly across the street from the school, had been destroyed by a horrific blaze. When firefighters arrived they immediately began to pump water into the basement. Quickly, they found the water pressure to be low. From investigation of the water tower that afternoon, the tank was found to be empty.

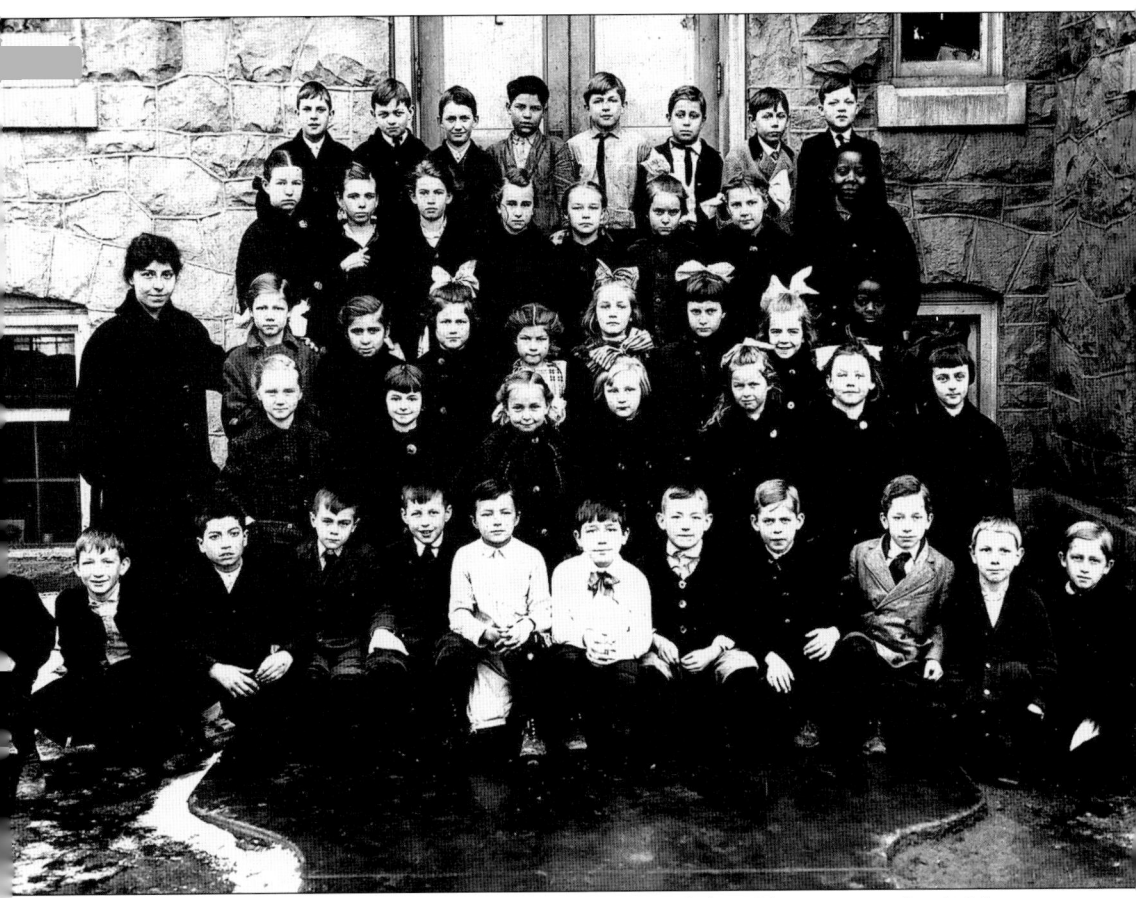

This was one of the last class portraits taken on the steps of the old grammar school. Marie Waite's third-grade class poses on February 7, 1917, just days before the disastrous fire. Glassboro historian and coauthor of *The Glassboro Story* Ed Walton Jr. (fifth row, far right), recalls, "I remember [Miss Waite] saying we were having a fire drill and to line up quickly and leave the room, which we had practiced many times. All the students left the room, and as we were going down the steps leading out of the building, you could see smoke and someone called out that we had a 'real fire.'" The evacuation of the school was most orderly, as all 500 pupils were saved. Once outside, Walton remembers running back into the burning building to retrieve his coat, fearing that if he returned home without it, his mother would punish him.

Just a week after the Academy Street School fire, students resumed classes in suitable buildings around town that were rented by the Glassboro Board of Education. The Women's Christian Temperance Union building, for example, located on South Academy Street, became class space for the second-graders shown here in 1920.

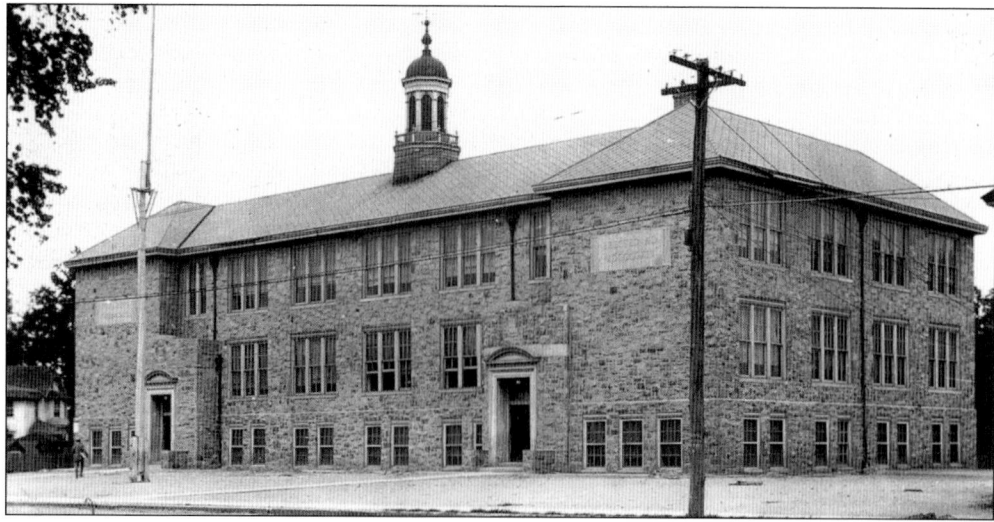

Elementary students continued to attend improvised class locations until 1920. The newly constructed, $117,000 Academy Street School opened within that year and served as an educational institution for seven decades. On June 18, 1993, its doors closed, with students, teachers, and honored guests bidding "Farewell to a Grand Old Lady . . . Academy Street School." That fall, the Dorothy L. Bullock Elementary School, located on East New Street, became Glassboro's newest elementary school.

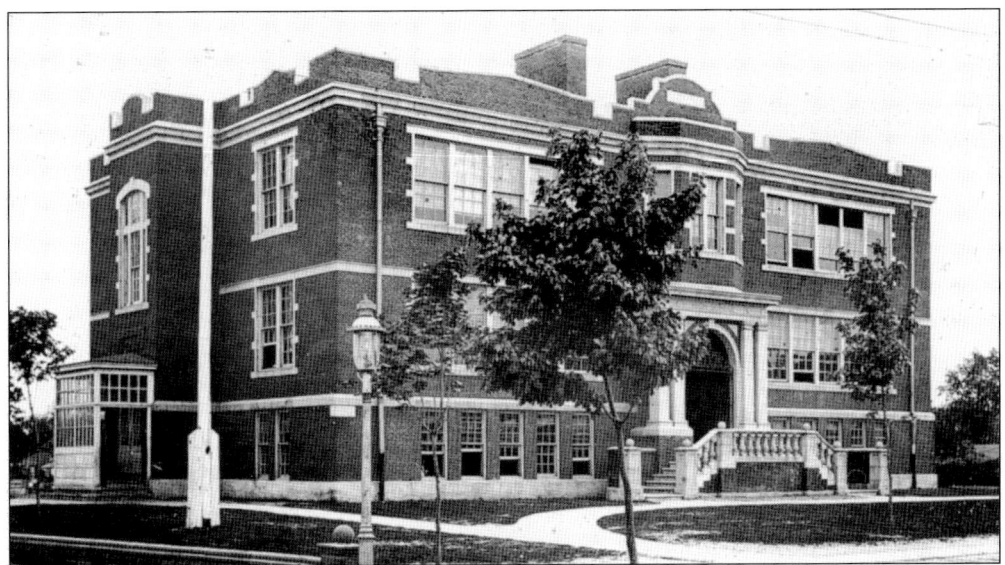

Glassboro's first high school was situated at High and Lake Streets. The property was purchased from the Whitney Glass Works for $2,199. Construction began in 1912 and was completed in 1913 by local builder Frank C. Ware for $28,500. The cornerstone was laid on November 30, 1912, with ceremonies conducted by the Masonic Lodge. The building was constructed of red brick and trimmed in white sandstone.

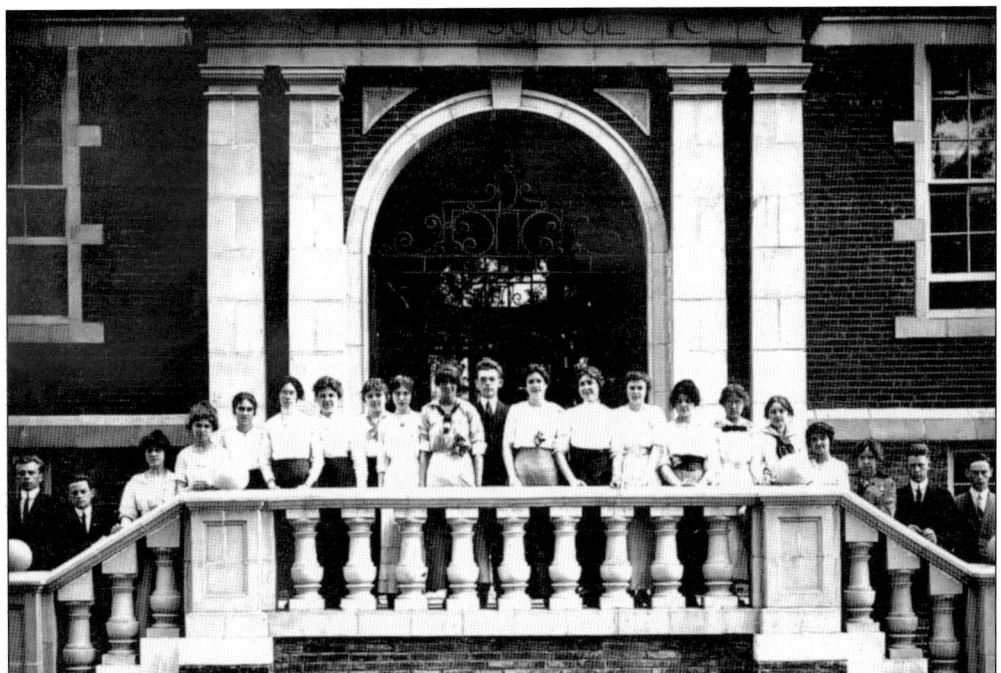

The class of 1914 poses in front of the former Glassboro High School. By 1929, student enrollment had outgrown the building, necessitating the construction of a much larger facility. The old school became the junior high school until 1946. It was then sold to St. Bridget's Church and used as a parochial school until 1971. The old building was demolished after a new parochial school was constructed.

The Glassboro Athletic Association basketball team won a 21-19 five-series championship game against Bridgeton to become the 1901 South Jersey champion. A newspaper article read, "Bridgeton was the victim and noses spurted bloody defiance." Team members are, from left to right, as follows: (first row) Clem Jones, Mike Bowe, and Al Scott; (second row) Jim McIntire, Bill Lickfield, William Long, Del Elkins, and Wayne Schantz.

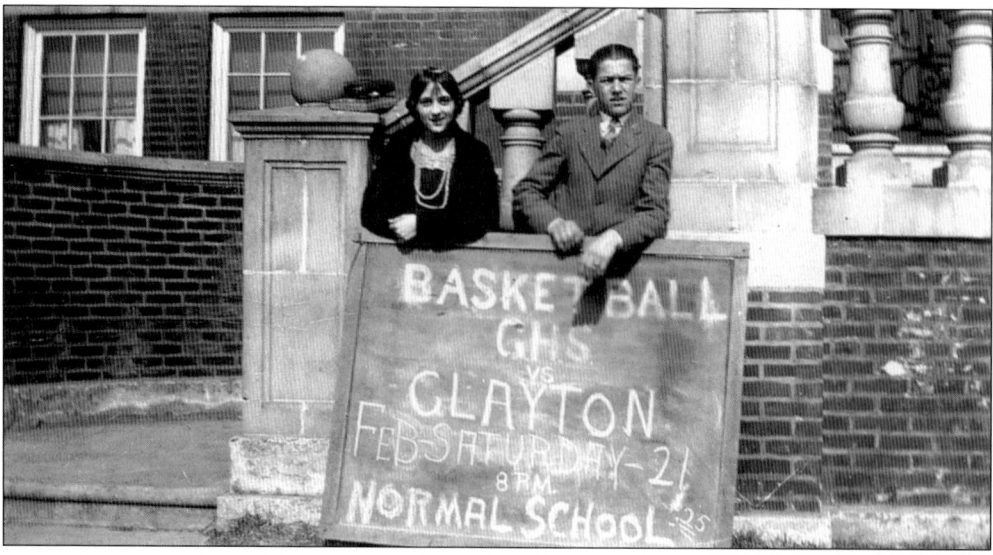

High school sweethearts Marian Pierce (Ware) and Frank C. Ware Jr. stand in front of the old Glassboro High School on High Street, promoting a Glassboro-versus-Clayton basketball game held on February 21, 1926 at the Glassboro State Normal School.

Overcrowding at the high school caused the board of education to place the problem before Glassboro voters. After six elections and a thin margin of 379 to 368, residents elected to build a new $400,000 high school on Delsea Drive. The three-story structure, completed in 1930, served as the Glassboro High School until 1965. Today, it is the Glassboro Intermediate School.

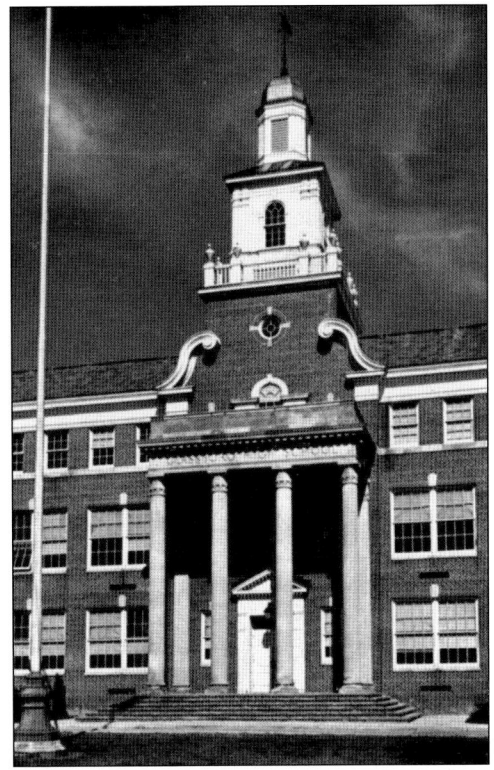

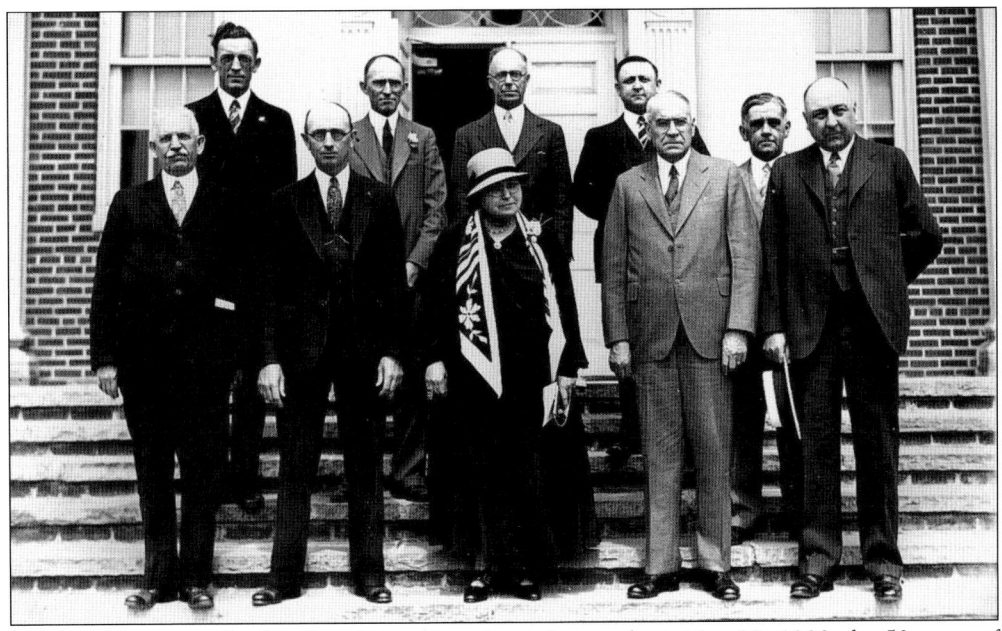

Teacher Marguerite L. Angelo (center front) was honored on May 29, 1932, for 50 years of service to the Glassboro public school system. Other participants in the testimonial program are, from left to right, as follows: (first row) Dr. E. Mortimer Duffield, J. Harvey Rodgers, Daniel T. Steelman, and Charles Keebler; (second row) Mayor William Downer Jr., J. Hartley Bowen, Walter Davis, Elmer Woods, and Charles Repp.

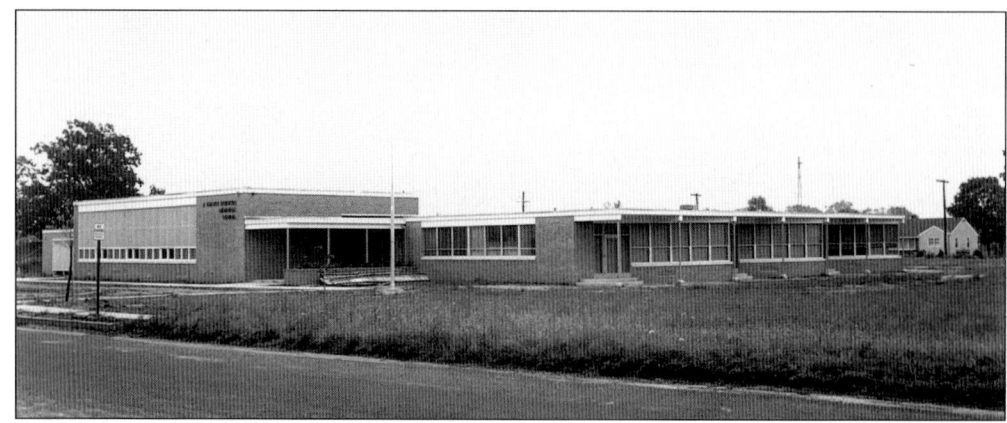

The J. Harvey Rodgers Memorial School was built in 1957 in the Chestnut Ridge section of town to accommodate the substantial growth in the community and to prevent children from crossing the railroad tracks to access the Academy Street School. It provided classroom space for kindergarten through sixth-grade. Teachers worked over the Christmas break to have the facilities ready to open in January 1958.

Glassboro police officers Dave Hurff (left) and Everett Watson teach bicycle safety to children at the J. Harvey Rodgers Memorial School, on Dickinson and Yale Roads, c. 1965.

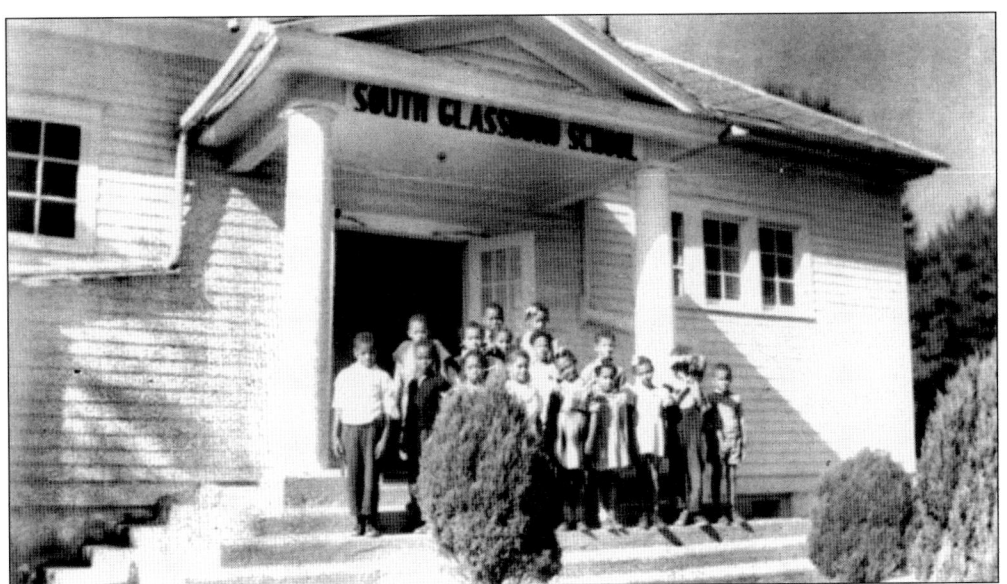

After the Academy Street School fire, African American children were segregated in their own neighborhoods. South Glassboro School was established in the early 1920s in the Lawns section, off South Academy Street and Washington Avenue. The September 1924 board of education minutes reported an enrollment of 97 students. For years, Dorothy (Latney) Bullock was the teaching principal here. This picture was taken in 1951. The school was closed in 1963.

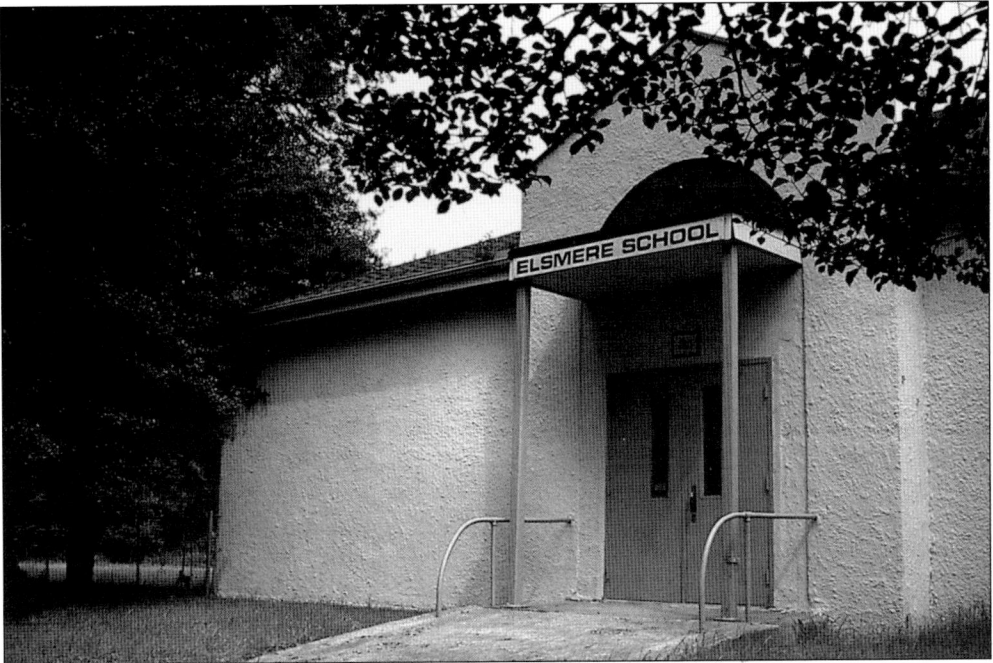

Elsmere School, located on West Ellis Street, was a segregated institution that had begun in the Emmanuel Baptist Church in 1924. The board of education hired teacher Bertha Turner for $100 per month. The board minutes "suggested . . . admitting to the new 80-acre school, only pupils eligible to attend the first 5 grades. This action will provide facilities for pupils of the higher grades to attend classes in the Lawns School." Elsmere School closed in 1963.

In 1958, the Glassboro Board of Education decided it could no longer be a regional school district and informed surrounding communities that growing enrollment prevented it from receiving their students. In October 1963, approval was granted to build a new $2.275 million high school on the Iszard Tract, located on Joseph L. Bowe Boulevard and Carpenter Street. Designed to accommodate the most effective teaching methods, the new high school opened in December 1965.

An agreement between the board of education and Glassboro State College states that the high school is to "be constructed . . . in close proximity to Glassboro State College, and that the laboratory high school be designed and operated to provide . . . the best practices in secondary education [and] can be demonstrated to Glassboro State College classes and students, and to personnel from schools in the region."

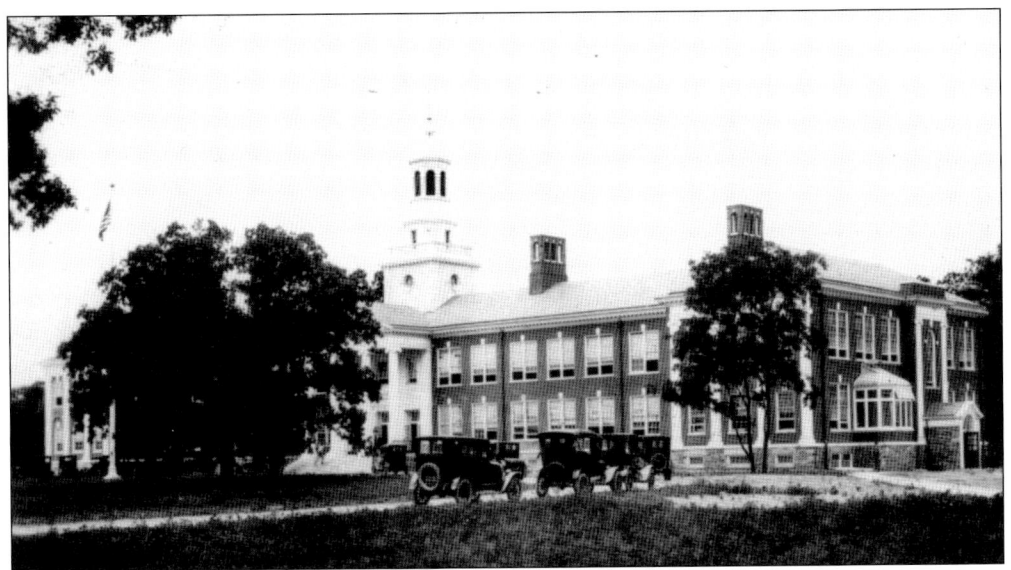

The Glassboro State Normal School officially began classes on September 4, 1923, with an enrollment of 236 students. Construction of College Hall, now known as Bunce Hall, started in February 1922. It had taken 10 years for local officials and residents to convince the state to locate a Normal School in Glassboro. This photograph of College Hall was taken prior to the school's official opening.

Chapel period is held in the auditorium of Bunce Hall in 1936. Similar to an assembly, this meeting was held every school day from 10:38 to 10:55 a.m. Dr. Jerohn J. Savitz, the Normal School's first president, led the students in a variety of chapel programs.

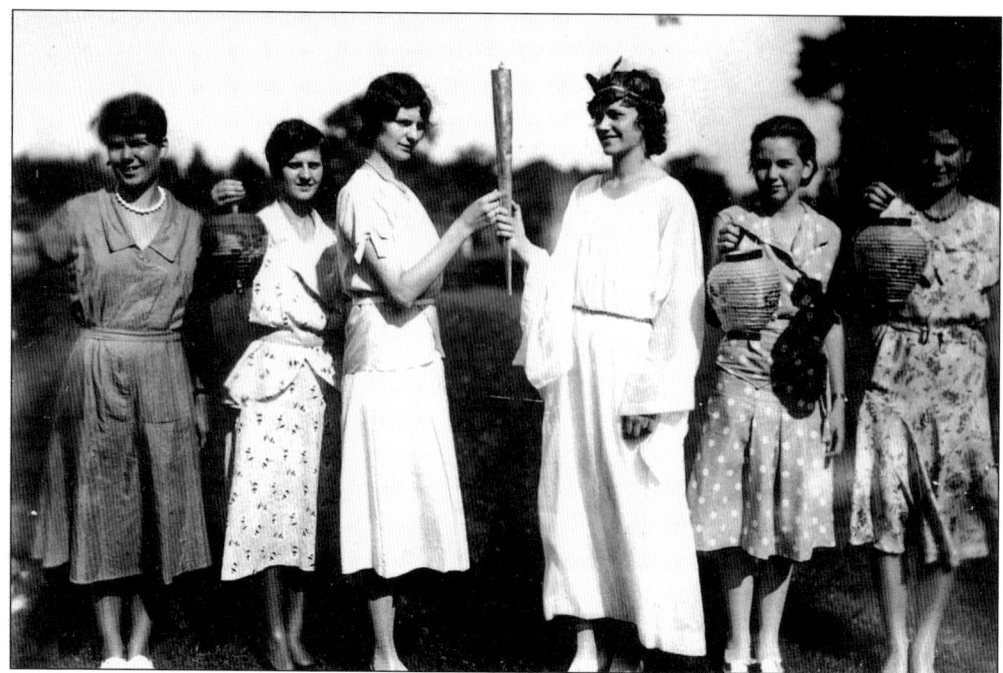

The first Lantern Night Processional took place in June 1931. This event became a tradition for the passing of the Torch of Knowledge. The president of the student council carried the lighted torch and passed it to the president of the senior class. The torch was then passed to the junior class president, whose responsibility was to "keep it ever burning brightly by continuing to uphold the ideas of the school."

Construction of Laurel and Oak Halls, the first dormitories on campus, began between 1927 and 1929. The need for student housing was great. It was reported that 125 students would wait two to five hours for transportation so they could depart either by bus or train for home. In 1923, several homes in town, as well as the Whitney Mansion, were rented as temporary housing.

Five
CHURCHES
THE MANY HOUSES OF WORSHIP

In the early half of the 19th century, religious organizations began meeting the needs of the ever-growing community. The many churches and meetinghouses reflected the diversity of Glassboro's inhabitants. The Gloucester County Bible Society saw this as an opportunity to place bibles in as many Glassboro homes as possible.

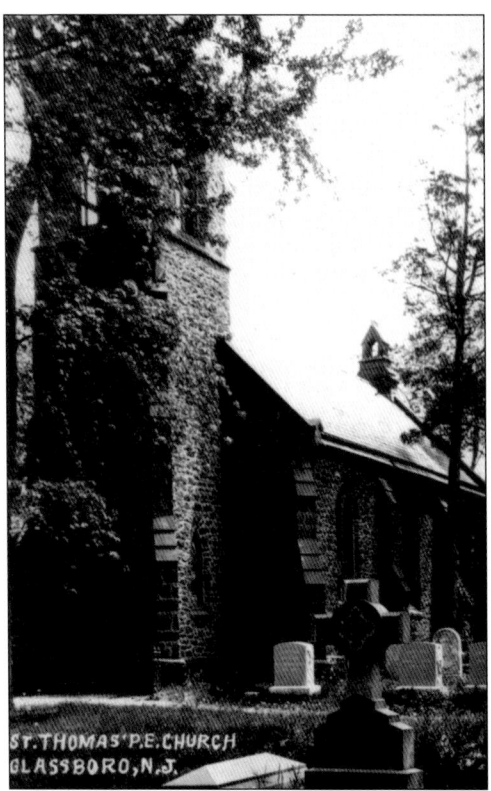

St. Thomas Episcopal Church, located at Main and Focer Streets, is Glassboro's oldest congregation. The first building was a log church constructed in 1791 on North Main Street. In 1864, Bathsheba Heston Whitney donated ground for the present building, constructed of native Jersey sandstone. The U.S. Department of the Interior recognized the historical and architectural importance of the structure and has listed it in the Library of Congress.

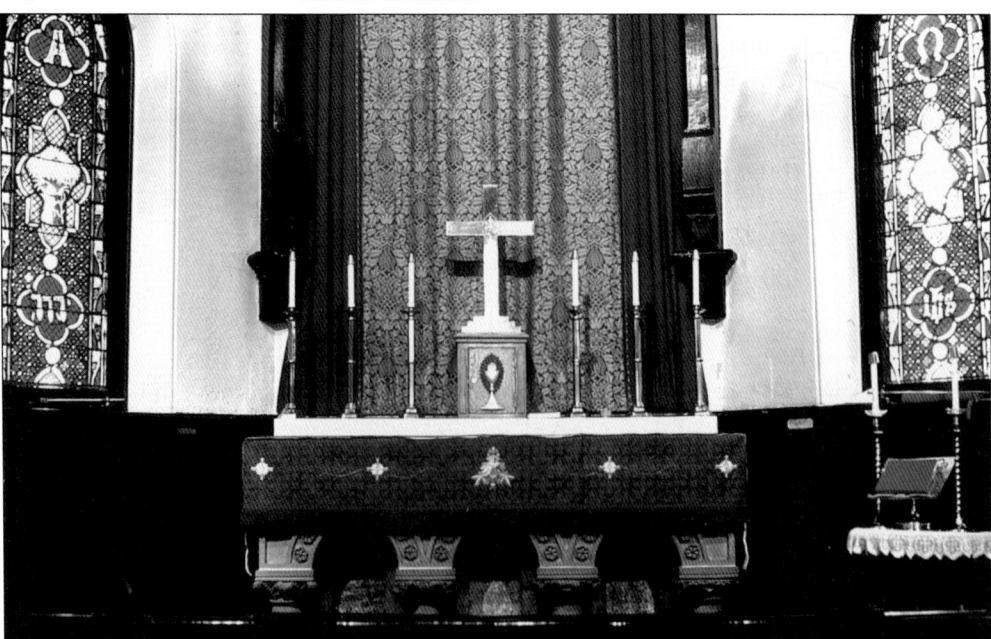

The interior of the church, shown here, has remained virtually unchanged since its construction. The altar was a gift from St. James Episcopal Church of Philadelphia. The handsome stained-glass windows were given in memory of Thomas H. Whitney, Abigail C. Whitney-Warrick, George W. Whitney, Bishop G. W. Doane, and John Campbell.

The Methodist Episcopal church was built in 1854 at Academy and New Streets. This picturesque view c. 1900 displays the building's pre–Civil War architecture. The church became known as "the Old Town Clock Church." The clock in the tower, a unique characteristic, was manufactured at the Custer Clock Works of Norristown, Pennsylvania.

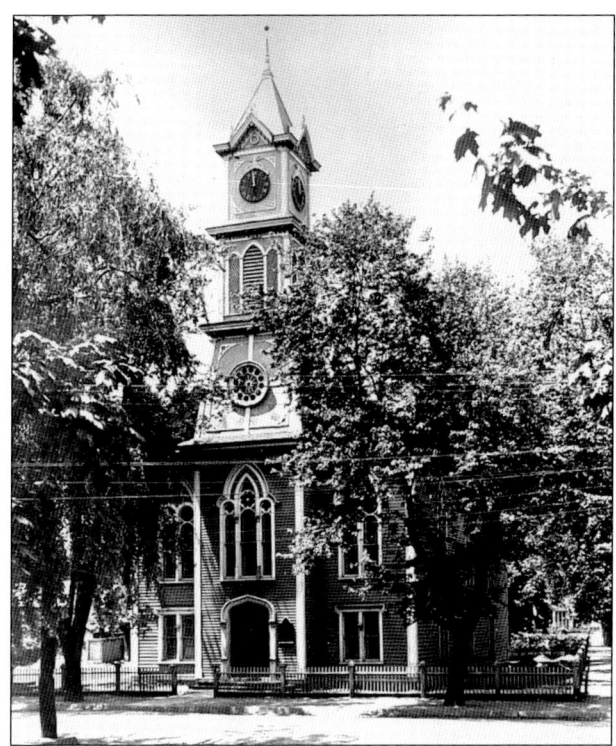

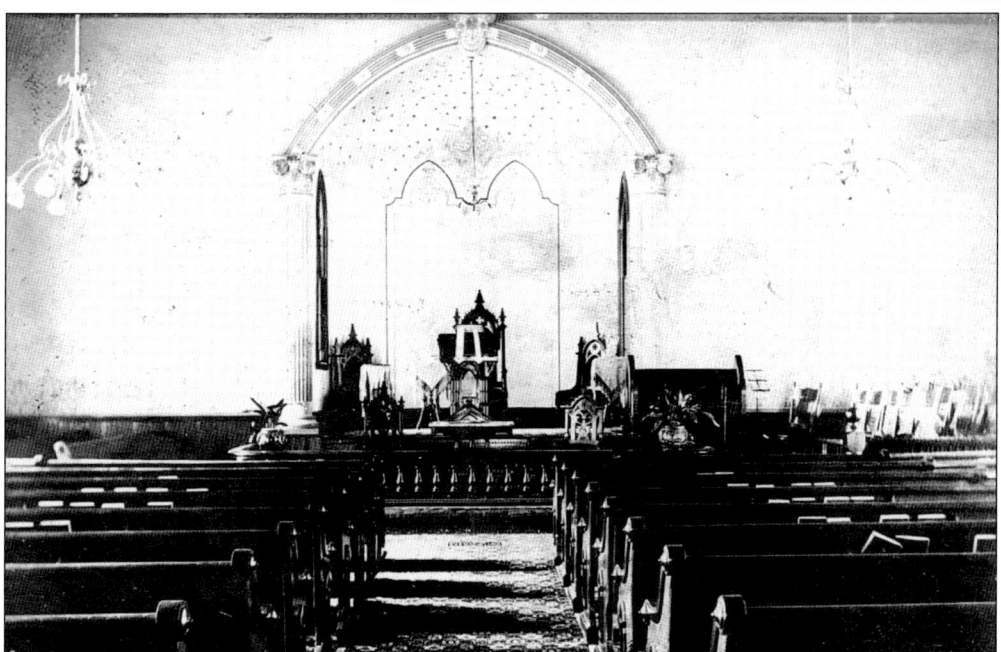

This rare interior view of the sanctuary of the Methodist Episcopal church was taken c. 1900. In the church's 121-year history, the sanctuary took on several appearances. One change occurred in 1905, when the Wanamaker family of Philadelphia donated an Estey pipe organ, which graced the front of the sanctuary until 1942. The final change occurred in 1976, when the church was demolished and a new building constructed.

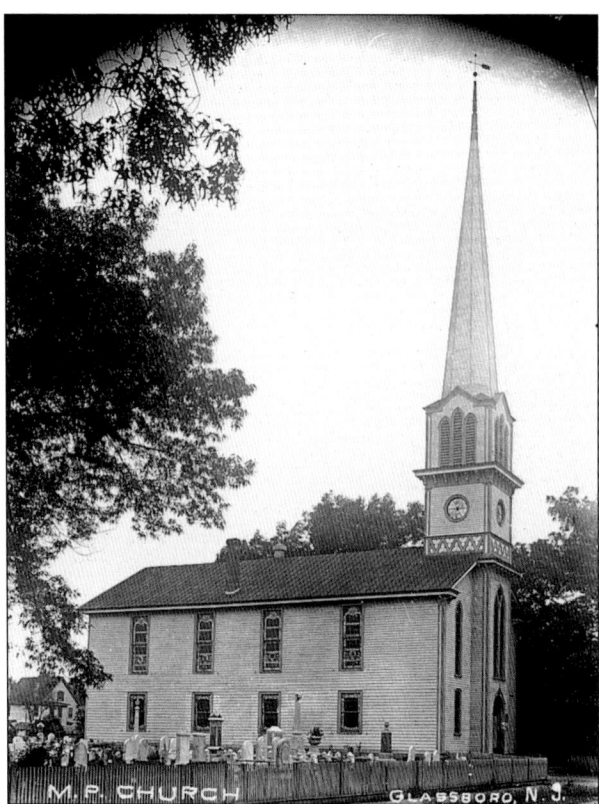

The Methodist Protestant Church is seen here in 1908. Known to many old-time Glassboro residents as "the Hill Church," it has been located on South Main Street since 1840. Over the years, extensive renovations have altered its appearance. In June 1923, lightning struck the tall spire, destroying it completely. The spire was then removed, and the bell tower was redesigned.

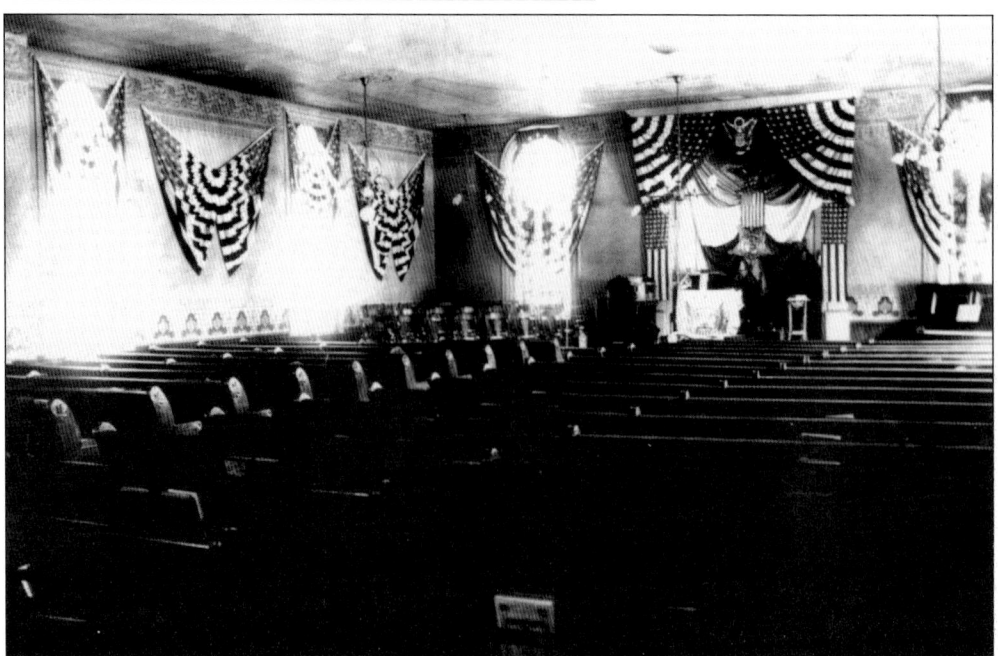

This c. 1920 interior view shows the sanctuary of the Methodist Protestant Church before the installation of the Estey pipe organ in 1923. The stained-glass windows, which bear the names of the early church founders, were installed in 1901.

The Bethlehem German Reformed Church, located on the point of Union and South Main Streets, appears here c. 1903 much the way it did when constructed in 1859. Many of the skilled glassblowers who worked at the local glasshouses were of German descent. Names of the church's early members bear this out: Dischert, Flohr, Meyers, Maester, Wetell, and Finger.

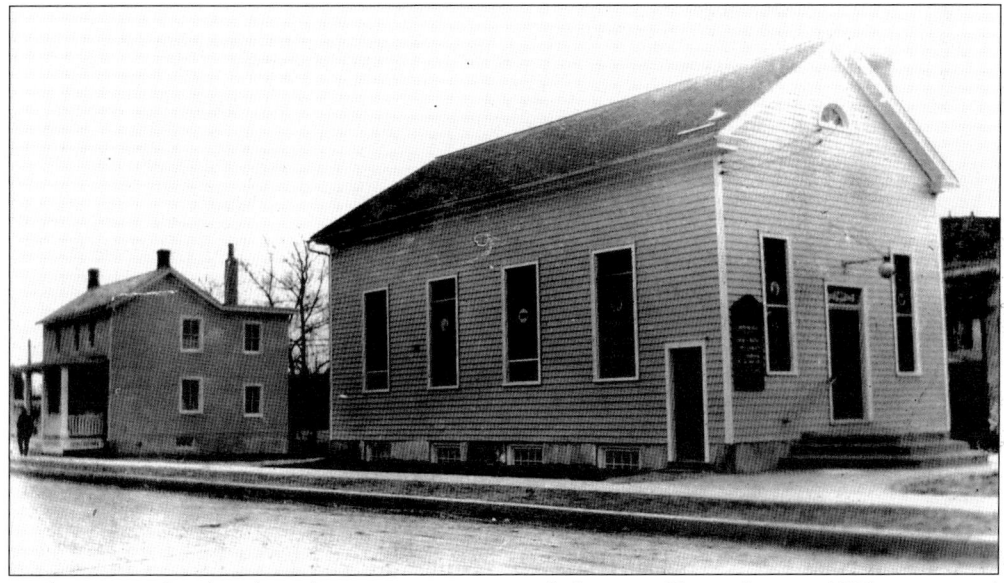

In the 1920s, the church underwent some structural changes. Shown here in 1925, it received a new coat of paint, a new roof, front concrete steps, and a basement excavation. The church parsonage (left) was sold in 1957 and moved to Oak Street.

The First Presbyterian Church, pictured here in 1906, was built in 1867. Originally located on Church Street, it was moved to Academy Street in 1883. The congregation had outgrown the building by 1912 and so moved to University Boulevard. In that year, St. Thomas Episcopal Church bought the old structure. The building, which still stands today, was purchased in 1939 to Frank Camiolo, who converted it into part of his dry-cleaning business.

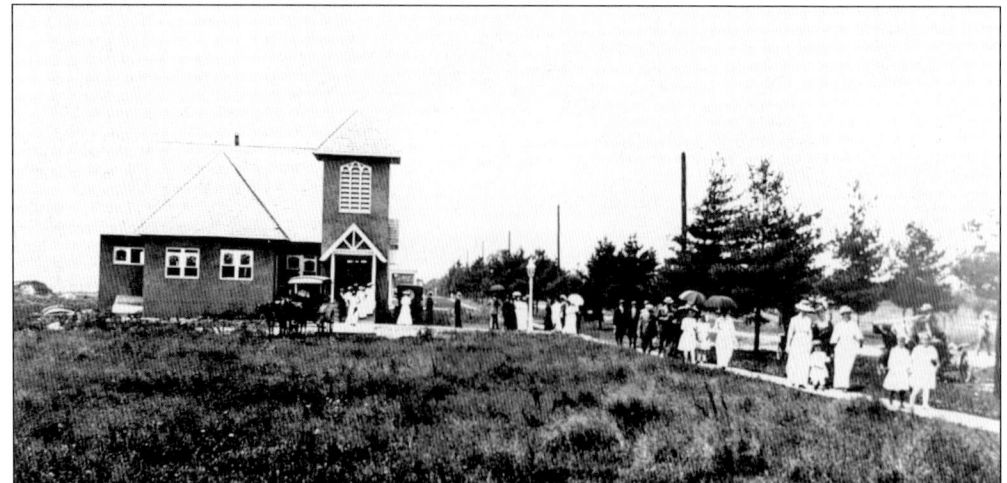

On the morning of August 25, 1912, members of the First Presbyterian Church attended the first service held in their newly constructed house of worship, located on University Boulevard in the Chestnut Ridge section of town.

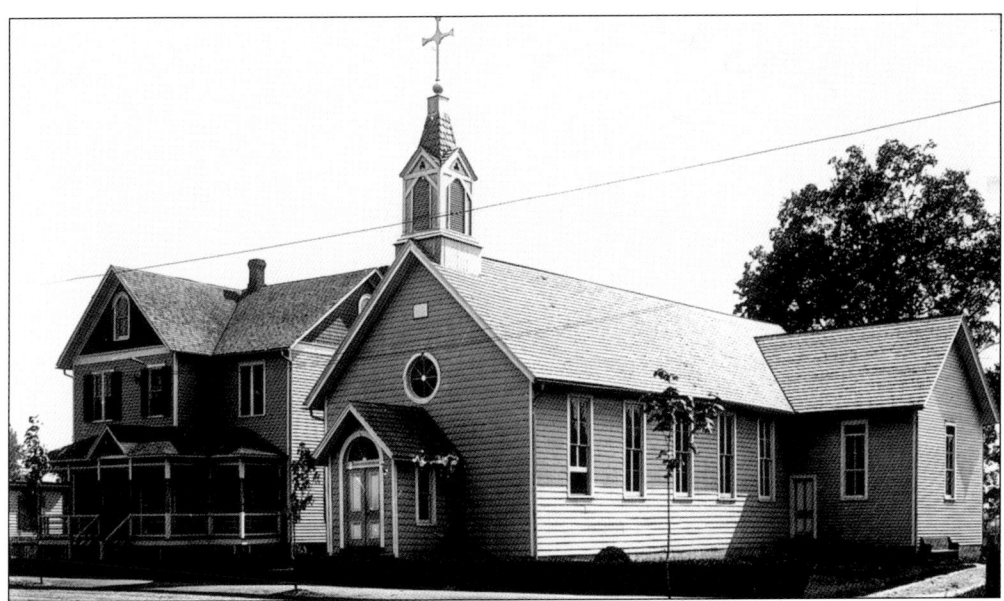

St. Bridget's Church and rectory, on Church Street, are seen here c. 1910. Initially, Gloucester City was the nearest Catholic parish. The distance and harsh traveling conditions caused church authorities to consider Glassboro as a site for a mission church. Thomas Whitney, who was not Catholic, donated a parcel of land on University Boulevard in 1868 as a church site. In 1882, however, the church was deemed to be too far from town and the structure was relocated to Church Street.

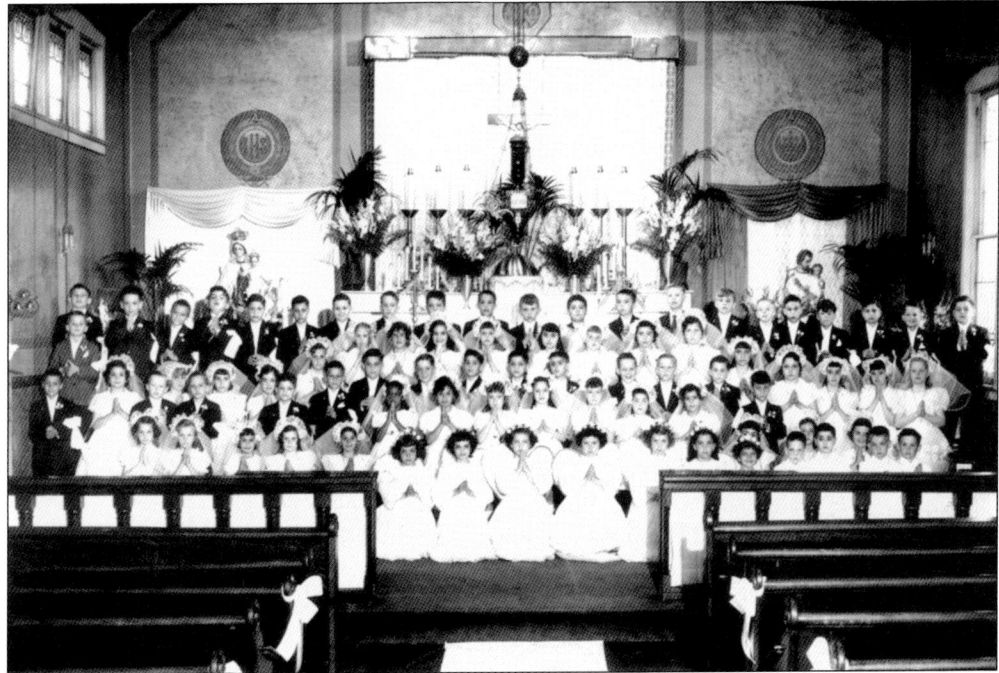

These second-graders have just received their First Holy Communion in the old sanctuary at St. Bridget's Church in May 1954. In 1963, a new $285,000 church was erected on the opposite side of the street, and by 1964, the 96-year-old wooden structure had been demolished.

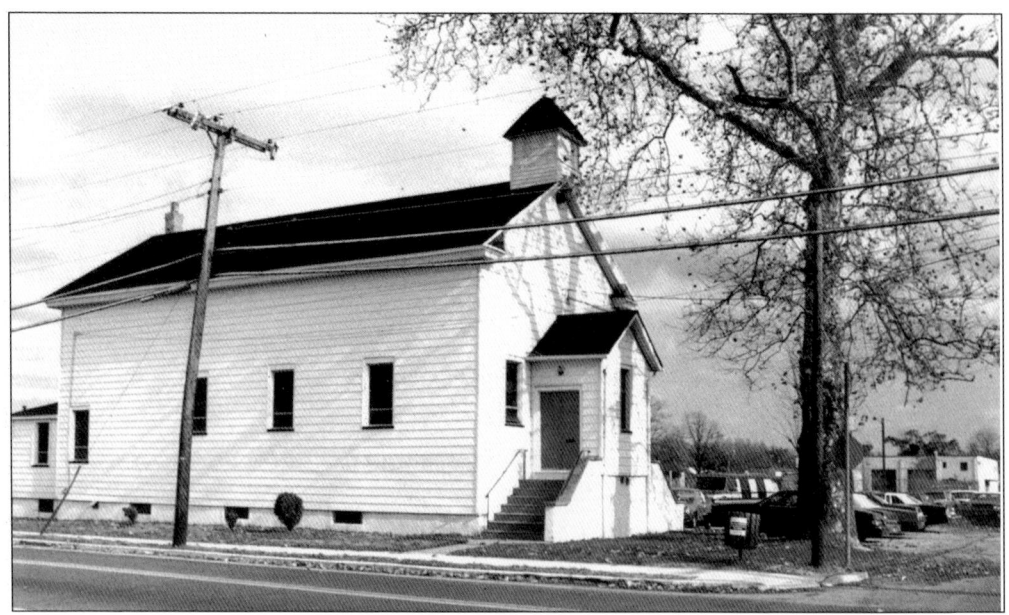

The First Baptist Church, at Grove and Academy Streets, was purchased from the Owens Glass Company for $1,500. The building had originally served the Whitney Glass Works. In 1917, under Rev. J. W. Williams's direction, the congregation moved to its present location. In the summer of 1946, fire broke out, destroying the basement. In 1997, the church was totally destroyed by arson. A new church was dedicated in February 2003.

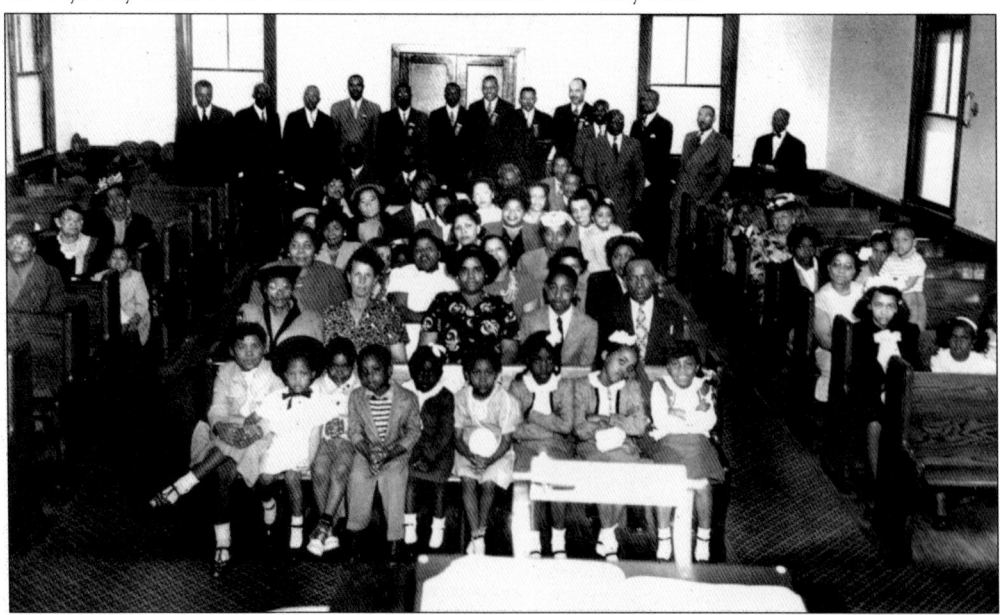

The interior of the First Baptist Church is pictured c. 1945. The congregation began meeting in 1913 in the home of Emily Slaughter. A council composed of white Baptists then organized the church in 1914. The council appointed Harry Latney, Victor Cole, and James Moore as its first trustees. In the 1930s, during the pastorate of Rev. James A. Russell, the church began to grow both spiritually and financially. Under his leadership, the church was completely renovated in 1943.

Mount Olive Baptist Church, located on North Lake Street, is seen c. 1965. In 1922, members met at the home of William Bright. They chose the name Second Baptist Church and appointed Rev. Henderson Adams pastor. In 1924, members constructed a church building, using money from many sources, including a donation from the mayor. In 1937, the church officially became Mount Olive Baptist Church. The present edifice was constructed in 1969.

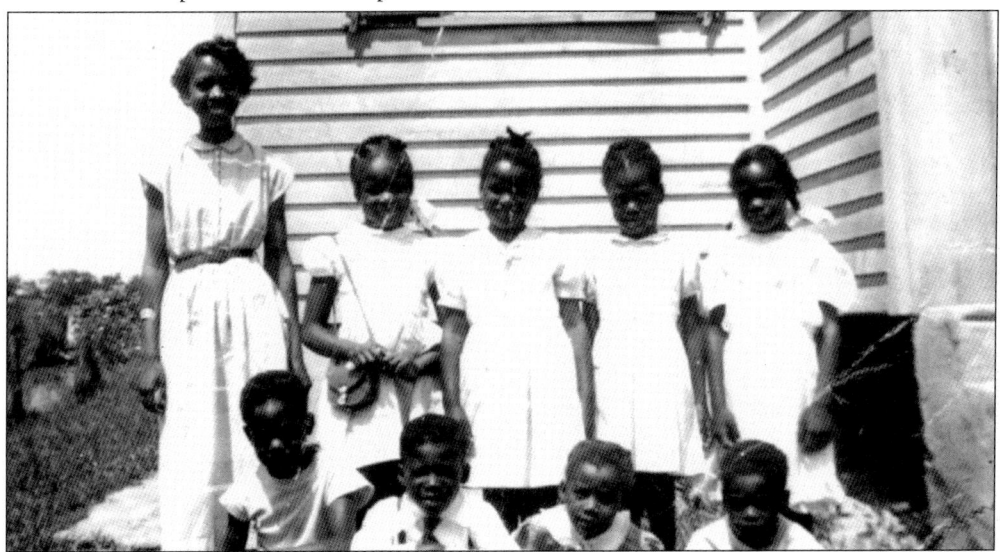

In 1948, during Rev. Clifton A. West's pastorate, members experienced a strong uplift in their church school programs. Here, the Sunday school class poses in front of Mount Olive Baptist Church in 1952. From left to right are the following: (first row) Earl Washington, Ronald Tucker (current pastor), ? Scott, and James Washington; (second row) teacher Betty Vincent, Christen Harris, ? Scott, ? Minatee, and Evelyn Washington.

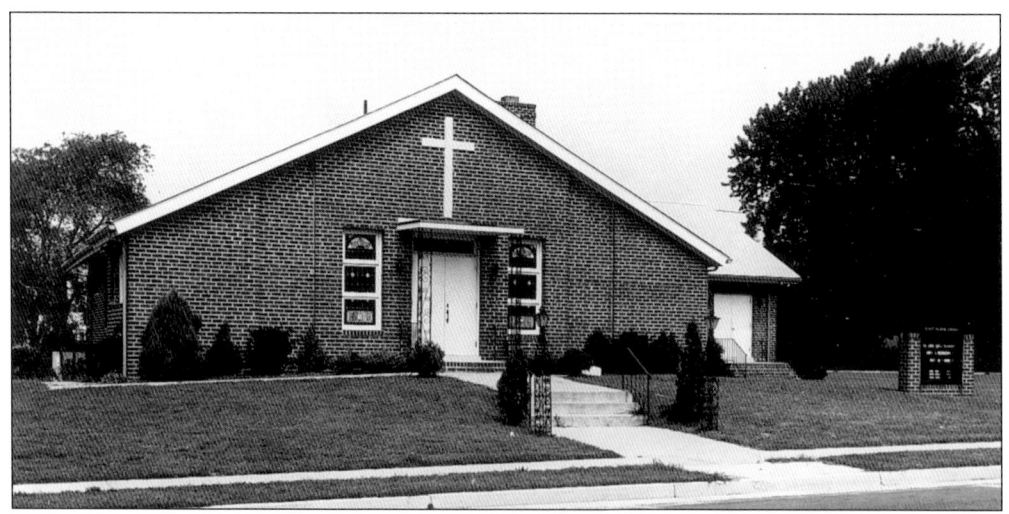

The Olivet Wesleyan Church, shown here in 1958, was originally known as the Olivet Pilgrim Church. Members began meeting in a home on Lake Street in 1902. Rev. William Jerrell was the first pastor for this newly formed congregation. Later, worship services were held in a church on South Main Street. In 1958, the present structure was built on the corner of Heston Road and Main Street.

Congregants at the Glassboro Holiness Camp pose after a gathering of spiritual enrichment and fellowship c. 1930. The camp, located at Main Street and Barger Boulevard, was affiliated with the Olivet Pilgrim Church. William W. Gallagher deeded the property to the trustees of the Holiness Camp Association on May 19, 1923. Camp meetings were held during summers from 1925 to 1978.

Six
CIVIC DUTY
GLASSBORO CITIZENS HEED THE CALL

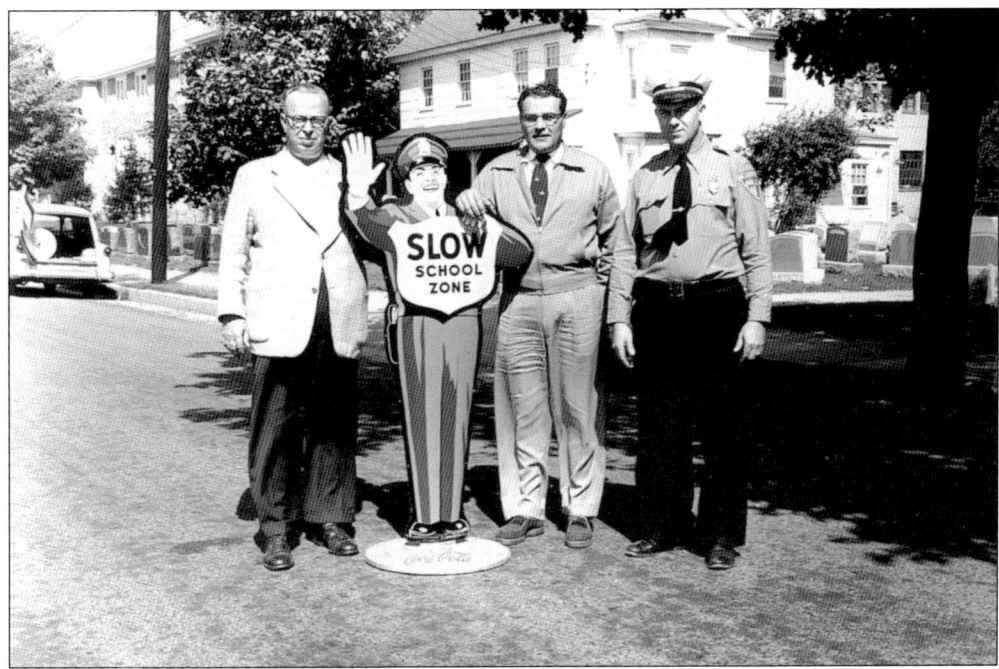

Officials promote school traffic safety on North Academy Street c. 1956. As the borough expanded, increasing traffic began to fill the roadways of Glassboro. Before the J. Harvey Rodgers School was constructed on the Ridge, students from that neighborhood had to cautiously cross the railroad tracks at University Boulevard and several busy streets to attend the Academy Street School. Identified in the picture are Mayor Frank Toughill (left) and Police Chief Everett Watson (right). Behind them are, from left to right, the Academy Street School, Harold C. Lingerfield's home, and A. A. Wiesner's monument business.

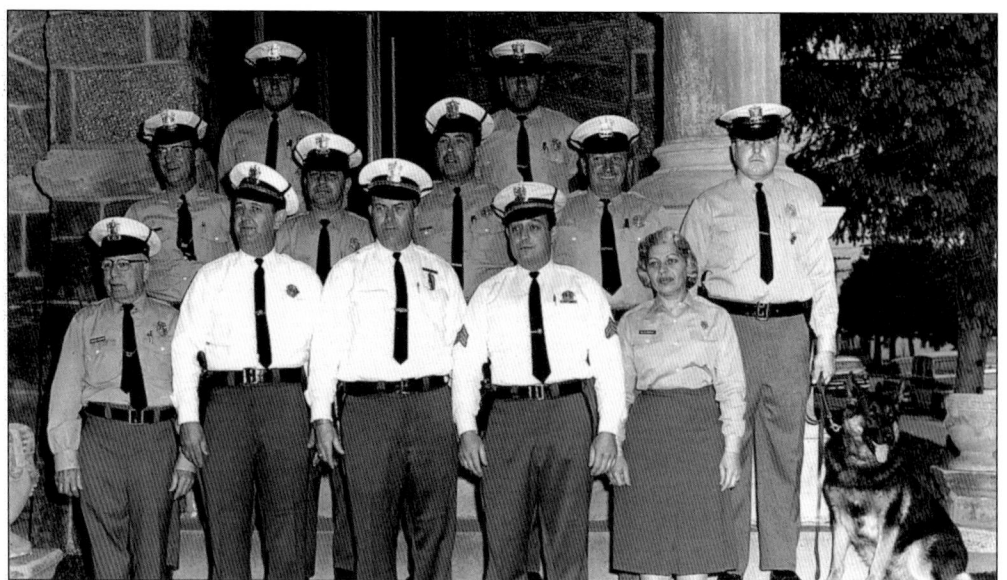

Glassboro Police Department members gather on the steps of the old borough hall, at High and Main Streets, c. 1964. From left to right are the following: (first row) Bill Spinlli, Pete Smerski, Chief Everett Watson, Phil Coppolino, and Bella Crumley; (second row) Bill Brennan, Joe Persalli, Robert Vanleer, William Menning, Robert Toughill, and Faro (K9); (third row) Myron Hurff and Anthony Esgro.

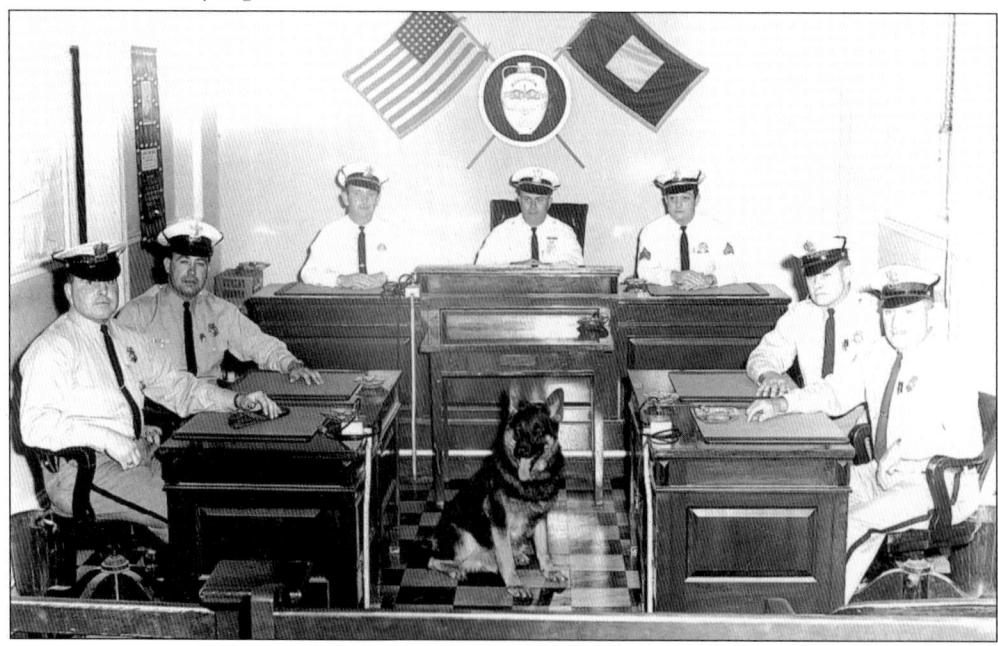

Glassboro police protection in the latter part of the 1800s was designated to a magistrate and two town constables. Organized in 1953, the Glassboro Police Department consisted of a chief, six patrolmen, and two desk clerks. Seated in the borough council chambers c. 1964 with Faro, the department's second K9 (serving from 1961 to 1970), are, from left to right, Robert Toughill, Robert Vanleer, Pete Smerski, Chief Everett Watson, Phil Coppolino, Myron Hurff, and William Menning.

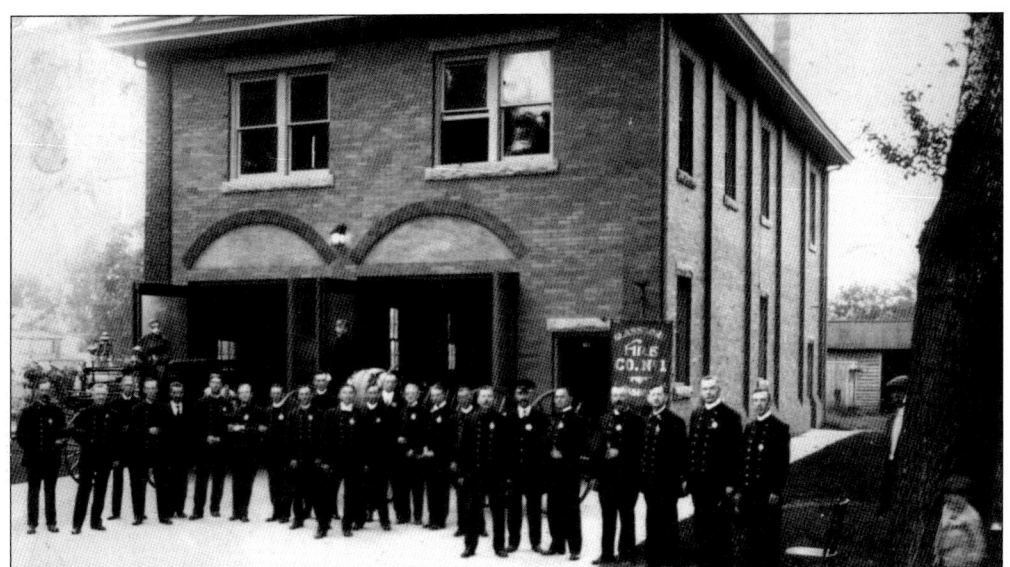

The Glassboro firehouse, located on West High Street, was constructed in 1910 by Frank C. Ware. This rare photograph depicts the dedication ceremonies on November 24, 1910. In 1981, a new firehouse was constructed at High and Academy Streets.

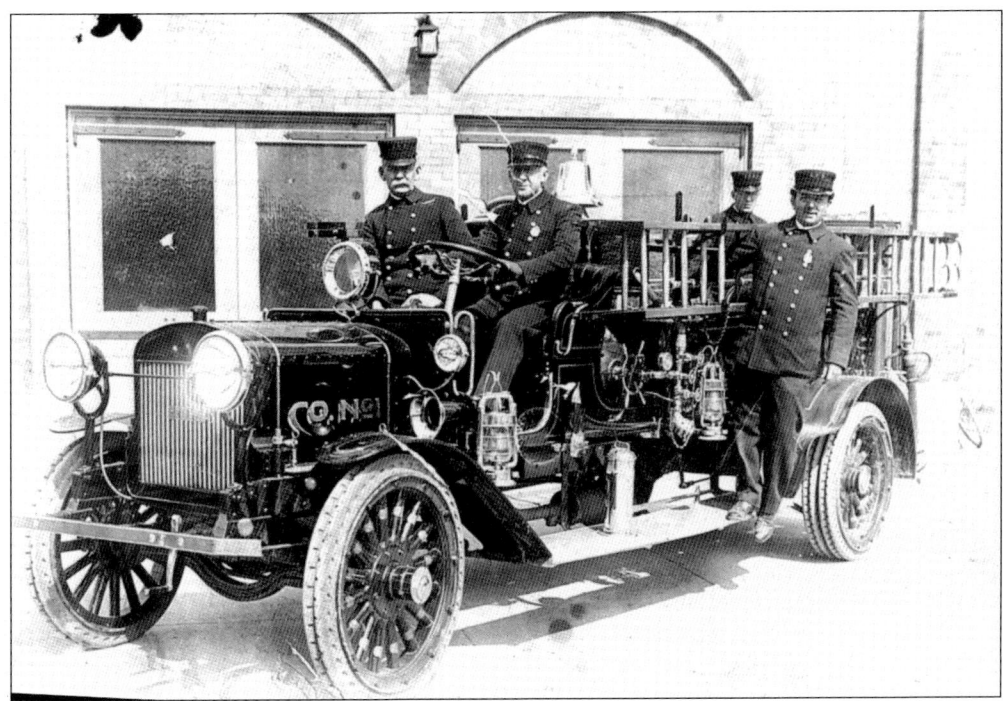

The department's first motorized truck was this Brockway, which entered service on March 20, 1915. Manufactured in Atlantic City by the R. G. Edwards Company, this combination chemical and hose truck sat on a Brockway chassis. From left to right are David Paulin, Frank Zane, Wilber McFadden, and Al Voelker.

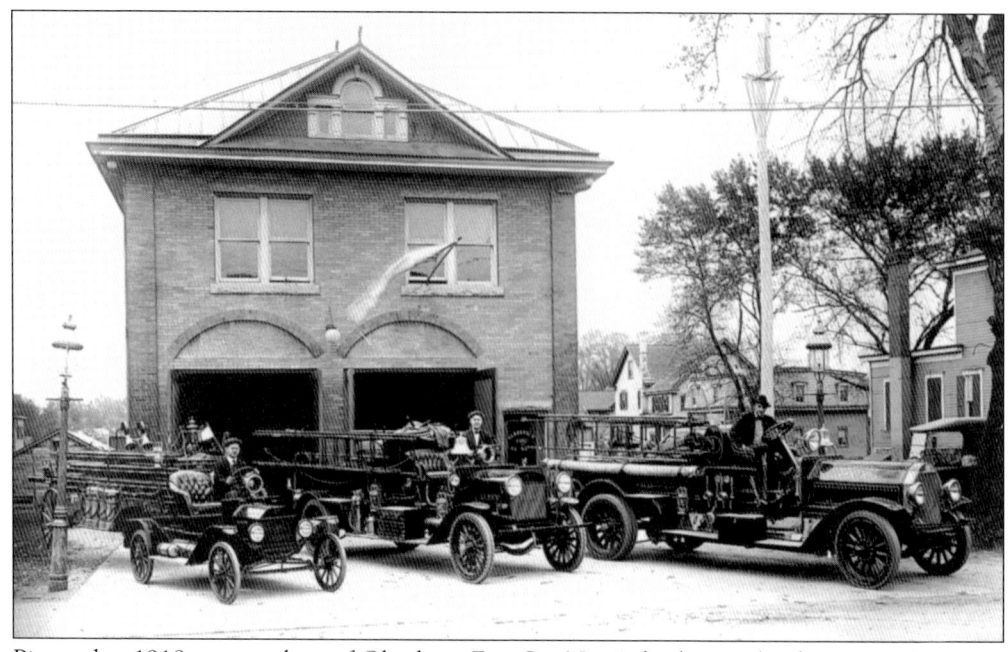

Pictured c. 1918 are members of Glassboro Fire Co. No. 1 displaying the department's newest equipment. From left to right are Andrew G. Stewart on the ladder wagon with the Model T Ford Roaster, B. Frank Zane (middle) is on the Brockway, and Al Johnson on the "Big Pumper," which could pump 750 gallons of water per minute.

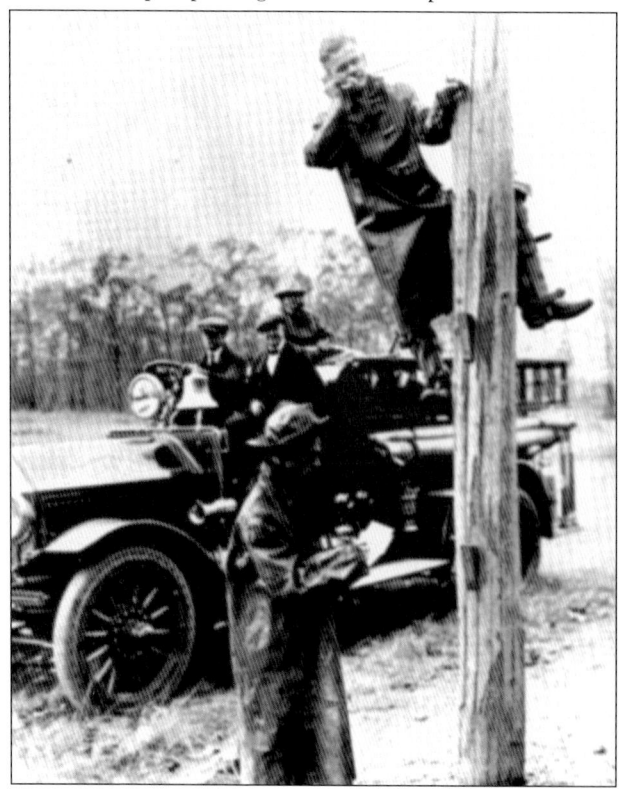

Early communication systems to announce fires were dependent upon bells, horns, and whistles. In 1920, Joseph T. Siebert (right) developed a portable road phone (pictured in his hand) that was added to the fire department's equipment. This form of dispatching enabled the department to communicate with the local operator, who relayed the fire's location. Below Siebert is Walt Dunham, recording the information.

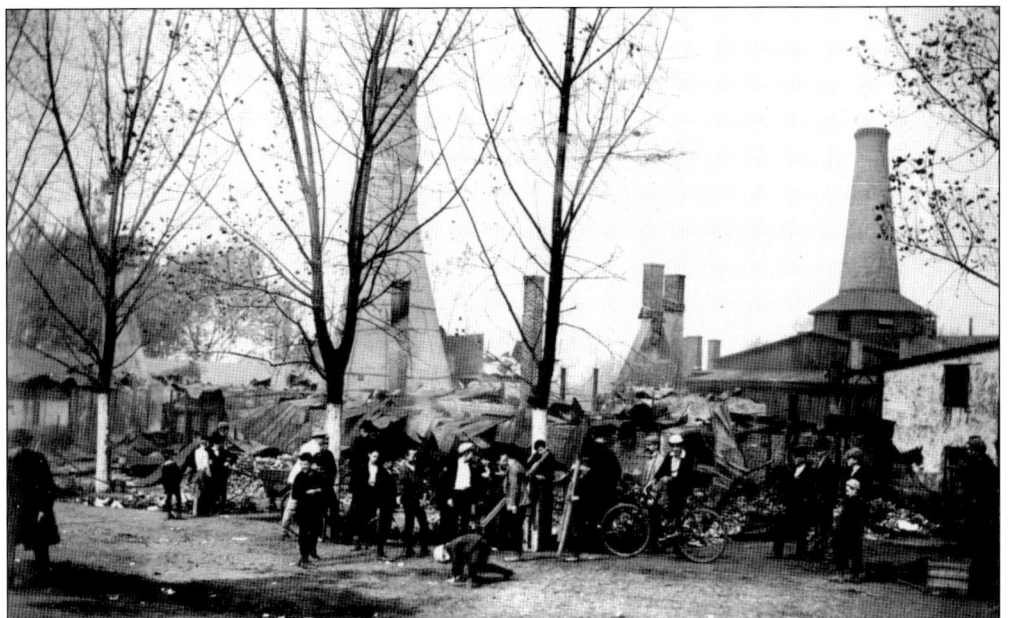

The Whitney Glass Works fire in October 1895 was one of the town's major disasters. In the early morning hours, fire broke out above the No. 1 furnace. Working at the time, 100 employees tried diligently to extinguish the blaze with a bucket brigade from a well located within the walls of the plant. Flying embers destroyed several homes and businesses. Only the bank and post office emerged unscathed.

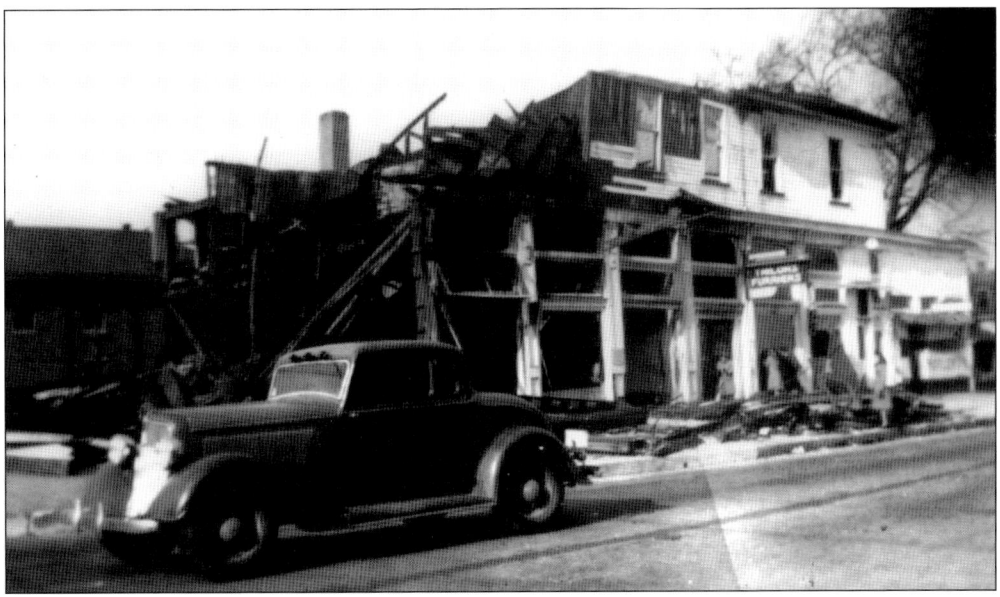

In its aftermath, the fire at the Junior Mechanics building, at High and Main Streets, attracts curiosity seekers. On the evening of December 31, 1944, flames broke out, destroying the building that housed eight stores, a sewing factory, offices, a dance hall, lodge rooms, and Wilbur Lutz's drugstore. Firefighters worked for hours to contain the blaze, which continued to burn into the late morning of the next day.

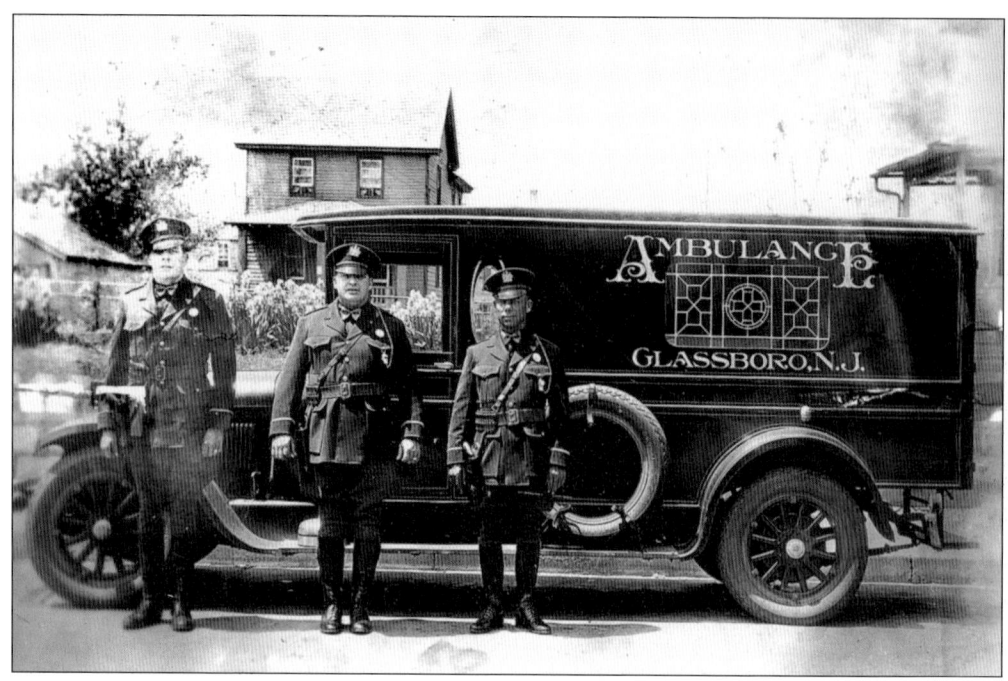

The borough's first ambulance was converted from an old dump trunk. Shown here c. 1925 are, from left to right, Wilbur Foulkes, Oscar Harper, and ? Smith.

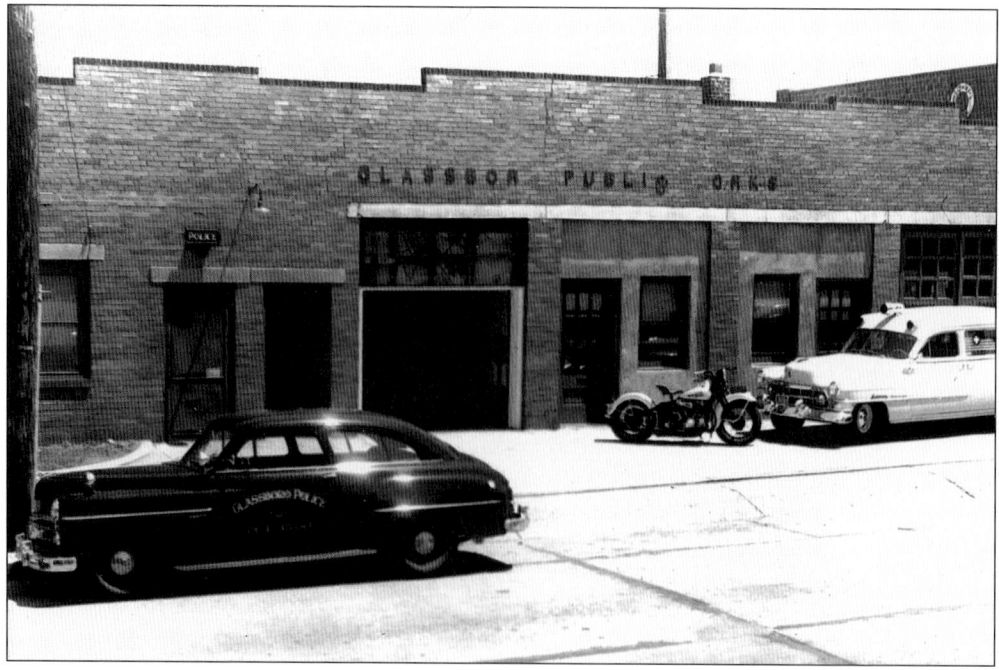

The Glassboro Public Works building, pictured here c. 1950, was located on South Main Street, directly behind the former First National Bank. The building housed the police station and ambulance hall. When the present municipal building was constructed in 1971, the police department moved into this facility. A vacant gas station on the corner of High and Academy Streets became the home for the ambulance squad.

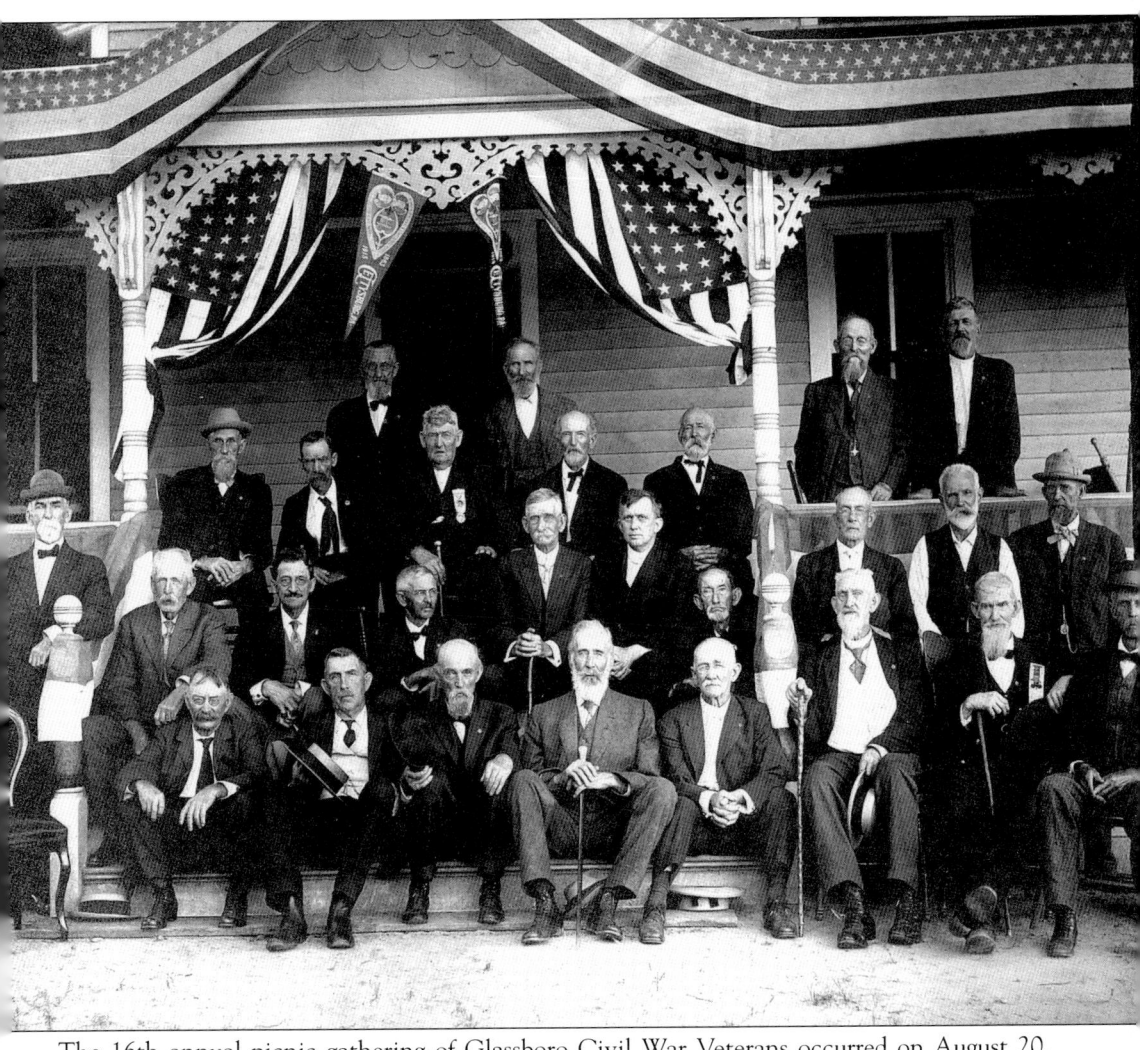

The 16th annual picnic gathering of Glassboro Civil War Veterans occurred on August 20, 1913, at the home of Samuel S. Ledden. Still standing today, the home is located at Buck Road and Stanger Avenue. The large porch on which the men have gathered has since been removed. Pictured are, from left to right, the following: (first row) Charles H. Doran, Martin Haines, Samuel Joslin, E. Sherwood, J. D. Heritage, M.D., William T. Cozens, William Randals, and ? Rodgers; (second row) Rev. L. D. Stultz, John Westcoat, H. Knox Stewart, M.D., Chris. L. Sharp, Joseph Simmermon, Rev. H. G. McCool, Jonathan C. Stiles, Robert Allen Pierson, Edward Hawkins, and Frank B. Ridgway; (third row) Joseph W. Moore, James Cassaday, William H. Chew, Samuel S. Ledden, and Frank Homan; (fourth row) Alfred Howes, John Atkinson, John Pimm, and James W. Hera.

In 1910, members of the Glassboro Chapter of the Grand Army of the Republic (GAR) gather on the steps of the Glassboro Auditorium, once located on North Academy Street. The GAR began on April 6, 1866, in Decatur, Illinois. In 1868, the group instituted the observance of Decoration Day, which is now the solemn observance known as Memorial Day.

The cornerstone is being laid for the Shaw-Paulin American Legion Hall on East High Street in 1922.

A memorial service was held in front of the borough hall in 1945 to honor the 18 young men from Glassboro who lost their lives during World War II. One of the first casualties was 1st Lt. G. Glendeon (Fritz) Ware, shot down in North Africa. Ware's parents, Mr. and Mrs. Frank C. Ware Sr., stand proudly in front of the honor roll that gave tribute to their son.

During World War II, a German prisoner-of-war camp was established in Glassboro's C. C. Woods, off South Delsea Drive. Nearly 500 prisoners were sent to the camp. Local residents recall seeing young Germans escorted to area farms to assist in the packing of produce. The Civilian Conservation Corps (CCC) camp appears in the upper left of this 1967 aerial view.

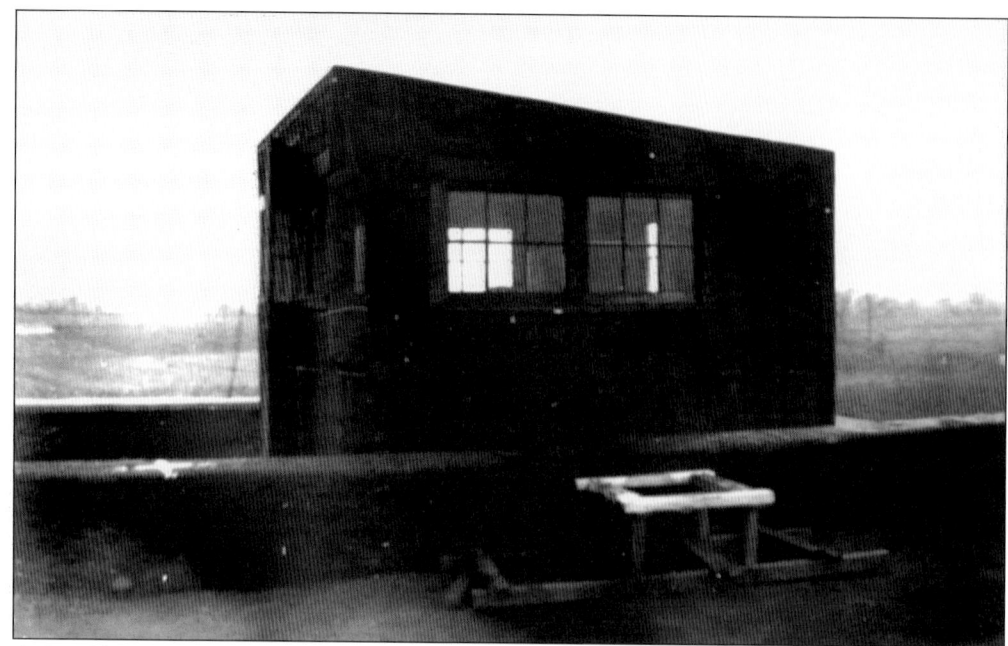

A World War II observation post was positioned atop the roof of the old Repp's Icehouse, located at Delsea Drive and Grove Street. Local volunteers kept night watch, searching the skies for any signs of enemy air strikes.

As Americans celebrated the end of World War II, the members of St. Anthony's Mutual Aid Society held a Welcome Home Dinner for their returning service boys on June 9, 1946.

Seven
Transportation
Venturing along the Roadways

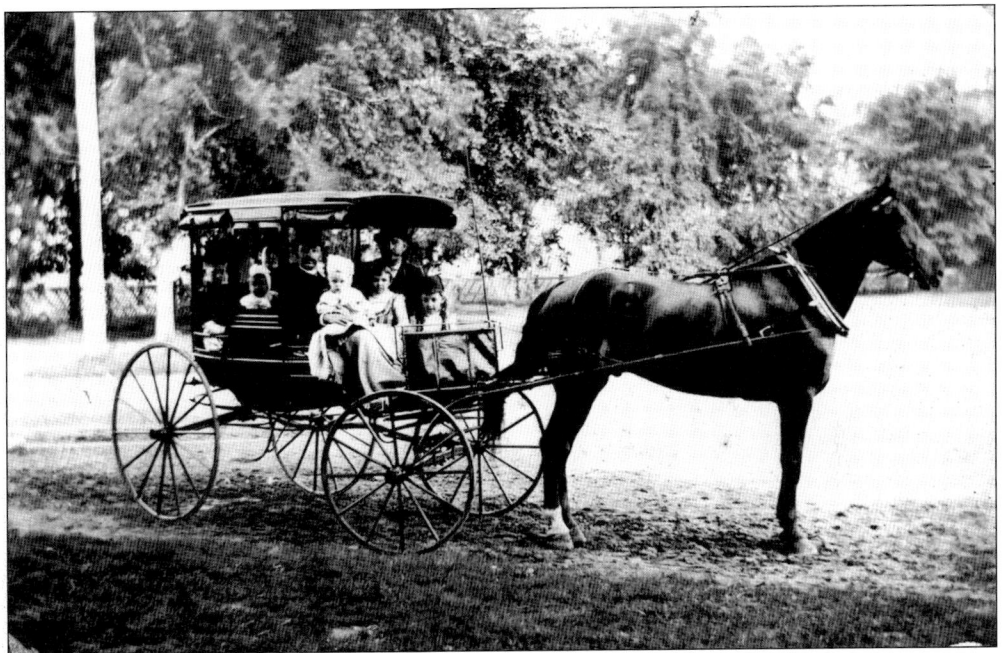

Between 1800 and 1860, Glassboro laid out most of its main thoroughfares, connecting residents with neighboring communities. Before 1860, the basic form of transportation was the horse and wagon. During inclement weather, many roads were impassable and rough. Communities used a turnpike system to maintain the roads; for example, a tollgate once stood on North Main Street, near the Holiness Camp, leading into Pitman. In this 1889 photograph, the Ledden and Higgins family prepares for a Sunday afternoon ride through the beautiful Gloucester County countryside. From left to right are the following: (first row) Joseph J. Ledden, holding his son Earl, and Walter Higgins, holding daughters Avalinda and Bessie; (second row) Mrs. Merriam Ledden, Edythe Higgins, and Etta Higgins.

Rail transportation arrived in October 1860. Construction began in Millville, led by Richard Wood, who created the Millville & Glassboro Railroad. Passengers arriving in Glassboro from Millville boarded stagecoaches to Woodbury, where the West Jersey Railroad took them on to Camden. This share certificate for the Millville & Glassboro Railroad Company, signed by company president Thomas H. Whitney, was purchased by John B. Garrett in July 1862.

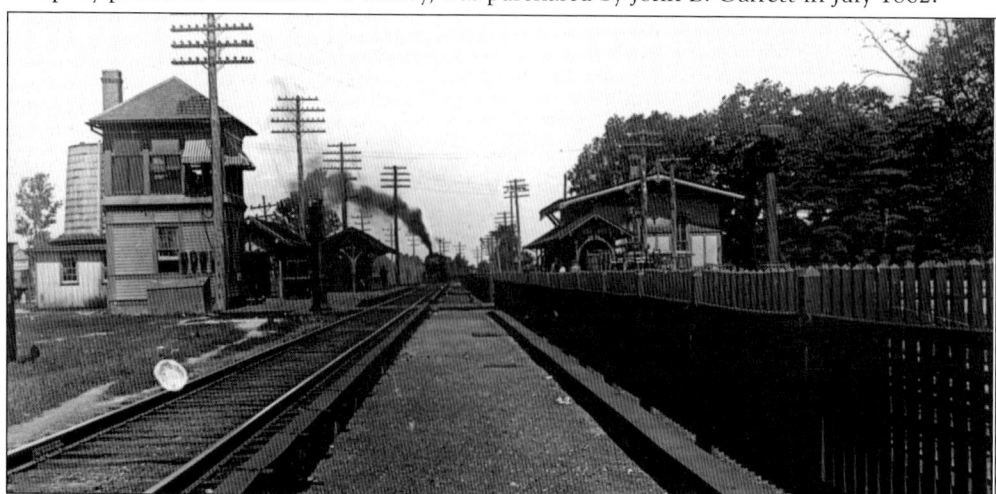

The West Jersey Railroad took over operation of the Millville & Glassboro Railroad in 1868. Changes were immediately made. One change was the relocation of the passenger station, seen here in 1908. In 1892, the West Jersey Railroad passenger station, which faced the west side of the Bridgeton branch, was moved across the tracks to the east side, facing the Millville Line, where the station stands today.

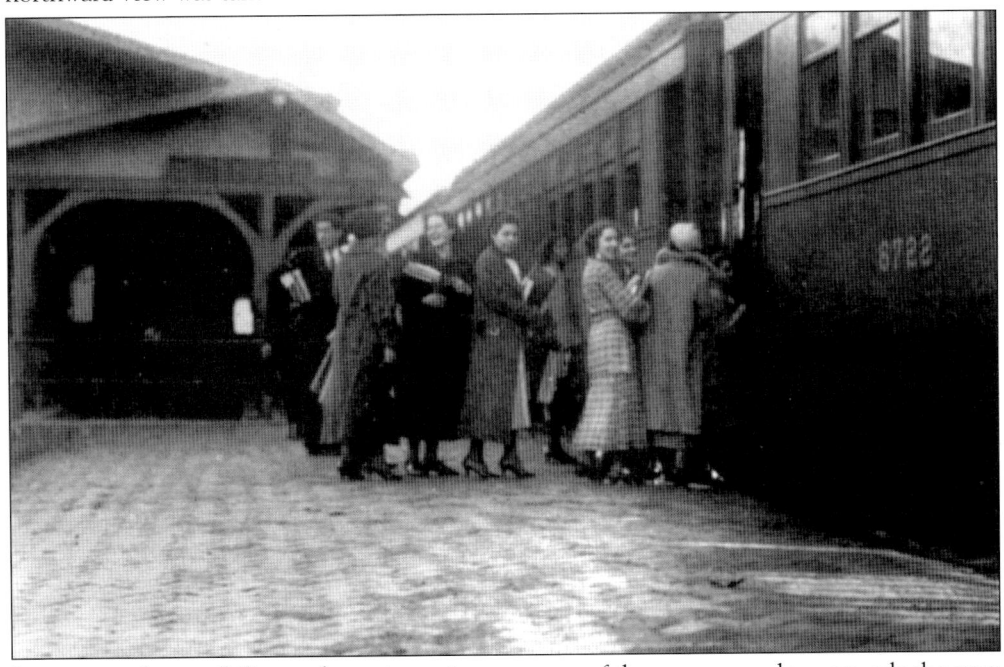

In 1906, a new two-story signal tower was erected on the west side of the Millville branch. This northward view was taken in 1908. Conrail demolished the tower in the mid-1980s.

Location and accessibility to the train station were two of the reasons used to persuade the state to construct a Normal School in Glassboro. Railroad officials even went so far as to add more trains and adjust timetables to coincide with class times. In this 1936 photograph, students from the Glassboro State Normal School board a train at the close of the school day.

Passenger service was not the only form of rail traffic that passed though the Glassboro station. Freight trains arrived in heavy volume, loaded with mail and consumer goods. A freight dock was located on the south portion of the passenger station. Pictured c. 1917, a handler pulls a newly arrived cart of freight. A small newsstand is located directly behind him.

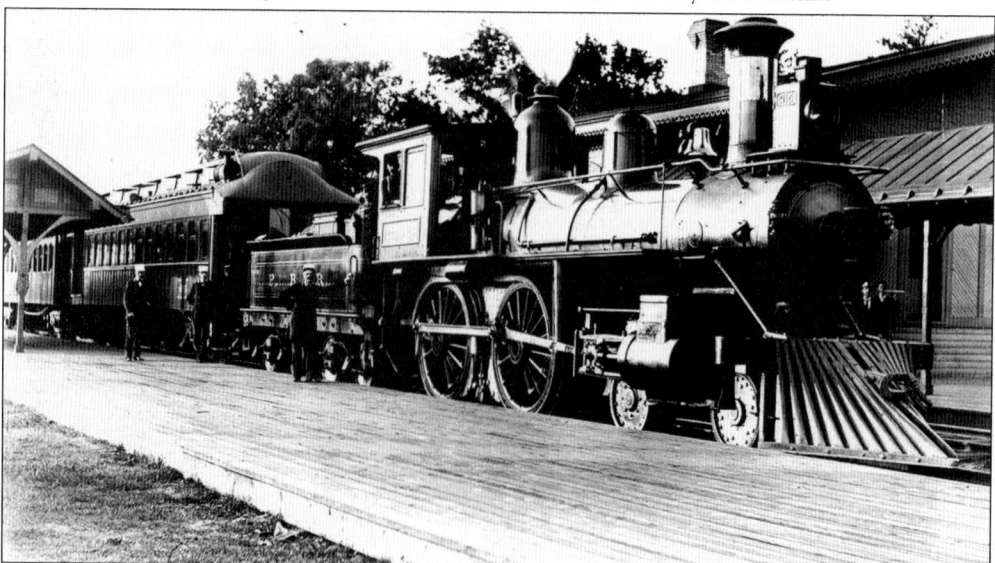

Locomotives like this one rolled through Glassboro on a daily basis. No. 204 American 4-4-0, shown at the Glassboro depot c. 1915, was built in 1884 by the Pennsylvania & Reading Railroad at its Altoona shop. Passengers could board a train in the early morning and arrive in Cape May by noon, or be in Camden in less than an hour. Passenger service through Glassboro was discontinued in February 1971.

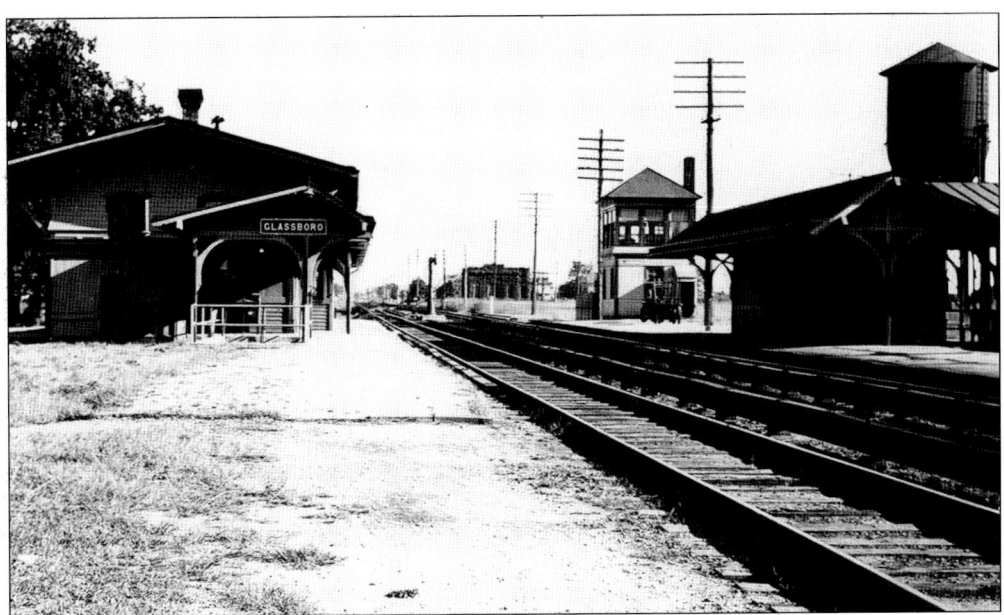

In 1906, most of the Seashore Line was electrified. A substation, built in Glassboro to generate power, can be seen to the right of the station. By the 1920s, close to 100 trains were passing through Glassboro daily. To ensure passenger safety, a tunnel was constructed under the tracks connecting both platforms in 1913. The entrance can be seen directly under the Glassboro sign in this 1941 photograph.

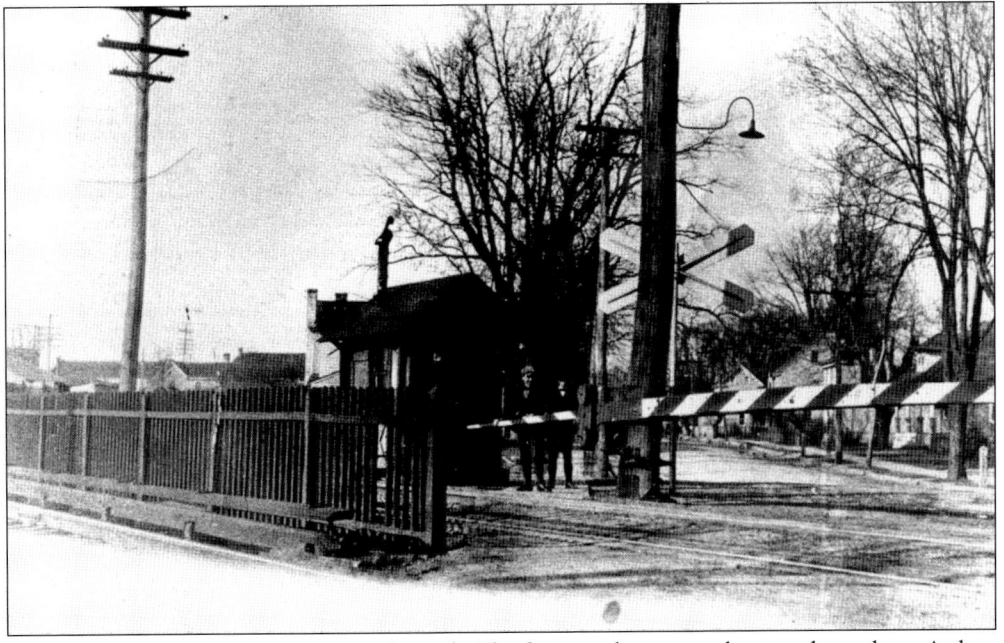

Due to the number of trains passing through Glassboro, rail crossings became hazardous. As late as 1923, residents were still being killed or injured by oncoming trains. The borough council forced railroad officials to install warning bells, red signal lights, and flagmen at dangerous intersections. A gatehouse operated this intersection on South Main Street near Sewell Street. Standing at the gate are Ignazio DeFrancesco (left) and Dominic Porreca c. 1925.

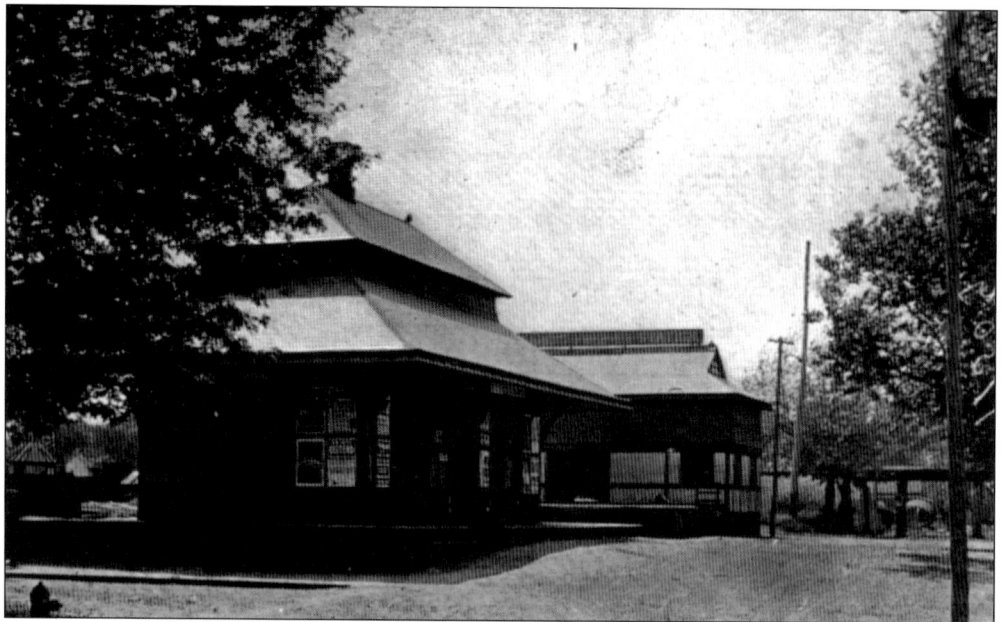

The Reading Railroad passenger station, built in 1885, was located at High and Academy Streets, a vacant lot today. The station actually stood alongside a spur that led into the Whitney Glass Works. Pictured here c. 1908 are the passenger station, with the freight station off to the side, and the trestle crossing High Street into the glassworks.

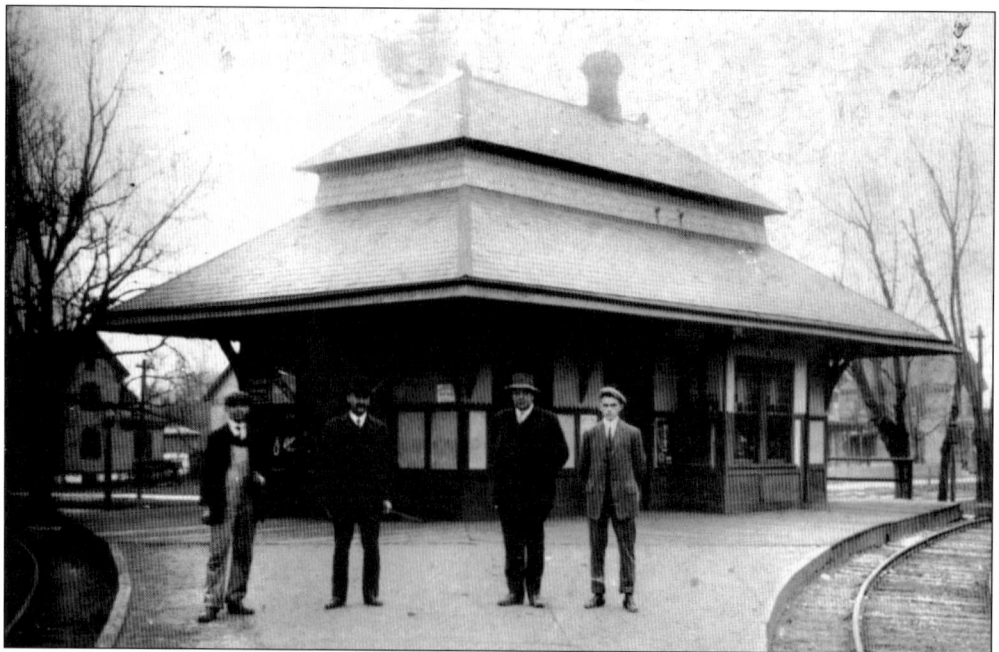

In 1908, the station was used as a terminal for students from Monroe and Harrison Townships who attended Glassboro High School. In 1913, the station was moved to the main Reading Line on South Main Street, where it stood until 1933. Pictured c. 1913 are, from left to right, Arthur Johnson, Frederick Winterburg (station agent), Lauren Weatherby (railroad agent from Mullica Hill), and Raymond Ewen (railroad clerk).

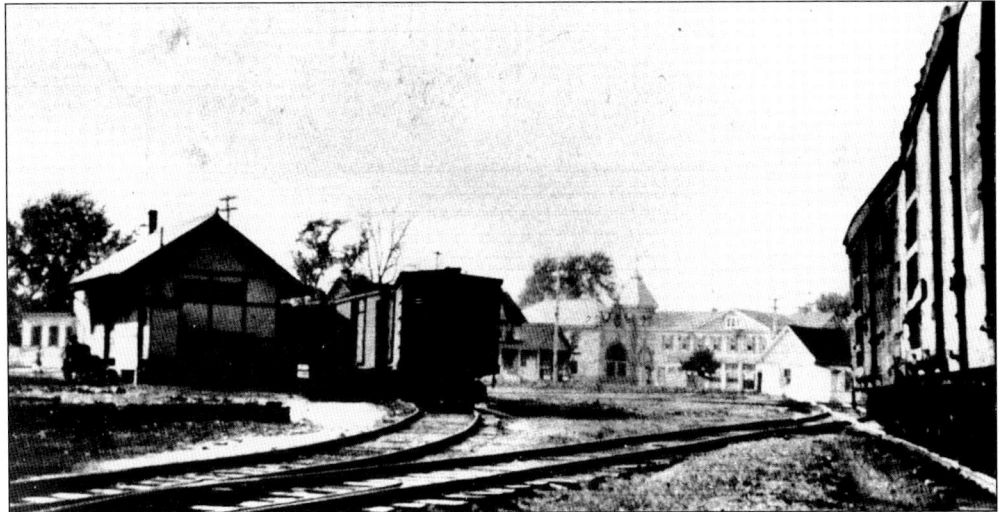

The Whitney Glass Works and the Warrick-Stanger Glass Works both had spurs leading into their plants from the Reading Railroad. The train shown here c. 1900, loaded with glass products from the Whitney Glass Works, was on its way to Williamstown Junction to connect with the Atlantic City Line and then take the freight into Camden.

The Williamstown-Glassboro Line became so resourceful in transporting industrial and farm freight that railroad officials rushed to complete a freight station in the area of Main and High Streets, where the present MSAA (Hodson) Manor is located. In 1885 alone, nearly 29,000 tons of freight were transported along the line. This photograph was taken c. 1900.

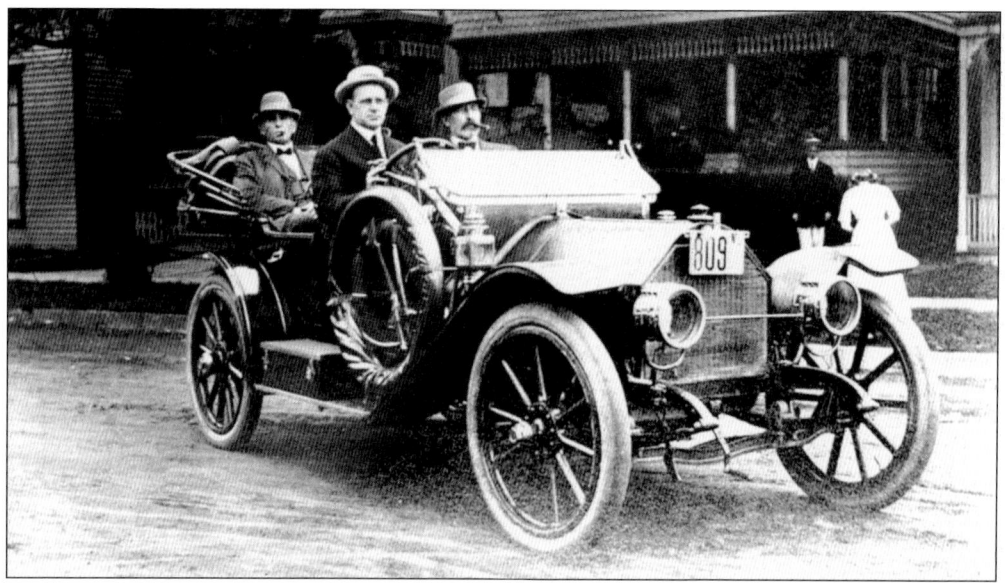

Between 1901 and 1905, six Glassboro residents began appearing in the new horseless carriages. Edward L. Sturgess was the first to be seen riding down the center of town in his Duryea automobile. Seen here in 1901 are, from left to right, Robert Meade, Glassboro's first mayor; Edward L. Sturgess, driver, who would later become a state senator; and Elbert Leap, one of Glassboro's postmasters.

Dr. Charles S. Heritage drives along Broad Street (Delsea Drive) in 1904. Heritage was the second resident in town to own an automobile. He followed Edward Sturgess's lead and purchased a Duryea in 1903.

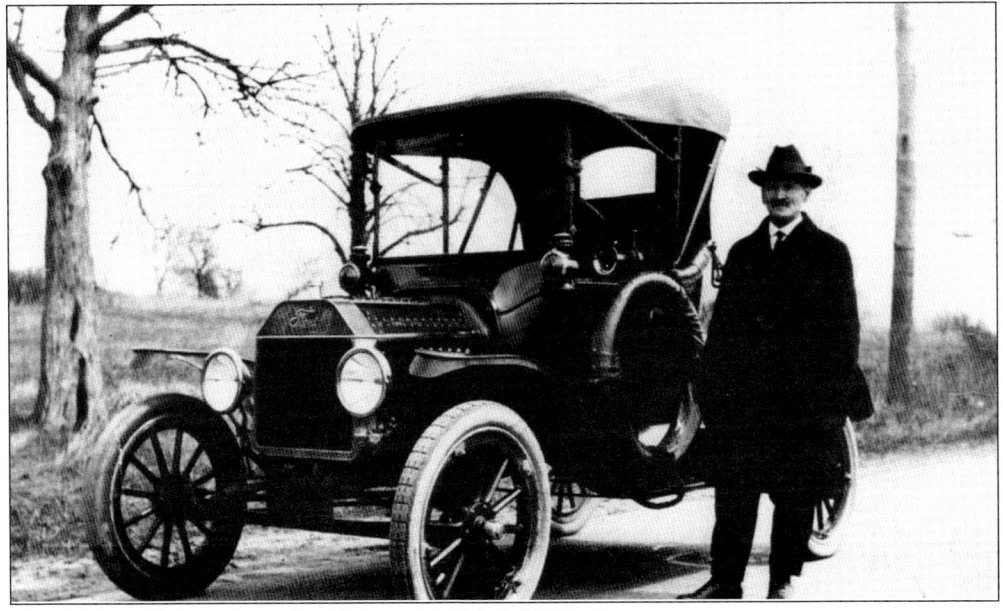

Edward H. Walton Sr. purchased his Model T Ford from George Higgins in March 1915.

Joseph J. Ledden is pictured with his 1916 Model T Ford.

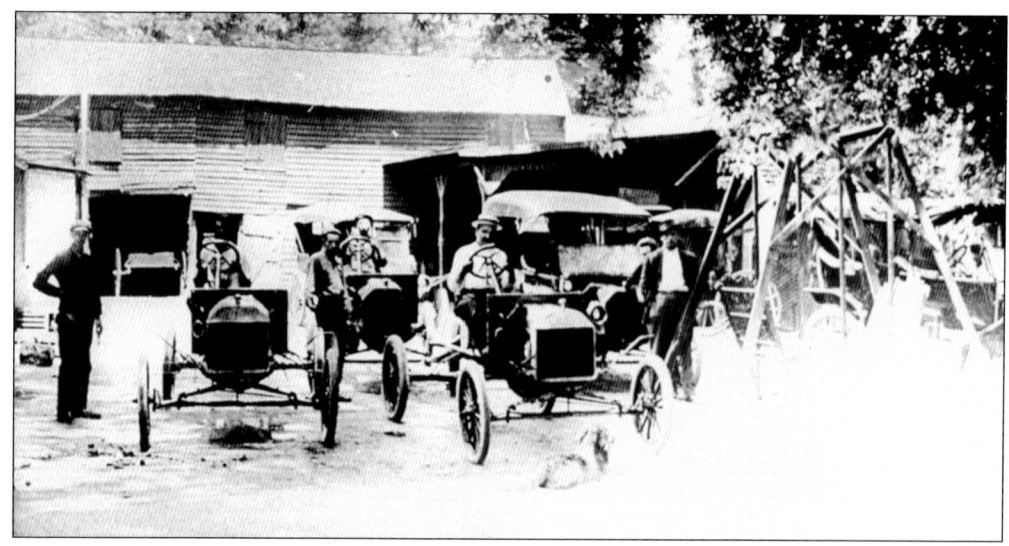

George Higgins was one of the first car dealers in Glassboro. He sold Ford automobiles from his home, at Main and West Streets. Shown in 1911 is Higgins's stable, where six cars were assembled. The disassembled frames were shipped from Dearborn, Michigan, hand carried off freight cars at the station at High and Academy Streets, placed on wheels, and towed to the stable, where the body, fenders, top, and windshield were put together.

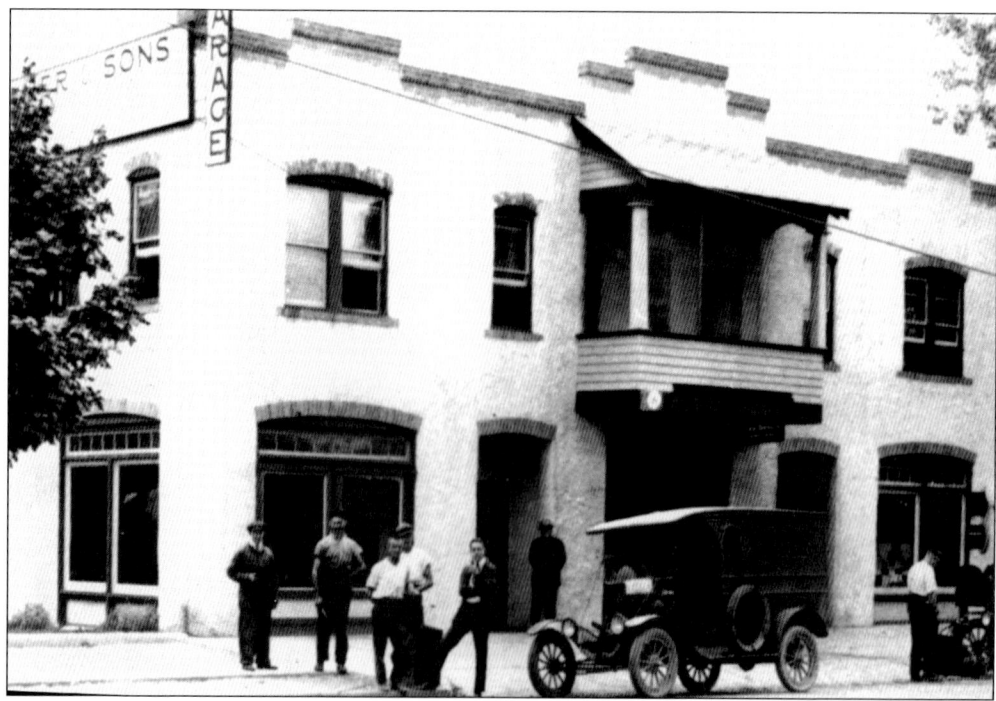

W. A. Downer & Sons Garage is pictured c. 1930. Downer & Sons was a distributor for the Auburn Sixes, Dodge Brothers' motor cars, and Republic trucks. The company also handled accessories, supplies, and auto repairs. In the late 1920s, Wilmer Dubois's butcher shop also operated in this building. The building still stands here today, on High Street, beside the Glassboro Municipal Building.

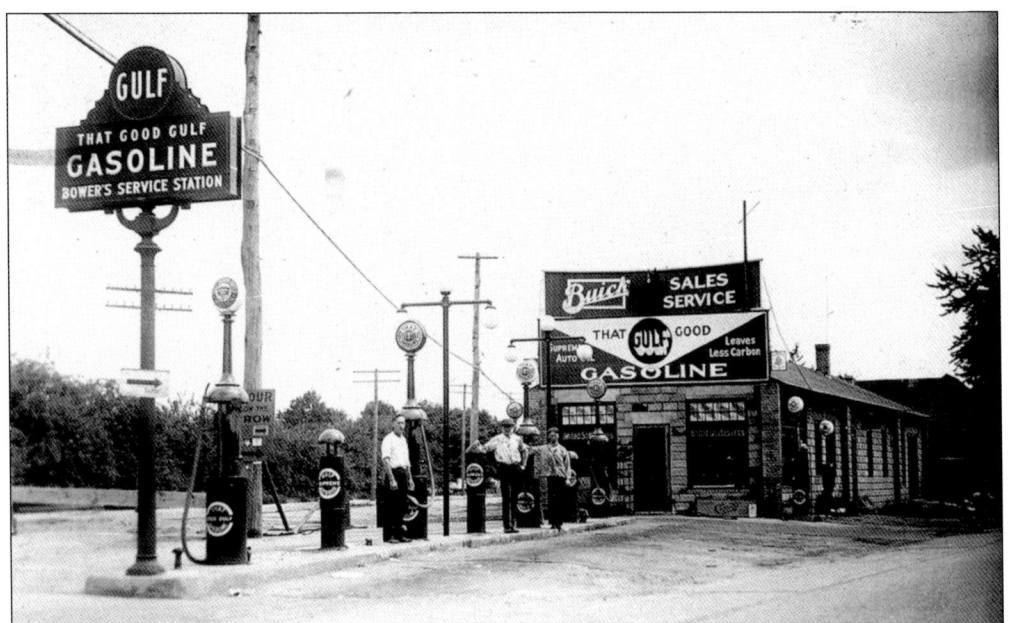

Bower's Gulf Station, on the south point of Delsea Drive and Main Street, is shown c. 1921. Thomas L. Bower Sr. began his business in the early 1920s. The station later became a bar known as Michael's. On October 3, 1962, the building became Bower's Automotive.

Bower's Sunoco Station, on the north point of Delsea Drive and Main Street, was also owned by Thomas Bower Sr.

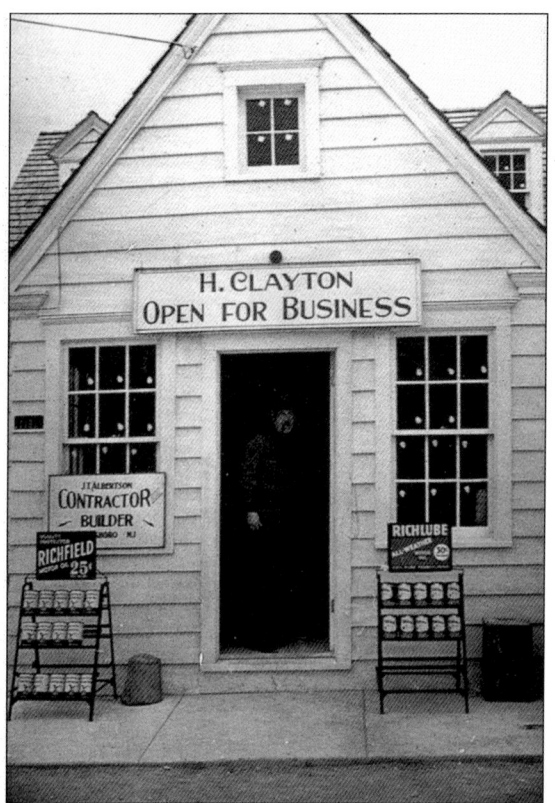

Clayton's Gas Station is pictured on the corner of Delsea Drive and West Street c. 1920. The station was owned and operated by Harry Clayton, who appears in the doorway. The structure still stands today, under different management.

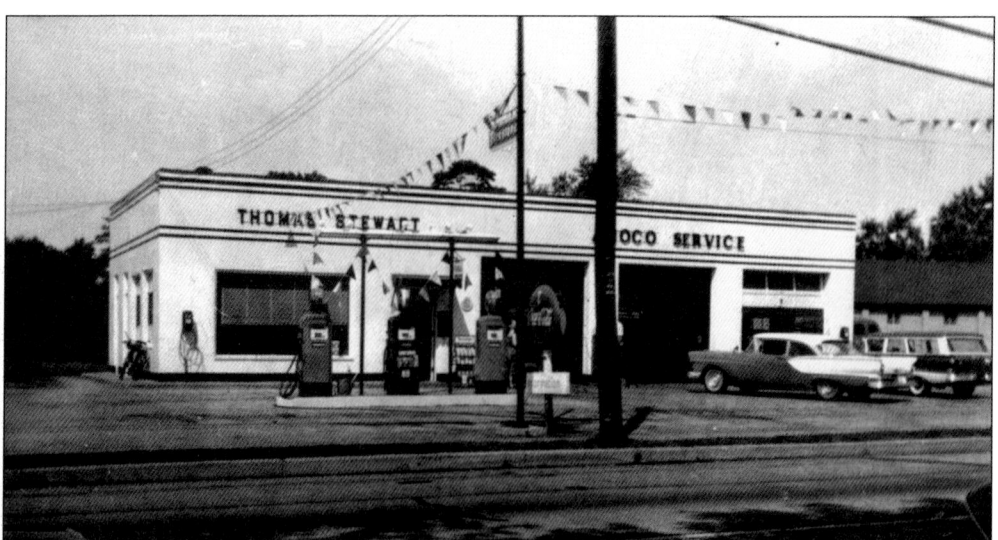

Thomas C. Stewart's Amoco station opened in 1945 on Delsea Drive, opposite the Glassboro Intermediate School. In 1967, at the age of 65, Thomas C. Stewart turned the business over to his son Thomas A. Stewart, who continued the business until sometime in the early 1980s.

Eight
NEIGHBORHOODS
HOME SWEET HOME

In 1900, the Women's Christian Temperance Union (WCTU) was given permission by the Glassboro Township Committee to place a fountain at the intersection of Academy, State, and New Streets. The public fountain served both man and beast for 21 years. A cup hung over the basin for human consumption, while fresh running water filled the lower portion, serving as a watering trough for animals. Inscribed around the lamppost was a quote taken from the Bible: "I was thirsty, and ye gave me drink." The lamp was originally powered by electricity, but more often than not it proved to be inefficient. In 1910, the gas company transformed the lamp to gas, free of charge for one year. This public fixture met its fate when automobiles began to control the roadways. Several collisions toppled the fountain off its base, creating a traffic hazard. The fountain was removed and placed at the WCTU building on South Academy Street, where it mysteriously disappeared.

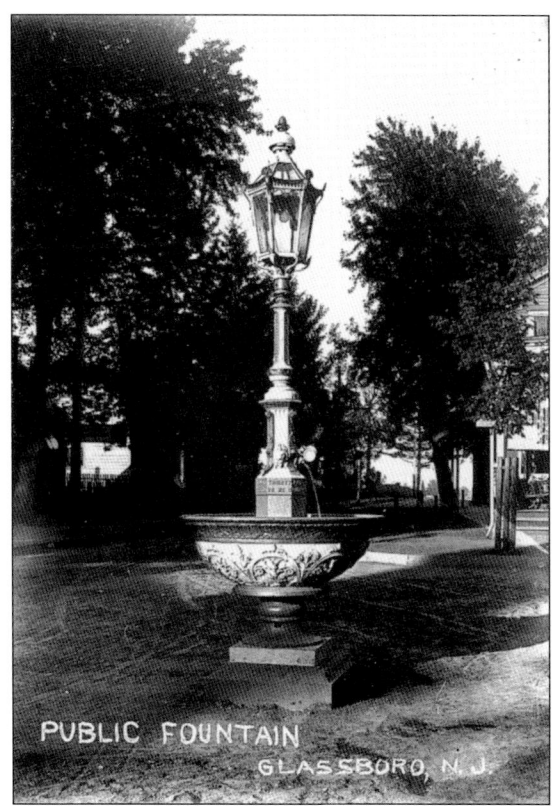

In this view looking north on Broad (Delsea Drive) and High Streets in 1908, J. T. Abbott's General Store can be seen on the corner to the left.

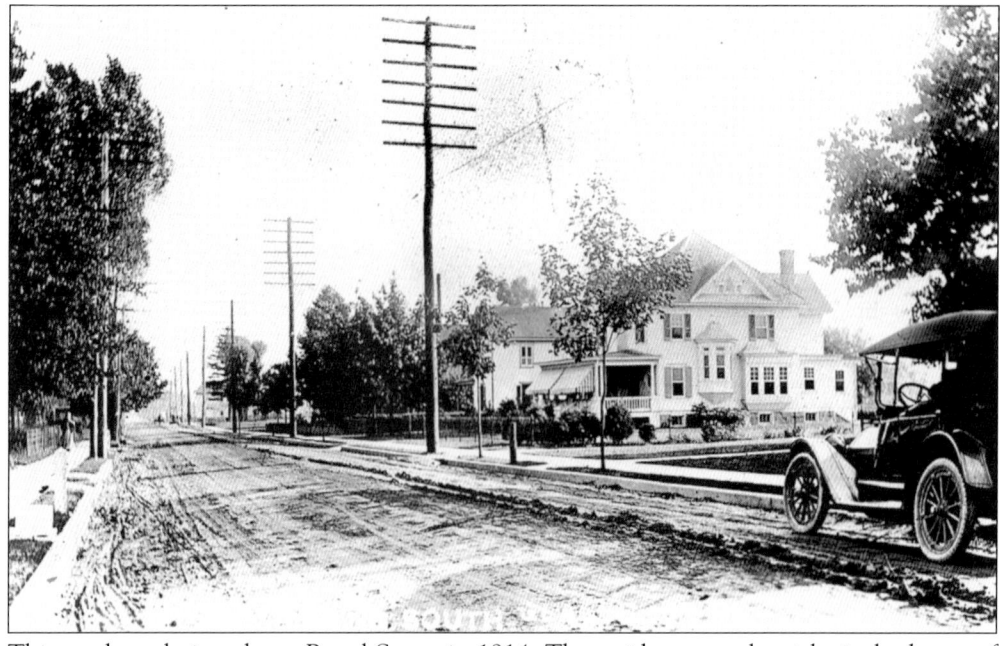

This southward view shows Broad Street in 1914. The residence on the right is the home of Charles F. Repp. William Krug, a contractor from Pitman, built the home in 1897.

The first water tower in Glassboro was erected in 1896 on North Main Street, beside the old St. Thomas Episcopal Cemetery. For nearly a century, the steel-frame tower rose 100 feet and held 132,500 gallons of water. The standpipe stayed functional until July 1983, when the tower was torn down and all water storage was converted to a new tower off Greentree Road.

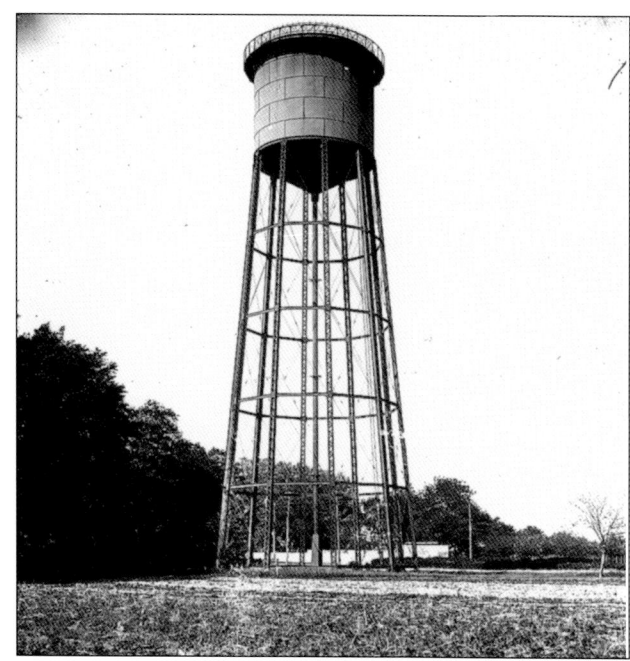

These two Glassboro homes, at Main and Focer Streets, were photographed during the blizzard of April 3, 1915. The residence on the left is the 1889 home of E. E. W. Carter. Joseph Seckinger purchased the home in 1951 and operated a radio and television repair shop there. To the right is the Herbert Moffitt home, built in 1910. The telephone company purchased this property in 1970 and demolished the structure.

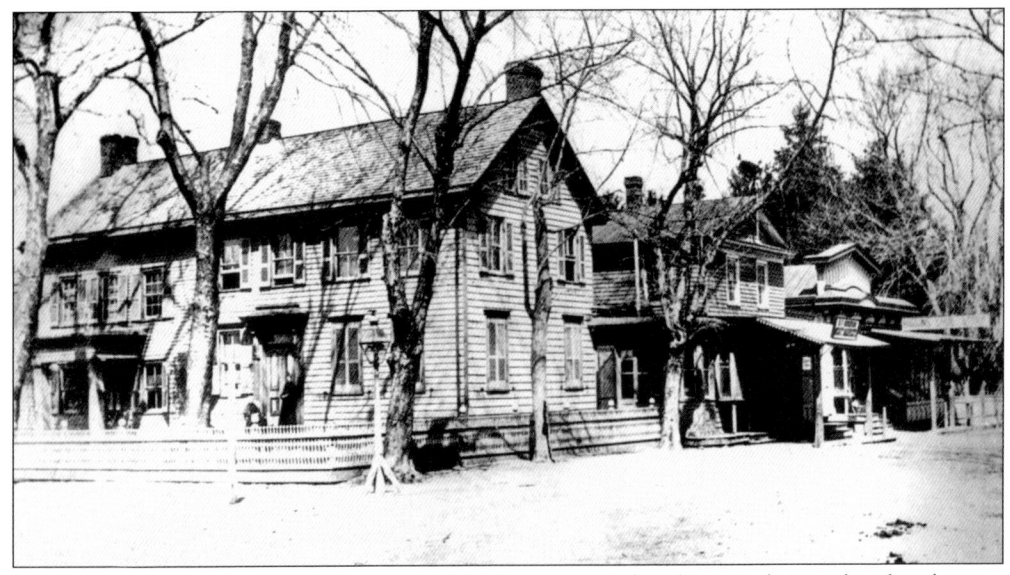

On the northwest corner of West and Main Streets stands a historic home that has been a part of Glassboro's landscape since 1817. Ebenezer and Bathsheba Whitney built the original portion, which is the left three-window section, and raised their family, who included glass mogul Thomas Whitney. In 1864, the property was sold to Joseph L. Higgins, who then enlarged the home to what we see today.

The Sturgess home, at State and Main Streets, has a history that dates back to 1786. Here, Col. Thomas Heston constructed his home in order to keep an eye on his glassworks, across the street. In 1934, the home was sold to Edward L. Sturgess, who altered the dwelling. Beneath many renovations and much remodeling is the original foundation of the Heston home.

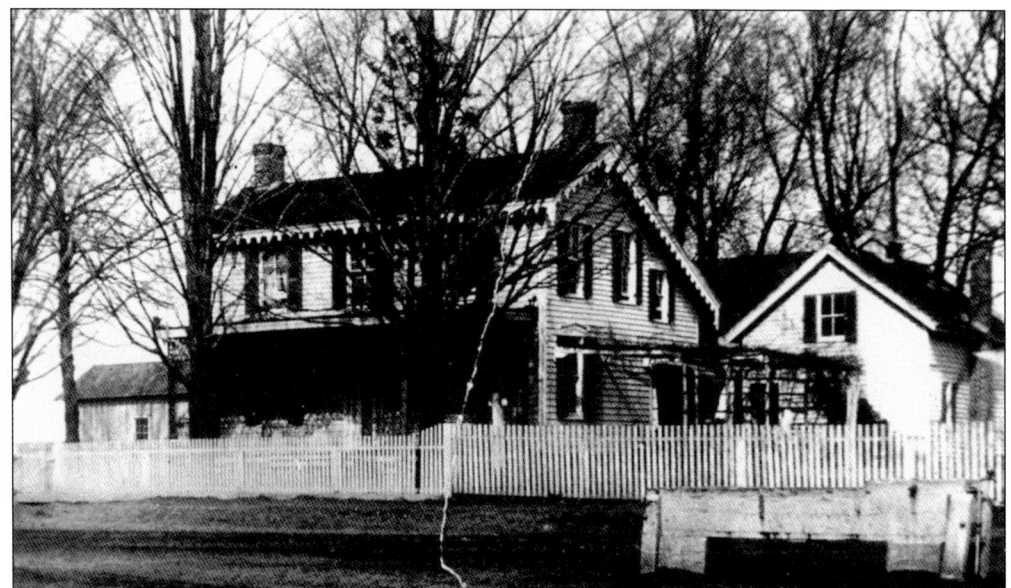

In 1835, Solomon H. Stanger Sr. built this farmhouse on North Delsea Drive, near the intersection of Main Street. Ownership of the farm, known as the Pomona Orchards, later passed to his son and grandsons. The farmhouse was sold in 1927 to Walter Jones, who lived there until 1963. The property was sold to Gino's, a local fast-food chain, and the house was moved to Market Place, where it stands today.

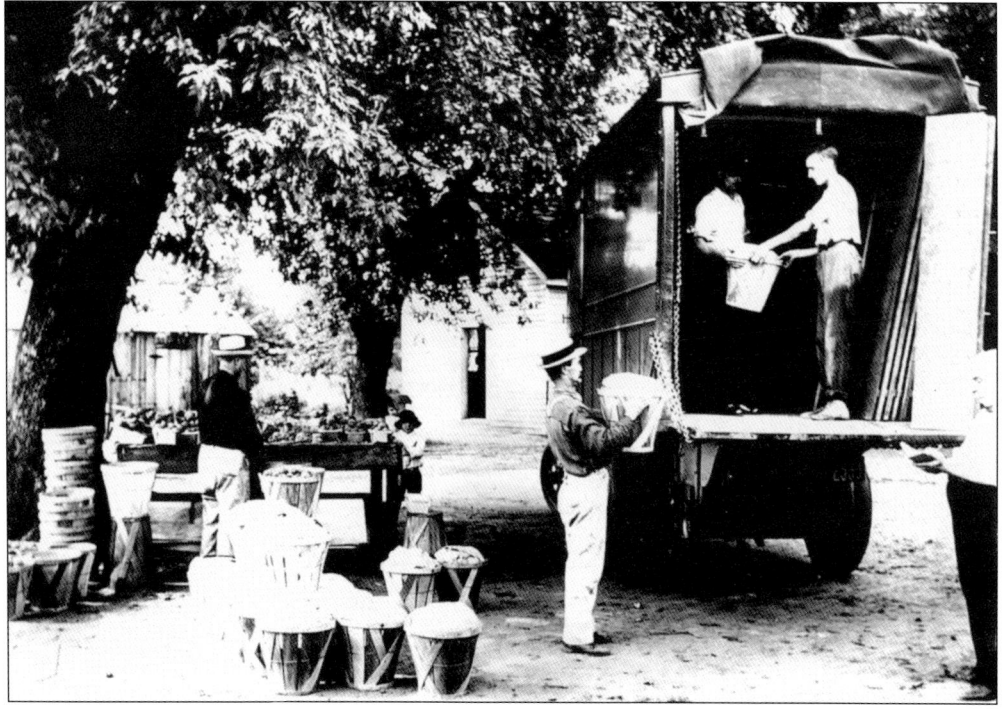

The Pomona Orchards consisted of 133 acres of peach, apple, and pear trees. In 1910, the farm produced 20,000 baskets of produce. Here, baskets of fresh produce are loaded into a John Repp's Ice and Cold Storage Company truck to be delivered to storage facilities in Philadelphia c. 1920.

Congressman Thomas M. Ferrell is the only Glassboro native to have been elected to office in Washington. Educated in Glassboro, he began working in the Whitney Glass Works at the age of 16. After learning the trade, Ferrell began to see the problems within the work force. He helped to establish the National Labor Bureau. In 1885, the Elk Township community of Fairview officially changed its name to Ferrell.

Thomas M. Ferrell built this home in 1872 at Main and New Streets, where Let's Dance Studio is now located. The Victorian architecture and exotic gardens made this home a showplace. After Ferrell's wife died in 1919, the property was sold to George B. Marshall. It stayed within the Marshall family until 1966, when it was sold to Joseph Brigandi and subsequently demolished in 1967.

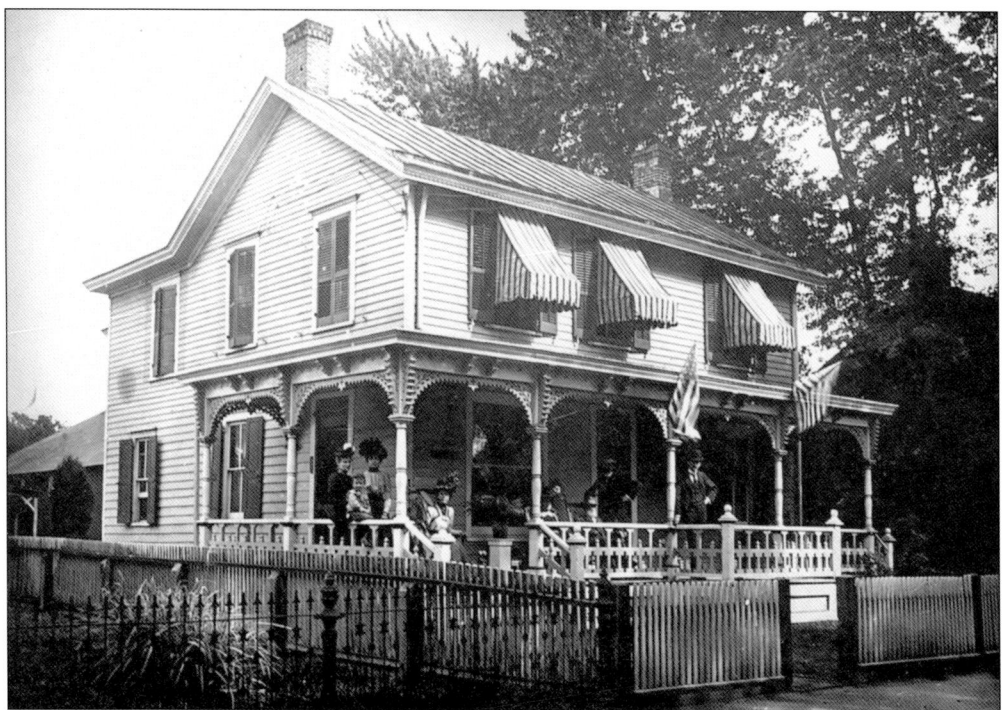

The home and office of Dr. Meredith Jones Luffbary were located on North Main Street. Shown here in 1899, the home was built by John S. Beckett in 1875. William E. Carney purchased the property in 1912 and began a restaurant and oyster bar. Harry Canglin later operated a tailoring business here. Currently, the home has a two-story brick front housing a business and apartments.

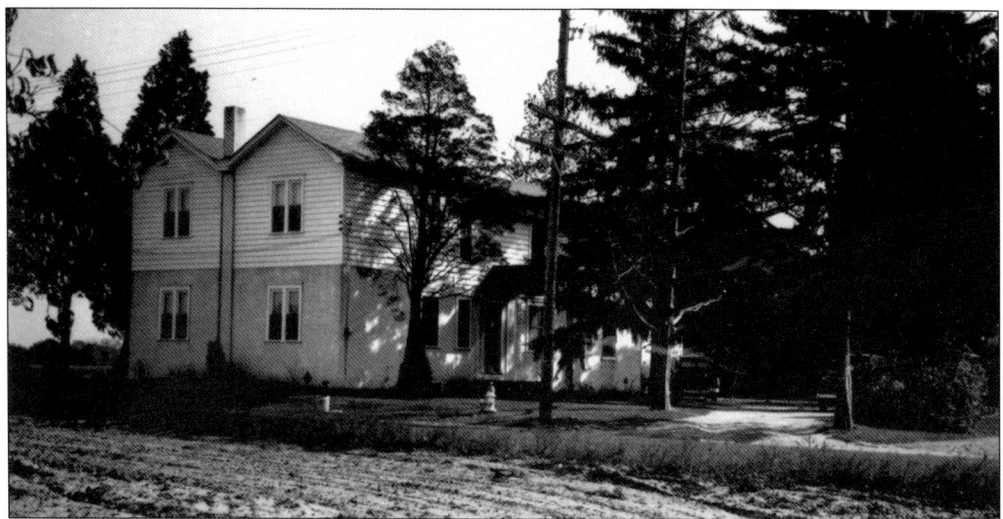

Shown in 1950, the birthplace of Spanish-American War hero Adm. Mark Lambert Bristol stands beside the Bullock School on New Street. On July 3, 1898, aboard the battleship *Texas* at Santiago, Cuba, Admiral Bristol noticed the Spanish fleet retreating. He sounded the alarm, and the enemy was conquered. His service to the U.S. Navy earned him high honors. Bristol died on May 13, 1939, and is buried at Arlington National Cemetery.

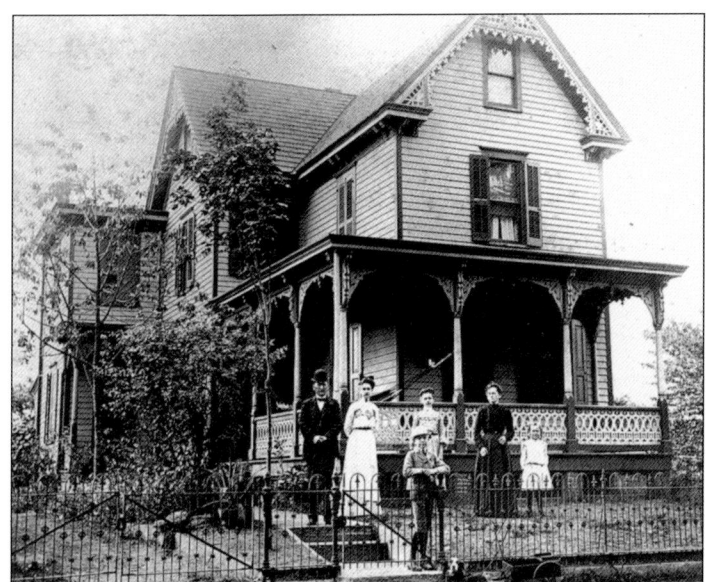

The George M. Keebler residence, a beautifully maintained home on Ellis Street, still stands today. In 1916, George Keebler (left) was appointed postmaster of Glassboro by Pres. Woodrow Wilson. He served until 1922. Pictured with him in 1899 are, from left to right, Nettie (Chappius) Keebler, Charles M. Keebler, Clara L. (Baldwin) Keebler, Rosa Anna Emrich Keebler, and Mary E. Keebler.

The A. A. Weisner home and business, located on North Academy Street, is pictured in 1906. A. A. Weisner (third from the right) was best known for selling granite and marble monuments. The right side of the house was a candy and tobacco store, which Nora Weisner (right) operated until her death in 1924. Pictured with A. A. and Nora Weisner are, from left to right, unidentified, Silas N. Weisner, two unidentified persons, Nevin A. Weisner, and Paul A. Weisner.

EAGLESWOOD Amusement Park

ATTRACTIONS:

GO KARTS - SINGLE, DOUBLE AND KIDDIE

BUNGY TRAMPOLINES

RIDES: FREE FALL, TORNADO, SKY GLIDER, KIDDIE JUMPIN JEEPS, FUN SLIDE

TWO 18 HOLE MINI GOLF COURSES

CRAZY CUBE PLAY AREA

FAMILY ARCADE WITH OVER 70 GAMES AND GREAT PRIZES

10 BATTING CAGES

GOLF DRIVING RANGE

2.5 Miles S. of Route 72
597 Route 9
Staffordville, NJ 08092
609-978-6606

www.eagleswoodsamusementpark.com

EAGLESWOOD Amusement Park

THE FUN IS WAITING...

SAVE $4 PER Wristband

UP TO A $40 VALUE

AVAILABLE EVERYDAY FOR ALL DAY PLAY

UNLIMITED RIDES ON
FREE FALL, TORNADO, SKY GLIDER, FUN SLIDE,
MINI GO KARTS, BUNGY TRAMPOLINES & KIDDIE JEEP RIDE.
UNLIMITED MINI GOLF, CRAZY CUBE PLAY AREA.
ALSO INCLUDES REDUCED PRICING FOR SPEEDWAY GO KARTS

- Expires 10/31/14.
- Must present coupon.
- Not valid with any other offer.
- Only one discount per customer.
- Good for up to 10 people.

KidStuff ...and more!

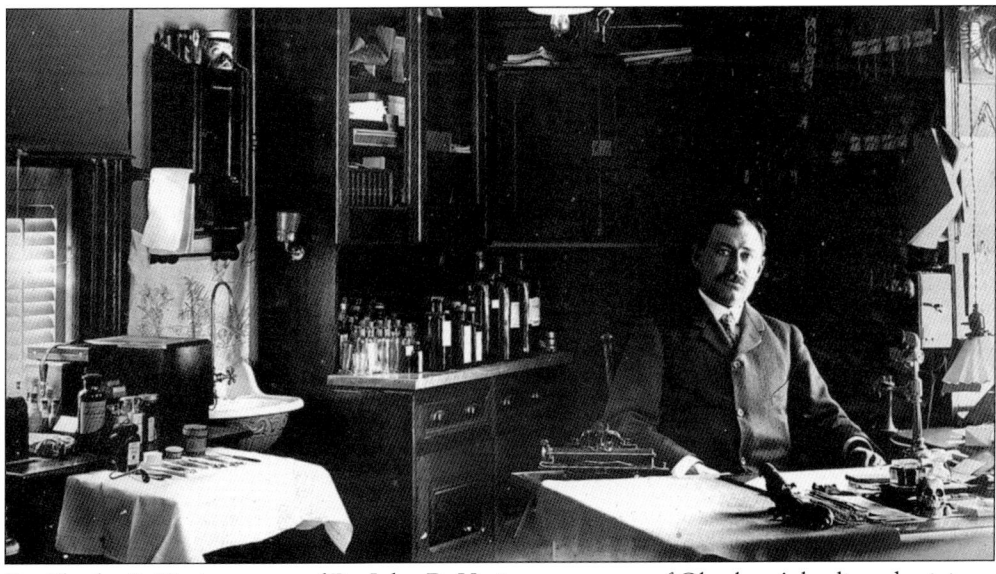

The home of Dr. John D. Heritage, seen here c. 1920, was located on New Street, directly behind the Methodist Episcopal Church. Dr. John Heritage was an assistant surgeon to the 11th New Jersey Volunteer Infantry during the Civil War. He built this beautiful house in 1869. Standing in front of the building are Elizabeth Heritage (left) and her daughter Sarah Heritage.

Dr. Charles S. Heritage, son of Dr. John D. Heritage, was one of Glassboro's leading physicians. He is pictured in 1899 at his office, located on the point between State and Academy Streets, in front of what is now the Methodist Church House. During the summer of 1882, an outbreak of smallpox struck. Heritage, along with other Glassboro physicians, treated eight patients in a makeshift hospital to prevent the deadly disease from spreading.

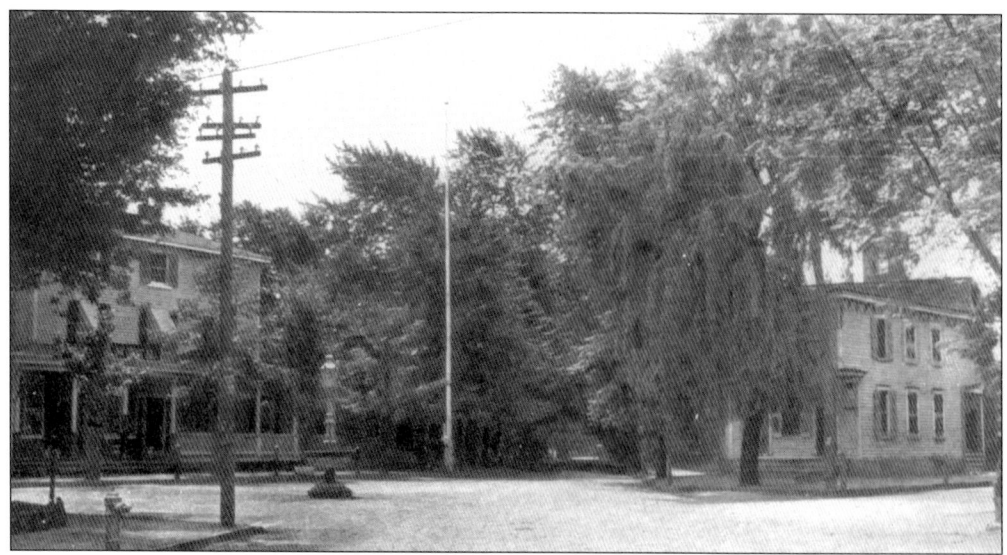

In this *c.* 1907 southward view of State Street, the building to the far right is the office of Dr. Charles S. Heritage. Also visible is the cupola of the Robert S. Moore property, behind Heritage's office. On the left is the S. H. Stanger Store and the public fountain.

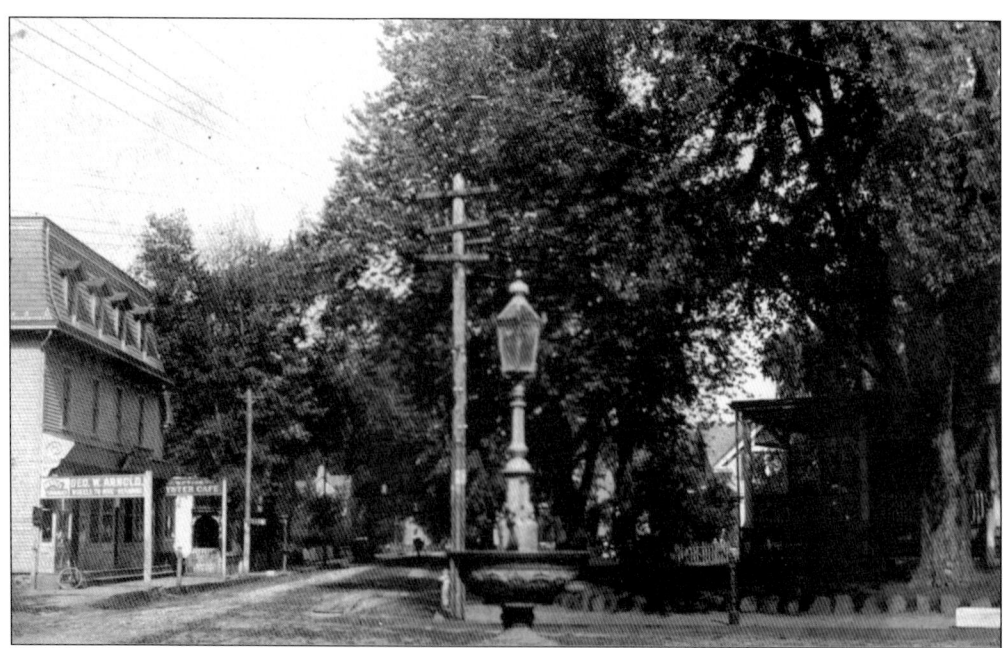

This view, looking northward, reveals State Street *c.* 1907. To the left is Wilcox Hall, later known as Association Hall. To the right is the residence of Glassboro's third mayor, Frank R. Stanger. In front of the home is a marble stone block that rests between the sidewalk and the street with the inscription "Frank R. Stanger 1904." Influential people, such as Frank Stanger, purchased a stone like this one and placed it in front of their home.

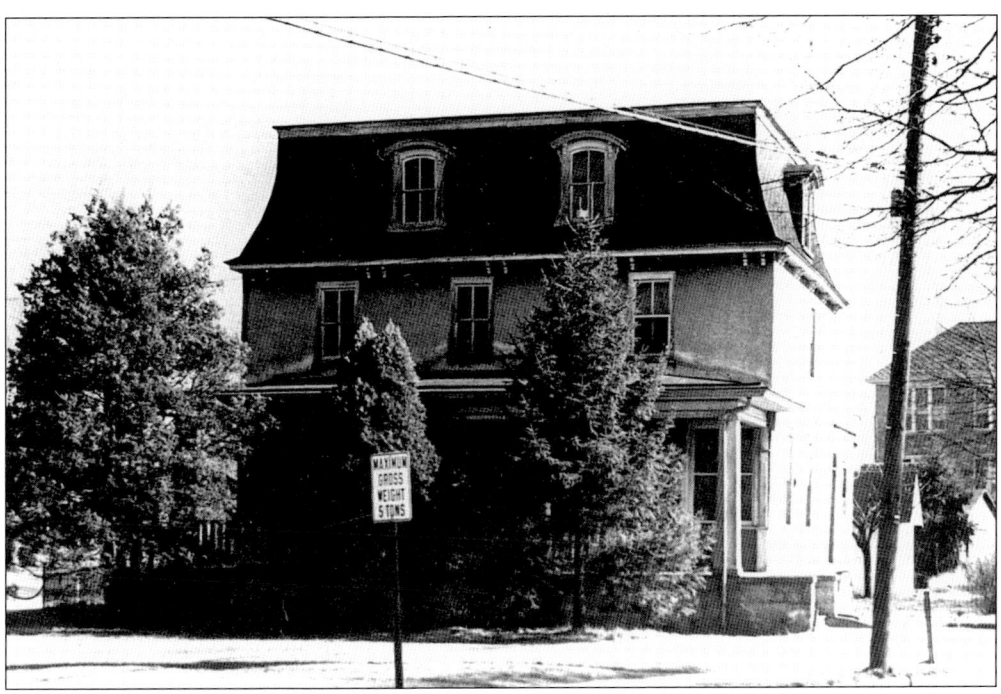

Robert S. Moore built this structure, shown here in 1954, on the point of Academy and State Streets in 1880. Skilled in the trades of sheet-metal, roofing, tinware, and stove work, he operated a small business in the basement of his home. He invented the R. S. Moore range, which became very popular. Olive S. Moore sold the property to the Methodist church in 1952.

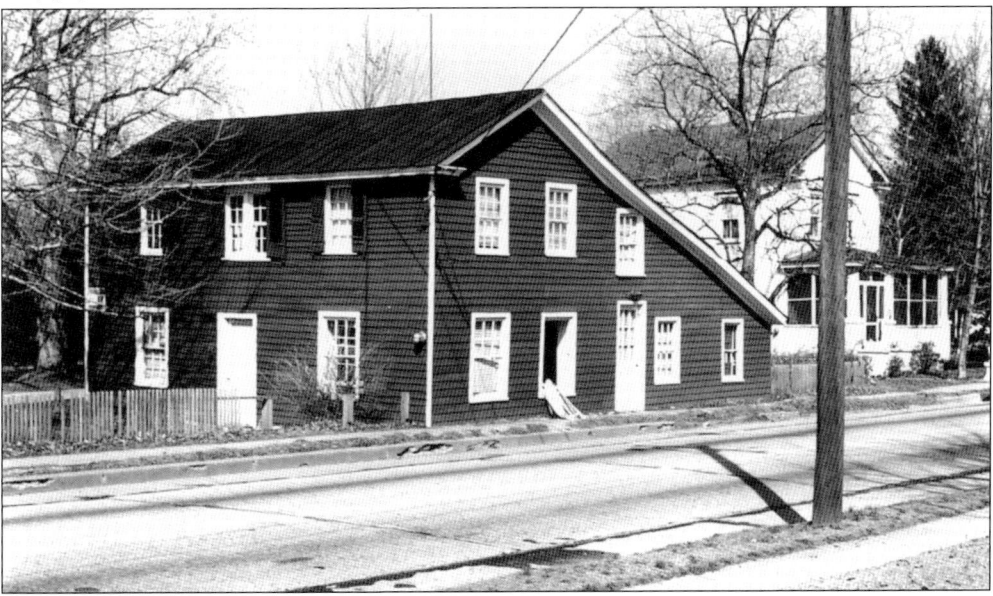

A saltbox home dating to the 1700s stood at the point of Main and Carpenter Streets. The building, owned by Grant William Patton and his wife, is shown here in 1965, vacant and vandalized. A county appraisal report argued the building might have great historical value but that the cost of restoration was questionable. The county purchased the property for $4,000 and demolished the structure in 1966 to widen the intersection.

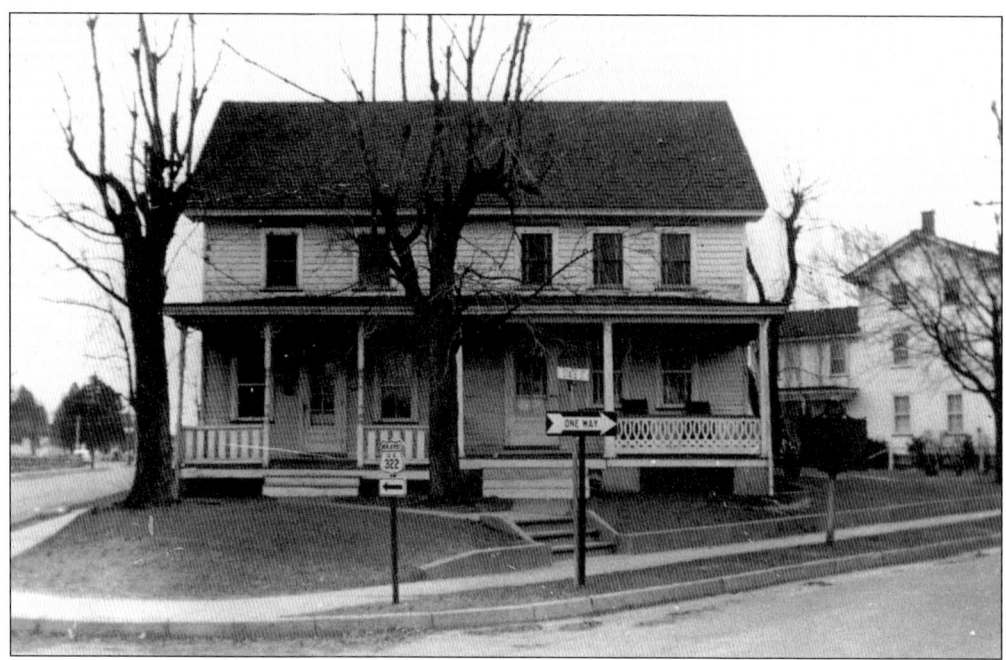

One of Glassboro's oldest homes occupies the southeast corner of West and State Streets. Built in 1780, the building was used as a general store and Daniel Stanger's home and was part of the original Stanger Glass Works structures. In 1922, the building was remodeled into a double dwelling. Shown here in 1945, the property was purchased by Edward and Elizabeth Batten.

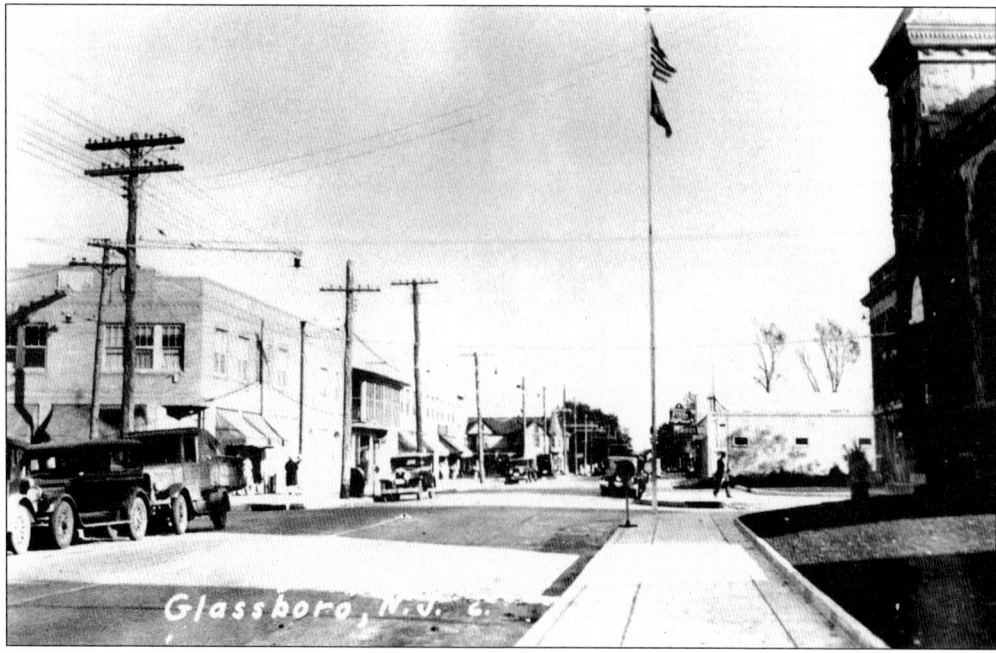

This view of High Street, looking eastward near the intersection of Main Street, was taken c. 1928. The building to the left is the Kotter Building, known today as Sid's Outlet, and the one to the right is the old Glassboro Municipal Building, originally the First National Bank of Glassboro.

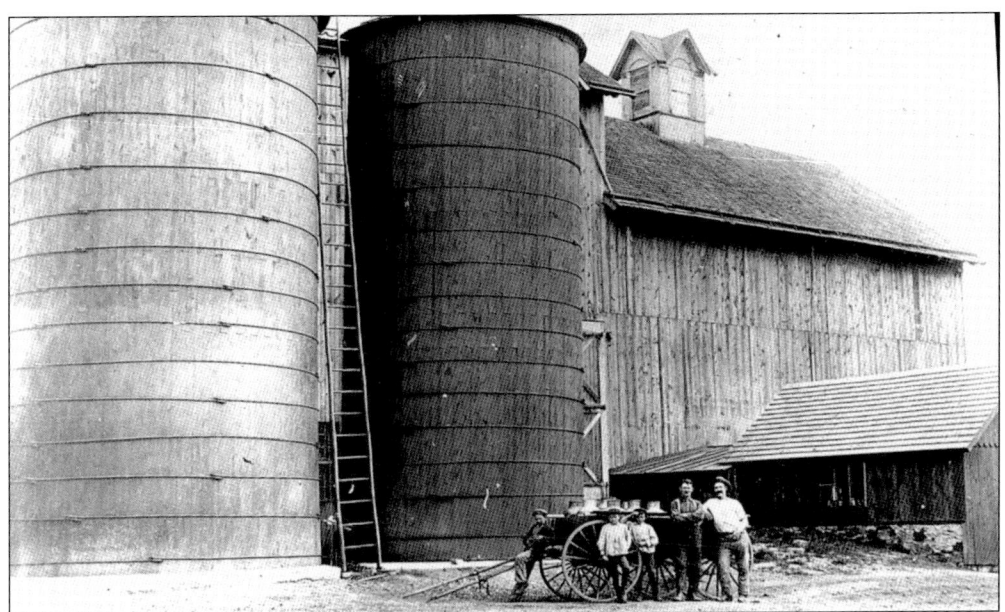

Shown here in 1896, the John P. Whitney farm was located in the Chestnut Ridge section and began producing goods prior to the Civil War. John Whitney, the son of glass mogul Thomas Whitney, sold grain and meat at the company store. The Whitney farmhouse, located on Swarthmore Road, and the silo foundations on Villanova Road, are only the remains of this establishment.

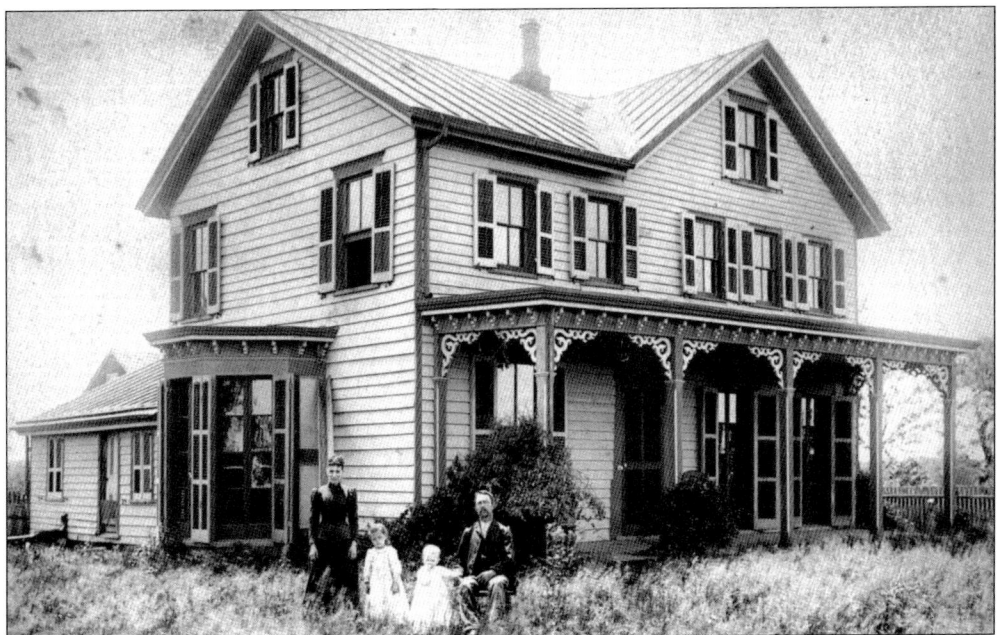

The Elmer Iszard farmhouse once stood on the site of the present Glassboro High School. The board of education purchased the Iszard tract in 1961 for $51,000. The home remained standing until 1963, when the fire department destroyed it in a controlled fire. Pictured c. 1892 are, from left to right, Madora P. (Sickler) Iszard, Elsie (Peterson) Iszard, Clarence Iszard, and Elmer Iszard.

Pictured in 1885, the home known as Maplewood was built in 1856 at Academy and Grove Streets by Thomas Stanger for himself and his wife, Hannah. The Stangers reared four children, three of whom lived in the homestead their entire lives. The last surviving child, Anna, occupied the home until her death in 1949.

Pictured in 1920 is the Pines, a Victorian mansion on North Main Street. Christopher Sickler built the mansion in 1856 but was unable to finish construction for financial reasons. Alfred C. Pedrick purchased the estate in 1860 and quickly completed the mansion. It was home to three generations of the Pedrick family. Later, it was used as housing for college students. The building was destroyed by fire in 1979, and the site is now a parking lot for the Mansion Apartments.

The Methodist Episcopal church parsonage, at Main and New Streets, was built in 1900 as the living quarters for the pastor and his family. In 1955, the church fathers felt the parsonage was becoming too costly to operate and moved the Rev. Robert B. Howe family to a parsonage on the opposite corner. Today, the old parsonage has become a fraternity house for Rowan University students.

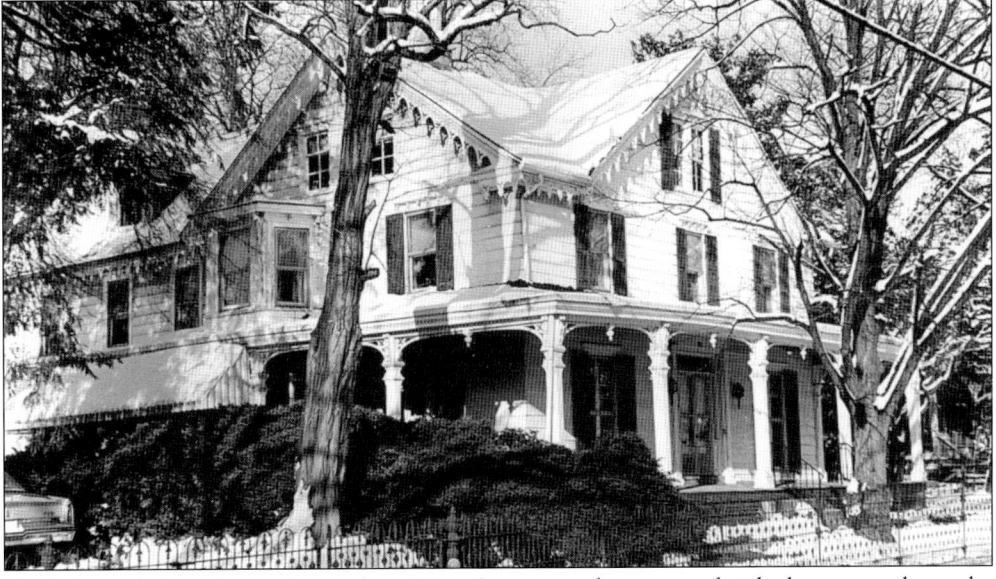

The Eben Whitney home, located on West Street, was begun as a brick three-room home by James Lock in 1847. Sold to John Stanger in 1852, the house was rebuilt to the way it appears in this 1987 photograph. Eben Whitney purchased the home in 1864, and the Whitney family occupied the residence for 116 years. The last descendant to live here was Annie Whitney Nock-Capie, who passed away in 1974.

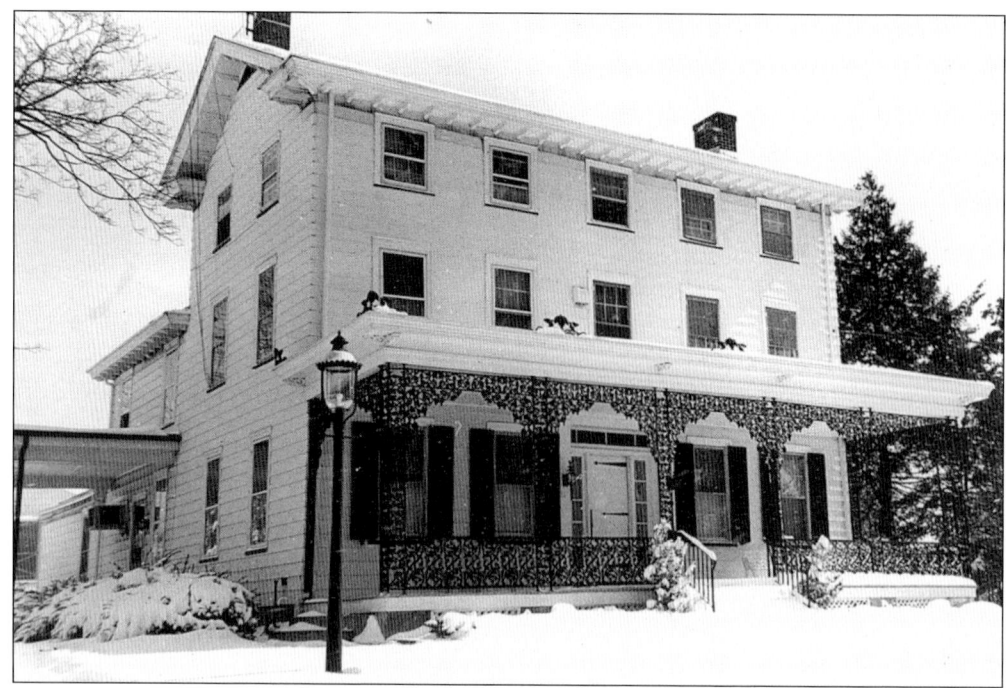

The Judge Joseph Iszard home was constructed in 1852 on North State Street. Pictured in 1987, the house is one of Glassboro's most stately residences and one of the last remaining Victorian homes built by one of the community's most prominent citizens. It was home to three generations of the Iszard family. In September 1945, Frank Jones purchased the property and operated the Jones Funeral Home here for many years.

The intersection of Delsea Drive and Main Street was known to many local residents as Bower's Corner. The southward view was taken c. 1958. It shows that, at the time, one could cross between the two streets.

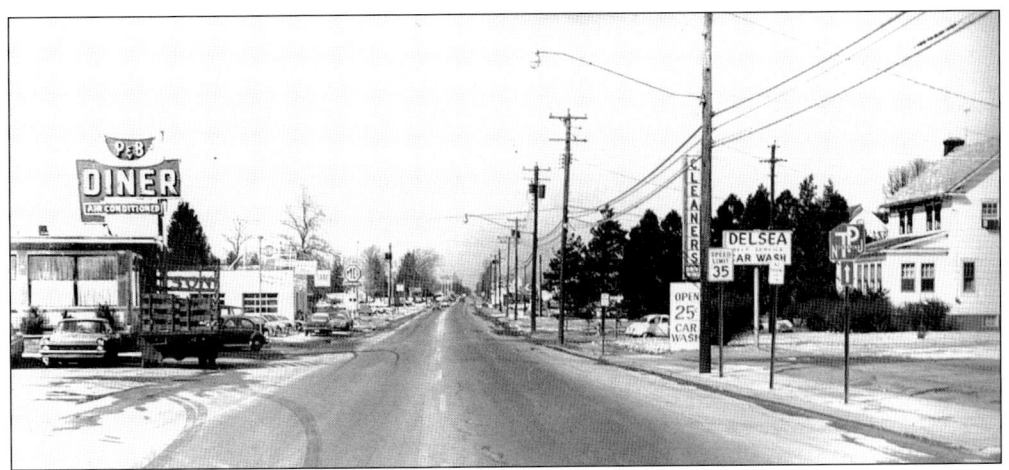

This northward view shows Delsea Drive and Greentree Road c. 1967. The house on the far right was moved to Greentree Road in 1979 to allow for a Burger King restaurant.

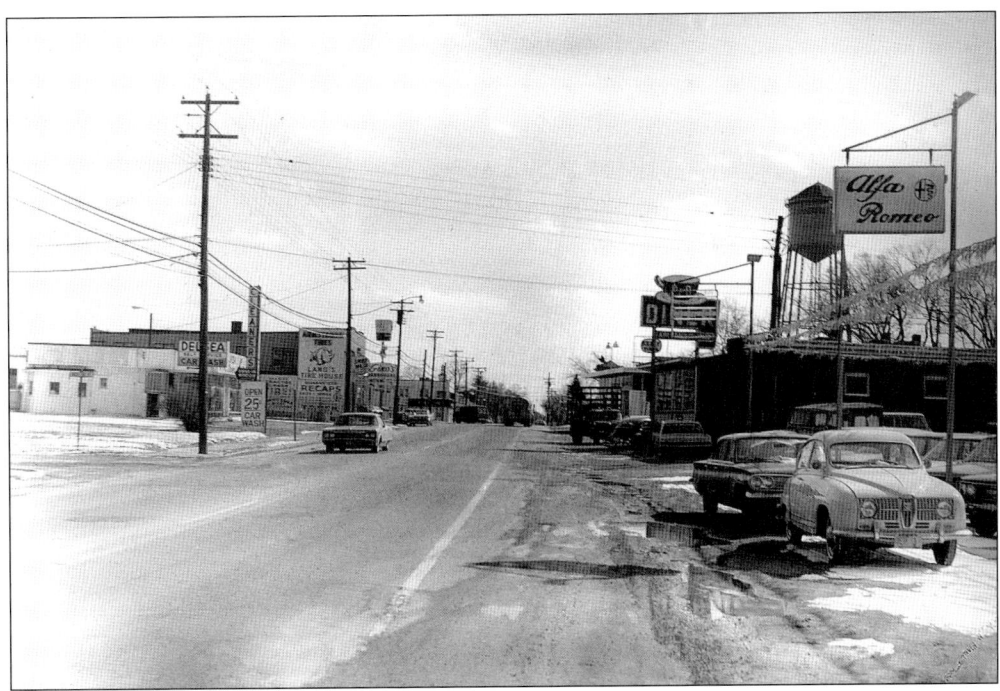

Delsea Drive and Greentree Road are depicted in this c. 1967 view, looking south. The Delsea Car Wash and Delsea Cleaners buildings (left) were demolished in 1979 to make way for a Burger King restaurant. Visible beyond them are Gino's fast-food restaurant and the Kentucky Fried Chicken bucket.

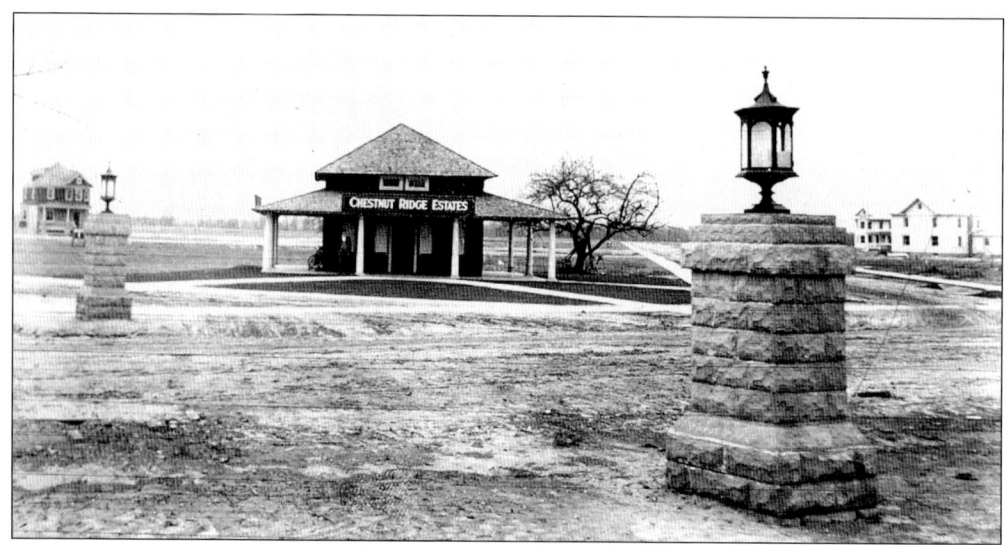

The Chestnut Ridge Estates office, at University Boulevard and Princeton Road, is pictured in 1911. This section of Glassboro was once the John P. Whitney farm. John Whitney derived the name Chestnut Ridge from a mountain view overlooking a farm he owned in Pennsylvania. In 1908, the farm was sold to the A. E. Mueller Company of Philadelphia and was developed into a neighborhood. The streets bear the names of Ivy League colleges.

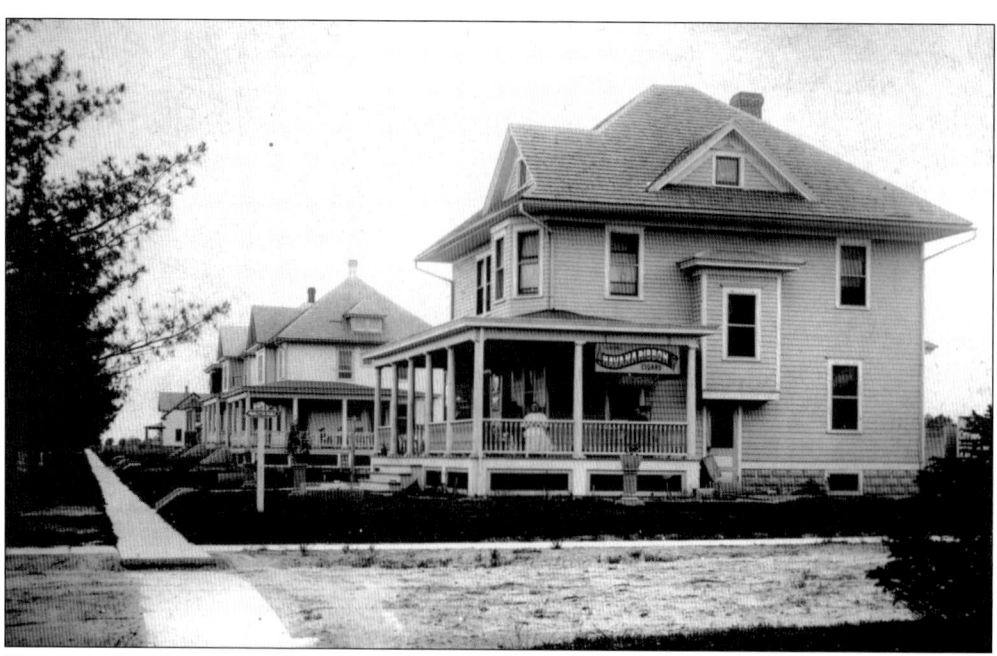

Homes in the Chestnut Ridge Estates occupy the corner of University Boulevard and Princeton Road c. 1915. Lots sold for $300, with the homeowner putting $10 down and making a weekly payment of $1.

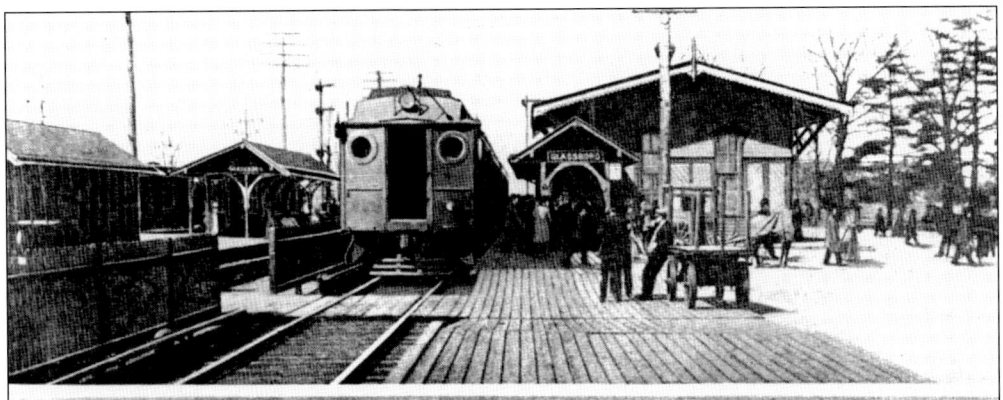

Glassboro Station—right at Chestnut Ridge Estates—Only 39 Minutes from Market Street, Philadelphia

Chestnut Ridge Estates

The all-year-round-home place with all city conveniences. Within easy commuting distance of Philadelphia.

THIS summer, like all summers, will have its weeks and weeks of hot, broiling, sweltering days, followed by sleepless, nerve-racking nights. Heat, heat, nothing but heat! And thousands upon thousands of children will pay the awful penalty, the penalty they pay with monotonous regularity summer in and summer out. Just look at the cold, unsympathetic figures of the Board of Health's report. These figures tell the story most eloquently, and this mowing down of little folks happens just because they are denied the cool green of the fields, the shaded woods, the pure sparkling drinking water, with plenty of air, the sweet, life-giving air of the joyous outdoors. How about *your* little folks? Surely you are not so inconsiderate as to have failed to give this serious thought

This advertisement for the Chestnut Ridge Estates appeared c. 1910. To promote this new development, the advertisement gives the potential buyer an idea of how accessible Chestnut Ridge is to all cities.

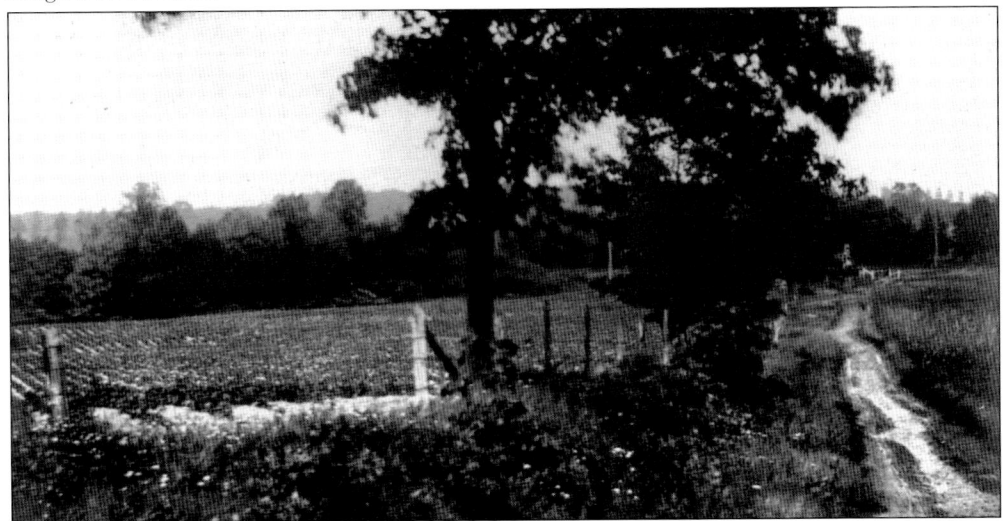

Joseph L. Bowe Boulevard and Mullica Hill Road (U.S. Route 322) are pictured c. 1905. The open field on the left was known as Hilltop Farm. This property was also operated under the Whitney establishment. Today, the Beau Ravage Townhouses and Audubon Ridge Apartments occupy this site.

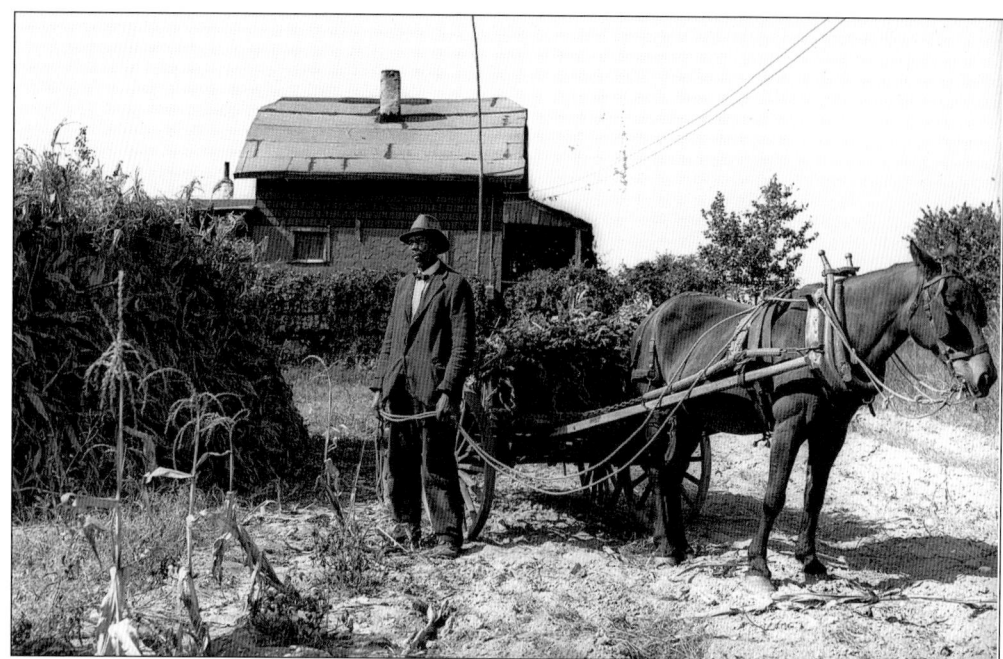

The Eighty Acres was a failed real-estate development for agricultural laborers from nearby corporation farms. It was part of the Farm Security Administration (FSA), which was created by the Department of Agriculture in 1937. The FSA and its predecessor, the Resettlement Administration, were New Deal programs designed to assist poor farmers during the Dust Bowl and the Great Depression. This is the home of Reverend White.

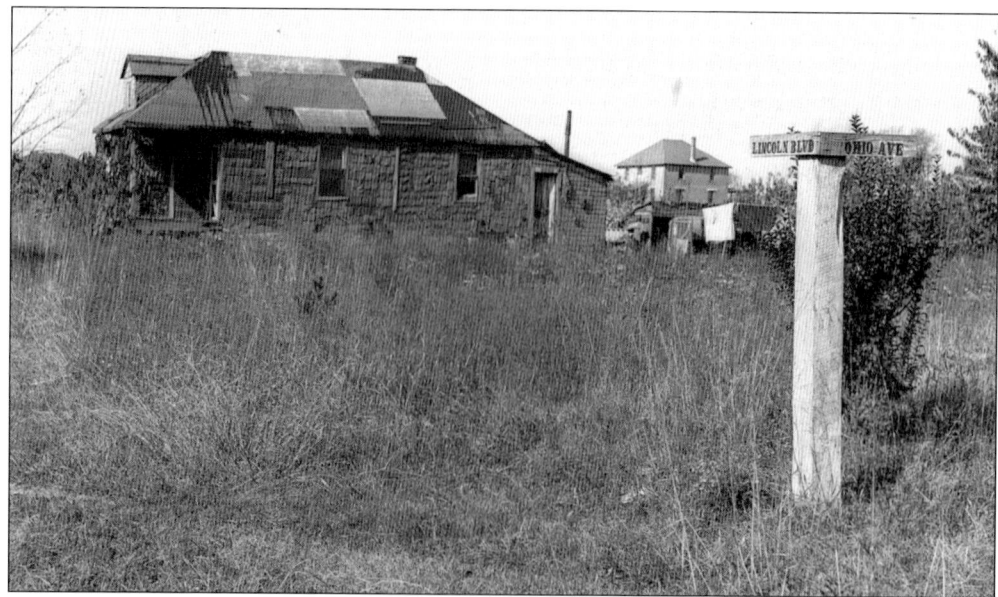

Images of the Eighty Acres were taken in October 1938 by Roy E. Stryker, who was the head of a special photographic department to record government-funded programs. Taken from the corner of Lincoln Boulevard and Ohio Avenue, this photograph shows the Smith residence (left) and the home of Rev. Clarence and Carrie Davis, which was the birthplace of Viola Bell Neblett, in 1929.

Nine
RECREATION
COMMUNITY ENTERTAINMENT

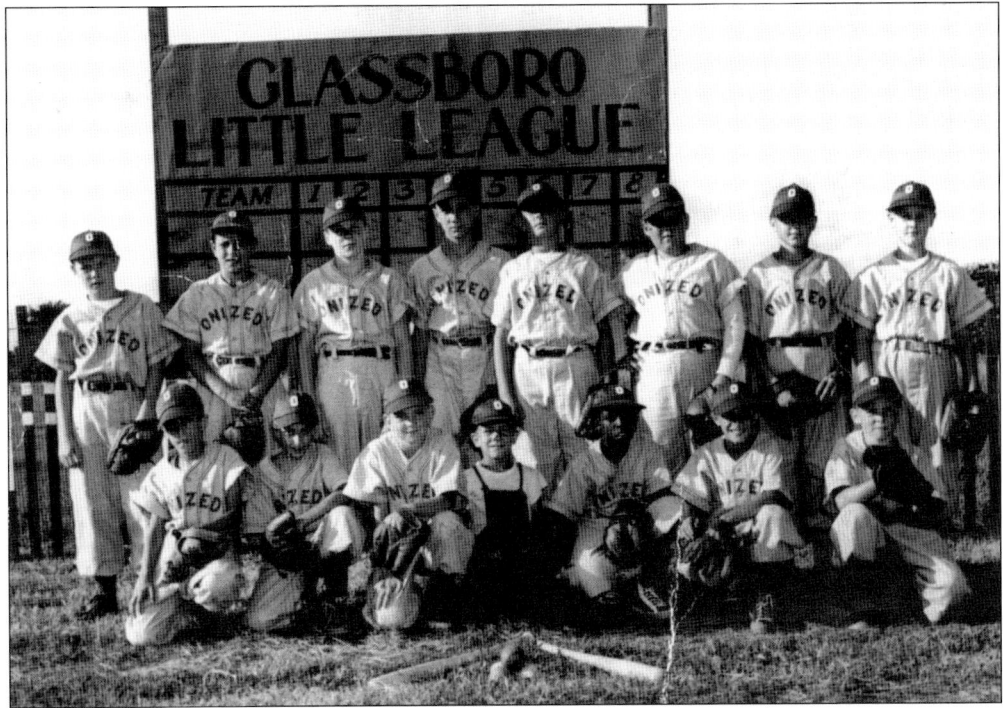

The headlines on the *Glassboro Enterprise* sports page read, "Glassboro 'Little League' Opened Monday Eve." On July 18, 1949, Little League was introduced in Glassboro before a crowd of 300 spectators. League president Herb Young headed the opening ceremonies, and Sen. Harold W. Hannold was the principal speaker. Mayor Harris D. Geschwindt threw out the first ball, officially opening the game. The league began with three teams: the OnIzers, L'Opera, and Repp-U-Tation. On opening night, L'Opera went on to have two straight wins, defeating the OnIzers 4-3 and the Repps 6-3. Shown here is the first group of young men that made up the OnIzers team in 1949. From left to right are the following: (first row) Frank Cibo, Frank Barbera, Paul McQuade, Ray Cibo, J. Harris, Nick Mitcho, and John Rhodes; (second row) Jim Bergman, Anthony Brida, Tom Kane, Hampton Turner, Bill Hussar, ? Fikes, Bob Costa, and Ralph Johnson.

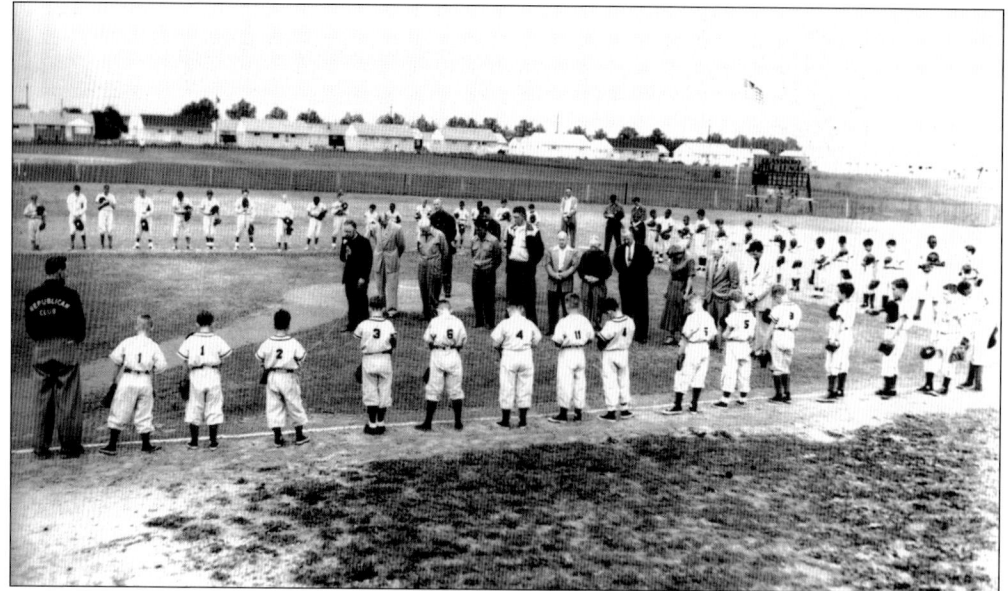

The Glassboro Little League season opener was played at Little League Park, located on Fish Pond Road, c. 1958. The Glassboro Board of Education originally owned the field. On the afternoon of July 8, 1950, the cornerstone for the new clubhouse was laid by club president Herbert Young and vice president Victor Mangeney. A double-header between the All-Star teams from Glassboro and Pitman followed the dedication ceremonies.

A vacant lot at Academy Street and College Avenue was once used as a ball field. Pictured in 1949 are members of the Pitman Employees Social Athletic Club, sponsored by Atlantic City Electric. They are, from left to right, as follows: (first row) Joe Mogar, Bill Good, Harold Ewe, Howard Mutzer, Anthony Costanzo, Amy Carter, Bert Beebe, and Joe Mick; (second row) Charles Lowrance, Robert Avis, Steve Buriak, Ed Coleman, George Wickward, Harry Kruger, Hank Blose, Warren Frymire, Walter "Shorty" Tanger, Cal Anderson, Joe Pettus, and Leon Leek.

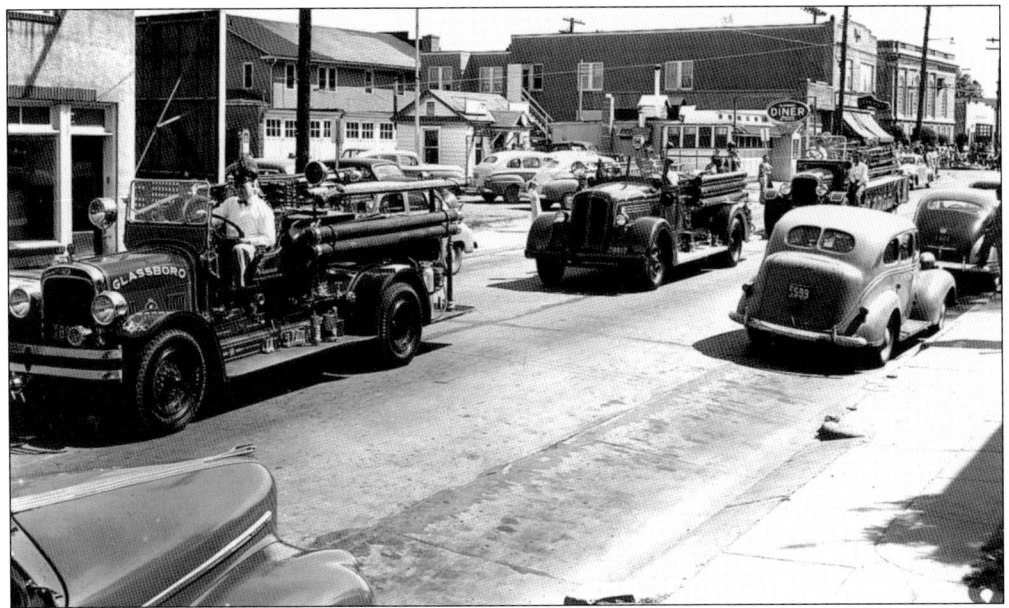

Glassboro's Youth Week was celebrated with a parade on April 30, 1949. In honor of National Youth Week, the borough planned a week-long series of events. The Glassboro Fire Department, shown here heading north on Main Street, near Angelo's Diner, was one of many local organizations participating in the event.

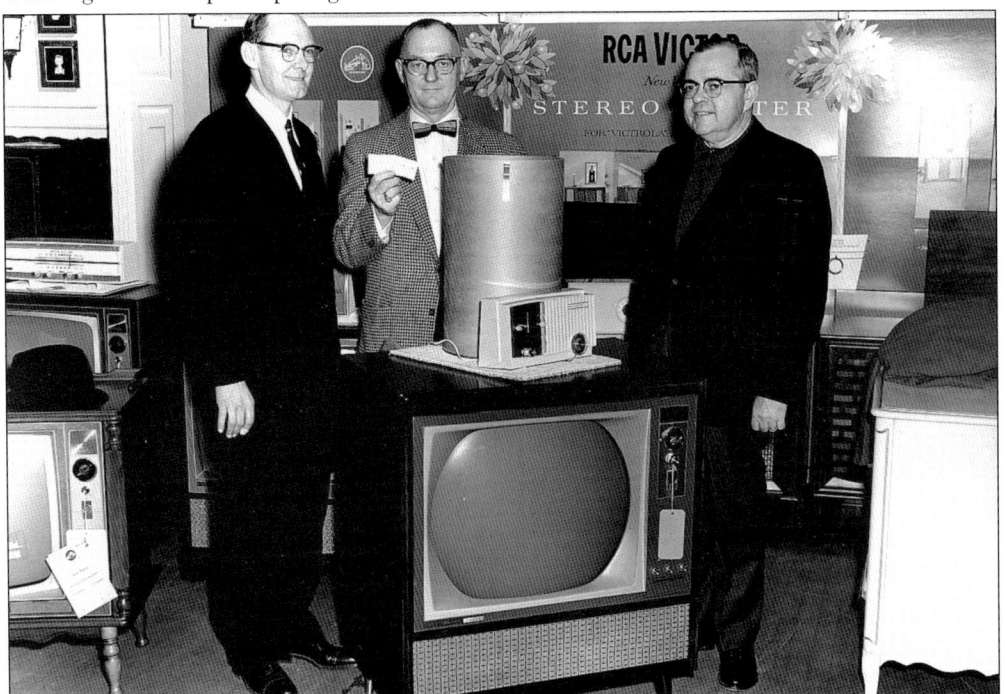

"How would YOU like to win an RCA Victor Color TV?" In 1964, that would have been a big deal. On February 22 of that year, the the Lion's Club drawing was held at the H & H Appliance store, on High Street. From left to right are Mayor Joseph Bowe, Harold Elliott (with the winning ticket), and Henry Greaney.

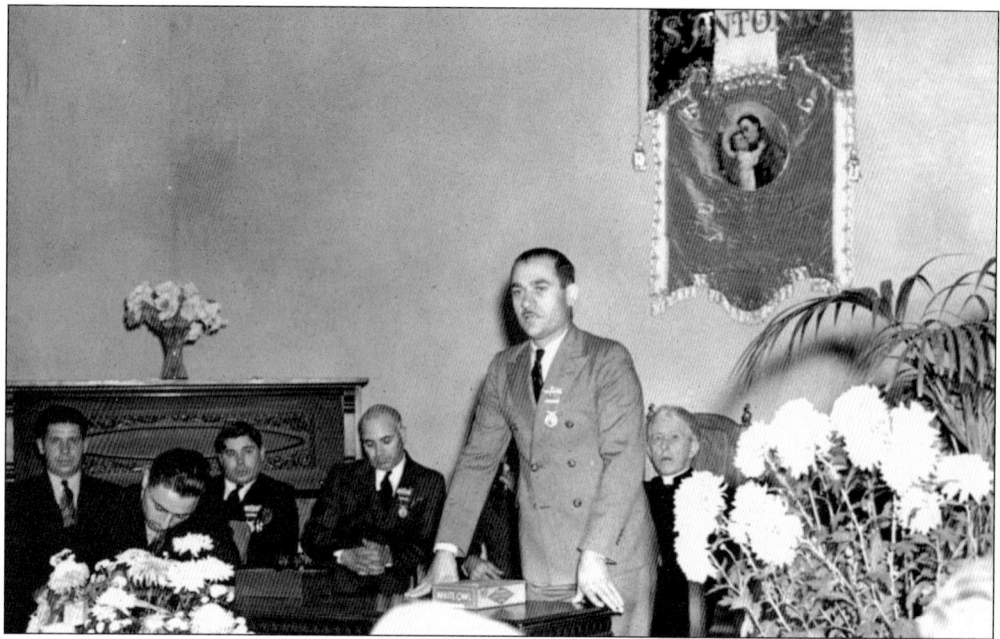

The Italian community of Glassboro found a social outlet in St. Anthony's Mutual Aid Society. On April 21, 1919, Pietro Grillo, Annatasio Amodei, Teodoro Testa, Vincenzo Porreca, and Antonio Maiatico began the process of incorporating St. Anthony's. The society provided not only providing a place of recreation but also emotional and financial support. On November 19, 1939, president Sam Saia leads the dedication ceremonies of the new hall, on Church Street.

A St. Anthony's Feast Day parade on Lake Street crosses over High Street in 1952. The young lady on the float is Nancy Mastroeni-Beach.

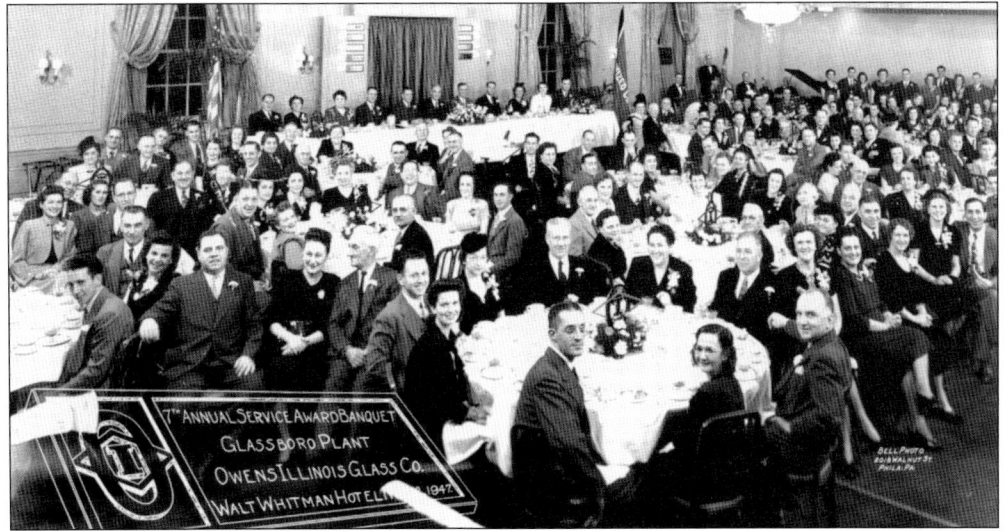

The first annual Basket Picnic for the employees of the Owens Bottle Company, also known as Whitney Plant No. 2, was held at Silver Lake in Clayton on June 18, 1921. This is only a portion of a long photograph that shows the 100-plus employees and family members who attended.

The seventh annual Service Awards Banquet drew 54 Owens Illinois plant employees and their families. The event was held at the Walt Whitman Hotel in Camden on November 12, 1947. Awards were given to employees with many years of service. Frank B. Ward, plant manager, served as the evening's master of ceremonies and presented the awards. Owens Illinois's secretary-treasurer J. H. McNerney gave the principal address.

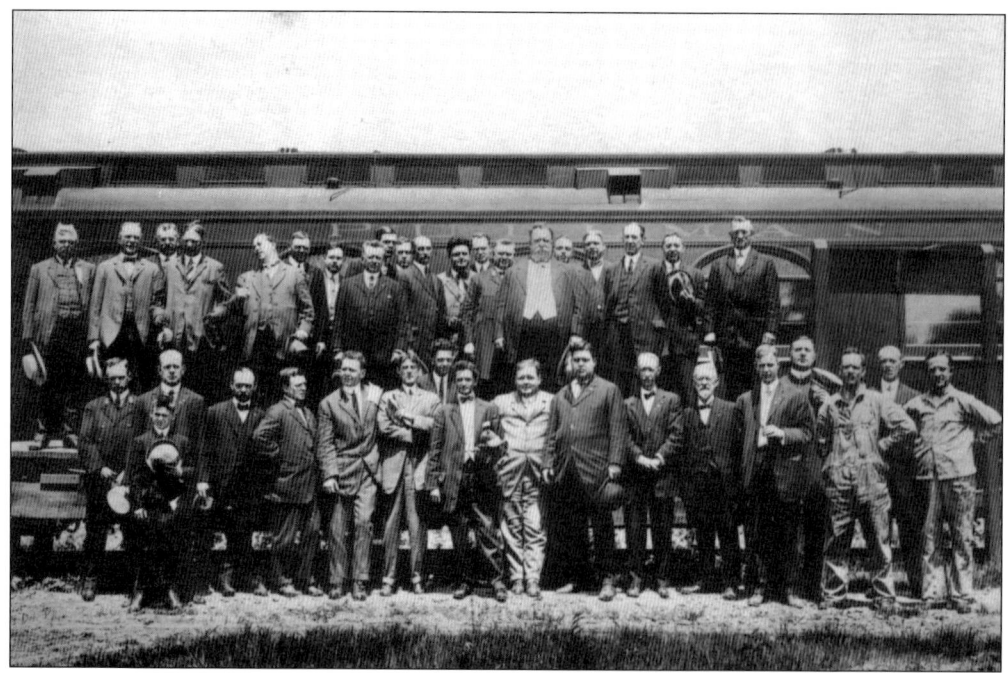

During a campaign tour of Gloucester County, Pres. William H. Taft (upper row, wearing the light vest) made two stops at the Glassboro station on May 28, 1912. The president's itinerary, printed in the *Woodbury Times*, lists the president leaving Glassboro at 8:08 a.m. by train to Woodbury and returning at noon to speak in front of the Auditorium. Taft appeared with his aides and other local dignitaries.

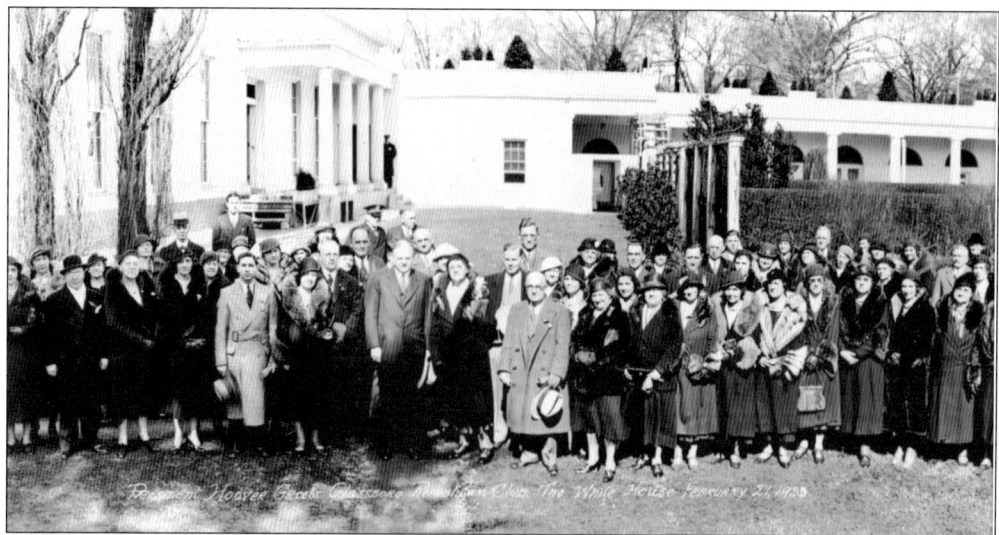

Members of the Glassboro Republican Club gather outside the White House with Pres. Herbert C. Hoover (front, left of center) and his wife (next to him) in February 1933. This may have been one of Hoover's last group photographs as president. The following month, Gov. Franklin D. Roosevelt of New York took the presidential oath. Hoover's failure to bring the country out of the Depression likely cost him a second term.

Construction of the Glassboro Auditorium began on March 1, 1910. Located on Academy Street, directly across from the grammar school, the structure was built by Charles P. Abbott and John Long for $35,000. History was made here when three presidential candidates visited during the heated 1912 campaign between Woodrow Wilson, Theodore Roosevelt, and William Taft.

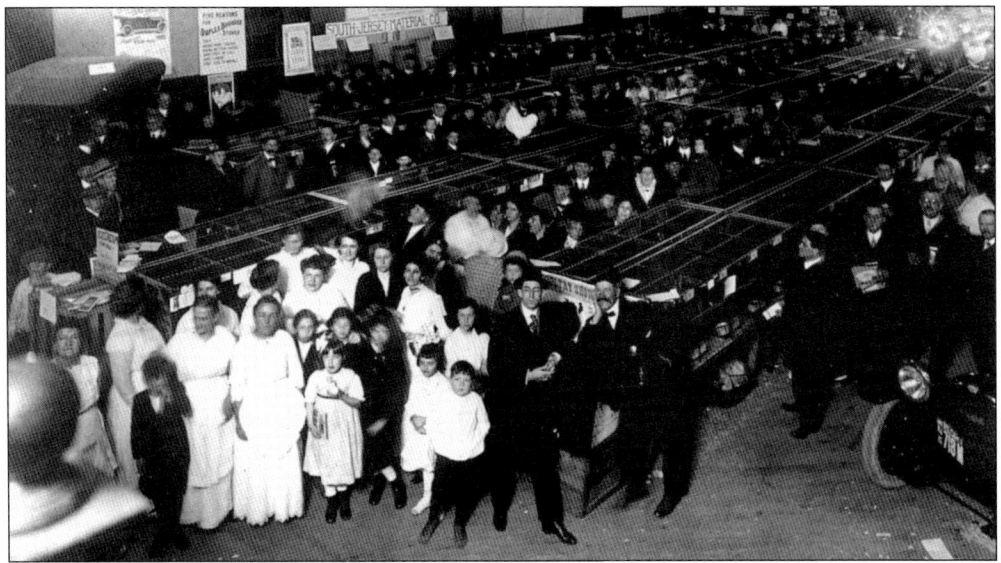

This rare interior photograph of the Glassboro Auditorium was taken during the poultry show held from December 9 to 11, 1915. It indicates the many uses the structure offered. With a seating capacity of 1,200, the building housed a large ballroom, the Masonic Lodge, billiards, bowling alleys, a lunchroom, and two commercial spaces. Motion pictures and stage performances became regular attractions. Not since fire destroyed Zane's Olympian Hall in 1907 had the community seen such a facility.

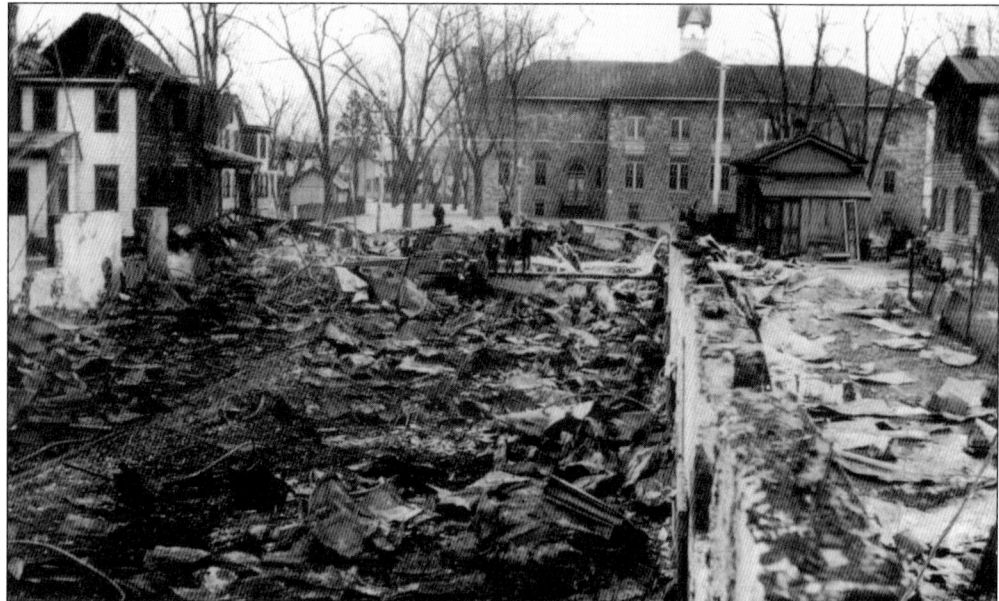

On the morning of January 26, 1917, a blaze completely destroyed the Glassboro Auditorium. Reports claim the fire started in the heater room. Ironically, a newspaper account stated, "The new auditorium hall is practically fireproof with the walls both inside and out covered with sheet metal and the heating is of the latest type." Edward Hawkins Shoe Repair shop (the small building in the back right) survived the fire and remains standing today.

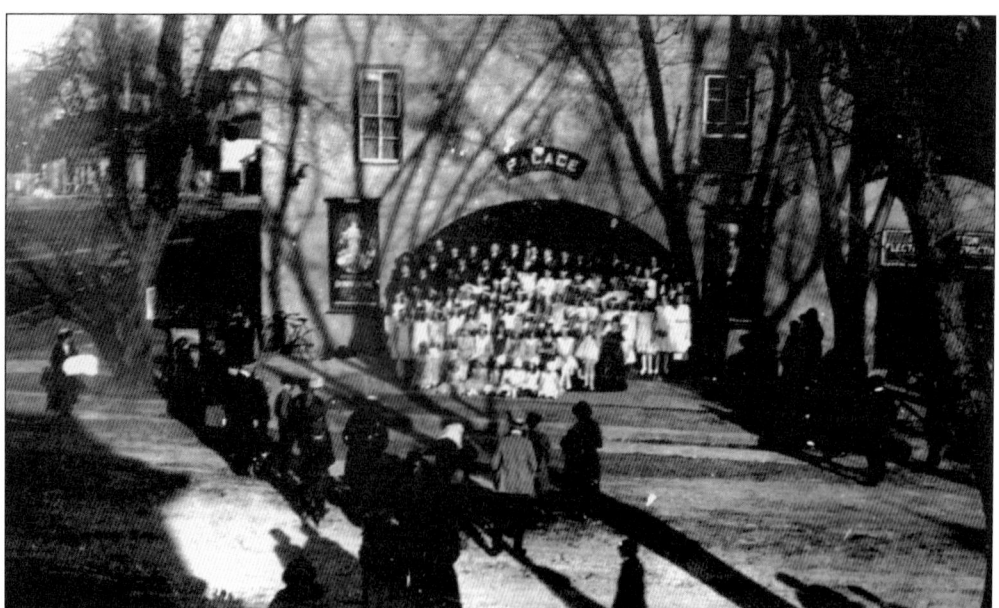

After fire destroyed the Glassboro Auditorium in 1917, owners Charles Abbott and John Long constructed the Palace Theater at Main and New Streets. It was the first theater in Glassboro to show motion pictures and later "talkies." Vaudeville shows were also a popular attraction. The public schools used the theater for graduations and school performances. Pictured in 1921 is the cast from the operetta *Cissy Rosebud*, performed by local schoolchildren.

A Glassboro landmark since 1928, the Roxy Theater opened at High and Academy Streets on Friday, September 21. More than 2,000 spectators from the surrounding area attended the evening's festivities, which began with a dedication exercise, followed by performances of several high-class vaudeville acts and a motion picture. The theater, shown here in 1928, was highly anticipated since the Palace Theater had closed in 1927.

Members of the Tall Cedars of Lebanon, Glassboro Forest No. 1, are pictured c.1910. This nationwide organization is a "side degree with no official standing," of the Masonic Order. During the mid-1800s, gentlemen from Philadelphia and South Jersey gathered in Glassboro to receive the Tall Cedars of Lebanon degrees. On November 16, 1901, the lodge became a permanent organization. Glassboro has forever held the title as Forest No. 1.

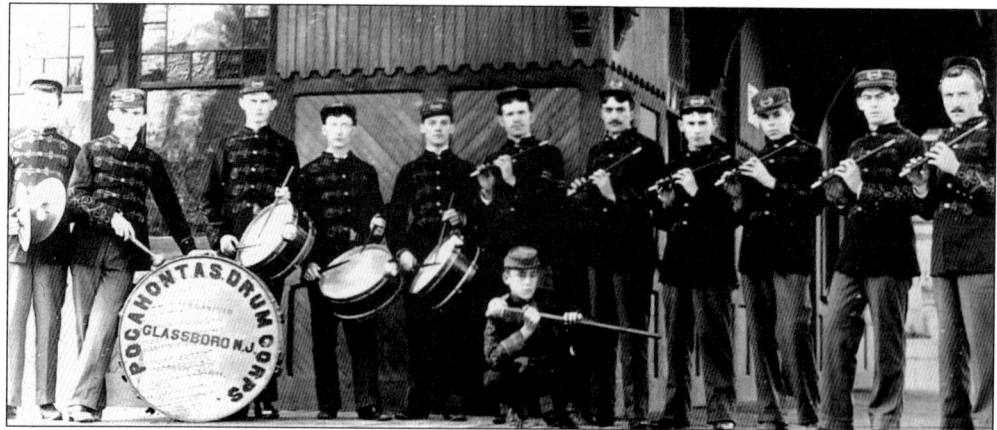

During hot summer months, Glassboro residents found relief at nearby lakes. One such place was Lake Oberst, located on Fish Pond Road. This postcard of the lake in the late 1940s shows how popular it had become. John and Anna Oberst purchased the lake in 1943. It was later bought by Dan and Gayle Pote, who operated the lake until it closed in the early 1970s.

The Pocahontas Drum Corps was organized on April 14, 1894. The group wore red uniforms with gold-braided trim and entertained the residents of Glassboro for several years. Standing in front of the Reading Railroad station at Academy and High Streets are, from left to right, E. Tremont Cake, James Barber, John Cake, Edward Barnett, William Warner, E. M. Duffield, Edward Crawford, Forest Tomlin, William Stanger, Firth Brown, and Burris Tomlin.

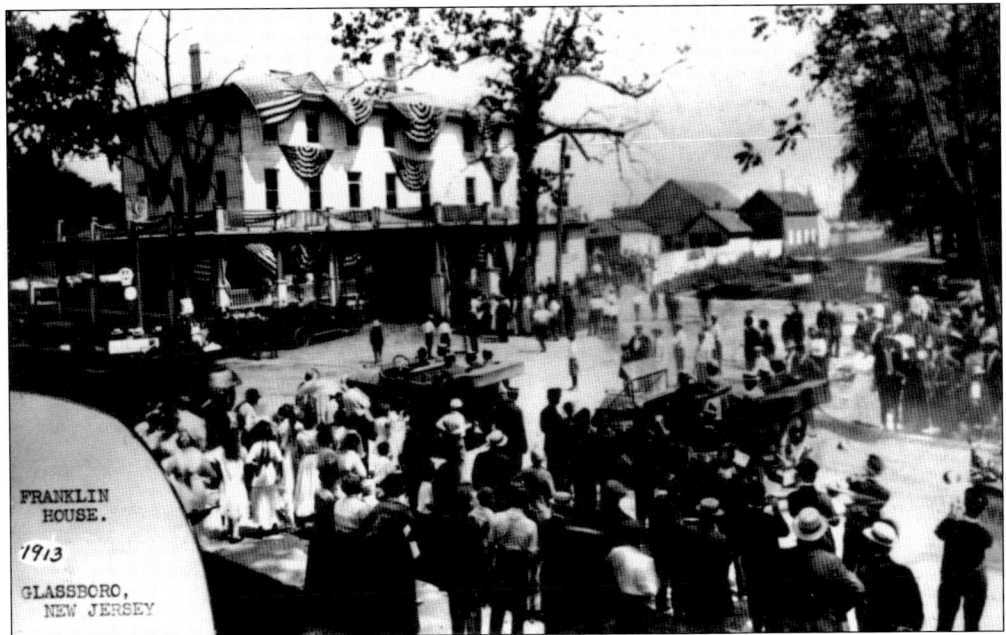

The Franklin House is trimmed in patriotic colors for Old Home Day on August 28, 1913. The next day's edition of the *Woodbury Times* read, "Old Home Day a Big Success." Under the direction of the board of trade, Old Home Day included a parade through town and other special events. A visit from Gov. James Fielder was the highlight of the day.

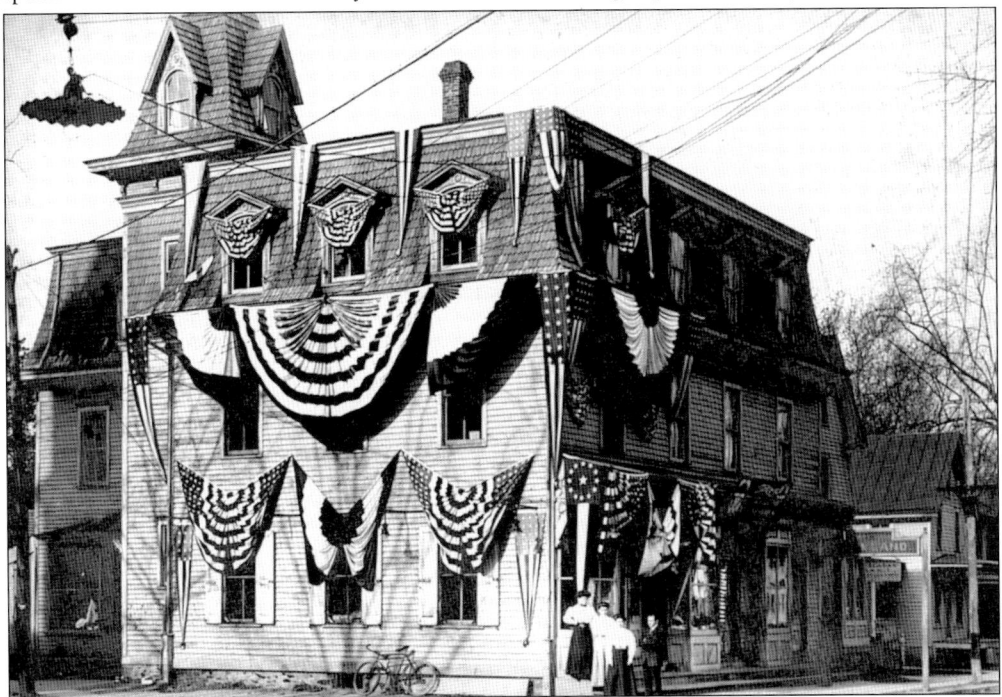

This rare photograph of Wilcox Hall, located on the corner of State and New Streets, was taken during Old Home Day in 1913. The angle gives a good view of the tower that once rose above this structure.

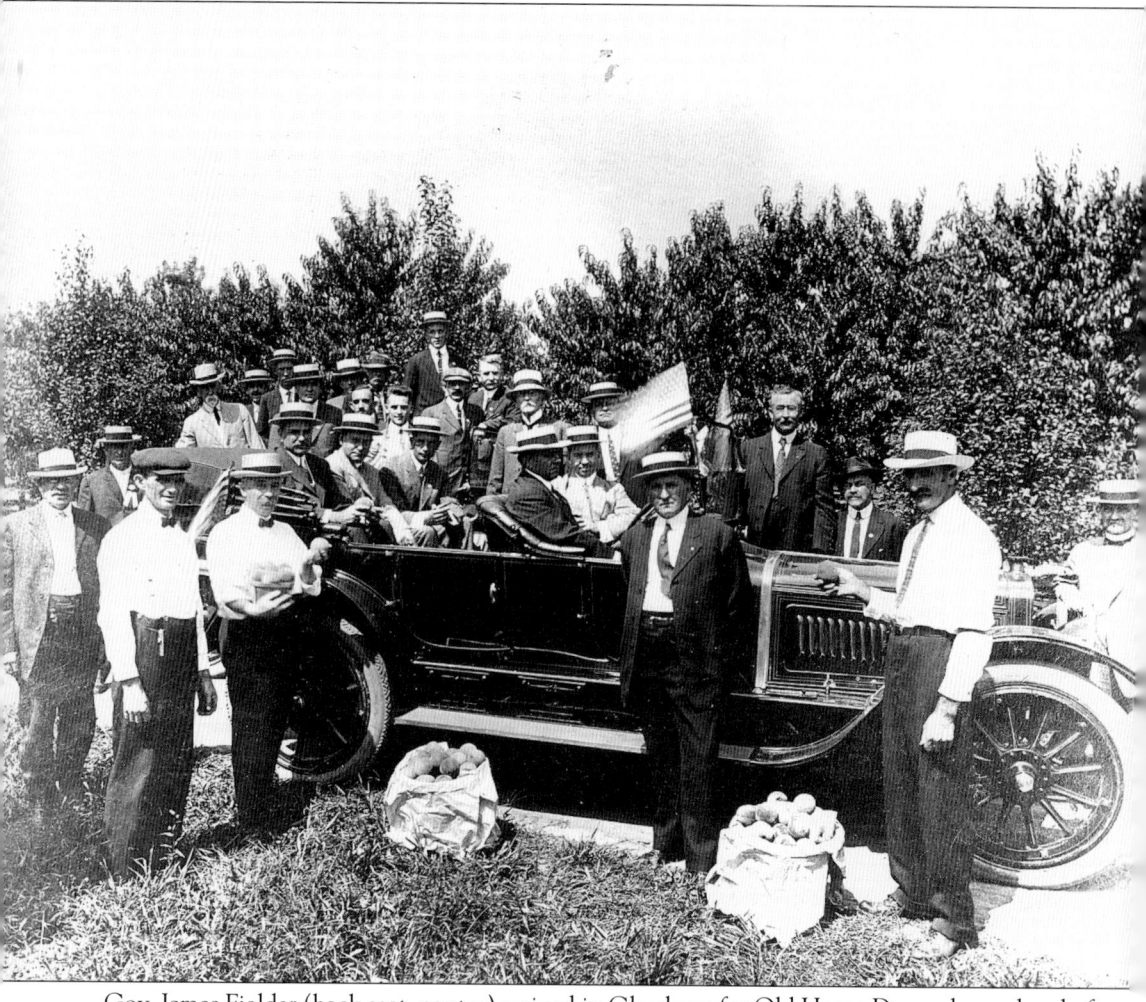

Gov. James Fielder (back seat, center) arrived in Glassboro for Old Home Day an hour ahead of schedule. He requested to visit fruit farms outside Glassboro. At the Pomona Orchards on Broad Street, he and his aides pause for a photograph with local dignitaries. Also in the automobile are Albert Repp (driver) and Dr. Howard Iszard (front seat). Standing are, from left to right, the following: (first row) Dr. E. Mortimer Duffield, Ben Ewen, C. Flaming Stanger, George Keebler, and Sam Magee; (second row) William Downer, Rev. Louis D. Stultz, Marshall Campbell, D. T. Steelman (all mayors from surrounding towns), Rep. Thomas M. Ferrell, Howard Moore, and Louis N. Shreve.